ART HISTORY 101

ART HISTORY 101

AN ESSENTIAL GUIDE TO THE CREATIVE WORLD

101

JOHN FINLAY

SIRIUS

For Elizabeth, without whom this book would have been impossible, and for Tobias for just being here.

For Dorothy and Judith-Anne

Text Notes: The notation in each chapter relates to publications listed in the Suggested Reading & Notes section which can be found on page 218. Definitions of bold italicized words can be found in the Glossary on page 216.

SIRIUS

This edition published in 2024 by Sirius Publishing, a division of Arcturus Publishing Limited,
26/27 Bickels Yard, 151–153 Bermondsey Street,
London SE1 3HA

ISBN: 978-1-3988-3689-1
AD011710UK

Printed in China

CONTENTS

INTRODUCTION

WHAT IS ART HISTORY AND WHAT DO ART HISTORIANS DO?

Art historians study the visual artefacts, objects and structures that humans have created. They do so to enrich our understanding of both the past and the artwork itself. History and art at first seem odd bedfellows: history an intangible record of the past, the artwork an object that can be touched and visually understood. Yet, while we can appreciate artworks, we do need to know the circumstances in which they were created. Art historians seek to ascertain the contexts for artworks. For example, scholars try to gain a full understanding of the historical circumstances that led to the commissioning of a religious altarpiece in early Renaissance Italy, or attempt to unravel the mountain symbolism of the Visvanatha Temple at Khajuraho in India (*c.* 1000 CE). Art historians study subjects from Palaeolithic art to the French Revolution, and interpret Maori cloaks (*whatu kākahu*) or conceptual art pieces. This is an academic discipline, and scholars must always back up their theories with research evidence.

The best art historians tackle artworks from various perspectives, and theirs is often an interdisciplinary enquiry. Working together, historians might require the expertise of a Netherlandish scholar to uncover the secrets of a fifteenth-century triptych, or adopt linguistic theory to describe the arcane language of a Cubist still-life sculpture. Others might make use of specialist X-radiographic technology to scrutinize the earlier states of a painting, or perhaps use chemical analysis to determine its composite makeup. Art historians use sophisticated carbon dating techniques to investigate the murals in Stone Age caves. On the walls of the caves at Chauvet in France exist the world's oldest paintings, datable to around 30,000–28,000 BCE. Recently, the sculptural design that Alberto Giacometti put on his father's tombstone – a relief carving of a bird, a chalice, a sun and star – was deciphered by an Egyptologist from the Brooklyn Museum, who compared it to the hieroglyphic for 'all people worship the sun'. New scientific technologies regularly unmask fakes or confirm expensive acquisitions, while archival material consistently establishes new facts, dates and contexts for artworks.

Art historians habitually use abstract theories, linguistic structures, iconology and iconography to interpret artworks (*see* Chapter 3). Scholars also adopt feminist, anthropological and ethnographical perspectives to deconstruct stereotypes and re-evaluate marginalized or neglected artistic figures, groups and cultures. However, art historians can never be entirely unbiased about the subjects they study. They always bring with them norms, presumptions and biases distinctive to their

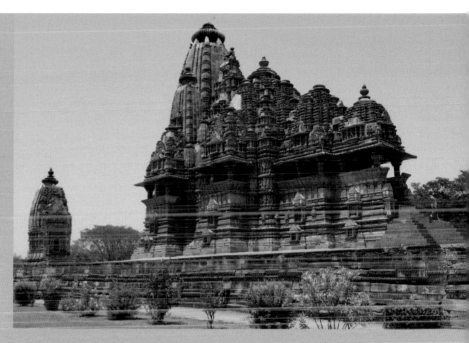

Visvanatha Temple, Khajuraho, India. Completed between 990 CE and 1002 CE and now a UNESCO World Heritage site, the temple is dedicated to Shiva and embellished with numerous symbolic sculptures and engravings.

own art and culture. Although scholars attempt to reconstruct balanced narratives of past events, or present unprejudiced facts on the subjects of class, sex, race and ethnicity, art historical studies are habitually threatened by artistic, cultural and gender short-sightedness. We will see how scholars such as Elizabeth Ellet, Whitney Chadwick, Griselda Pollock, Linda Nochlin, Susan Suleiman and many other feminist art historians have consistently challenged the male status quo. In assessing gender bias in art history, moreover, feminist scholars use ways of 'seeing' the often unrecognized role of great women artists in the history of art. New global art histories have similarly set the record straight regarding European attitudes towards diverse world cultures, challenging non-Western histories of the 'other' by dismantling historically skewed, restricted and far-away understandings of complex thought processes, cultures and artworks (*see* Chapter 9). As with all branches of learning, art historians nonetheless try to reach a consensus regarding the subjects they study.

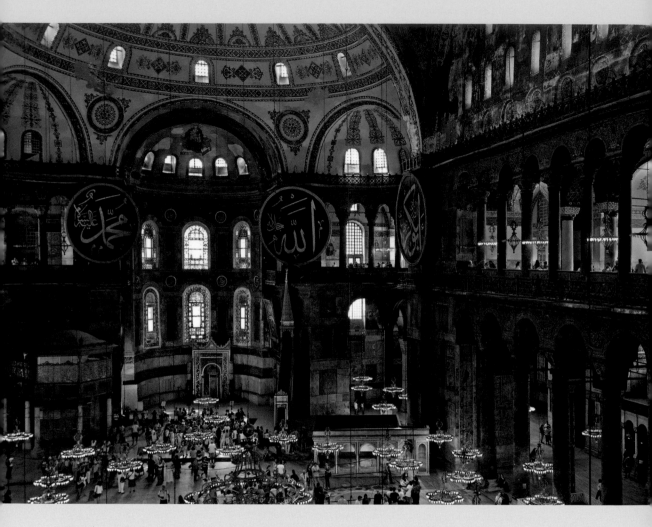

Today, we think of art as something we experience in a gallery, exhibition or museum space. We probably classify art as drawing, painting, photography, sculpture and architecture. However, art historians study numerous other art objects. These might include ancient ceramics, tapestries, carpets, jewellery, mosaics, illuminated manuscripts, religious relics, tribal masks, ceremonial cloaks, shrouds and caftans, ornate treasure chests, sarcophagi and drinking vessels – to name but a few. Art can alternatively involve a multi-sensory experience. In the great Byzantine Hagia Sophia (built in Constantinople, now Istanbul, Turkey, 532–537 CE), the faithful employed all their senses to bring themselves closer to God and the afterlife.

Sometimes art historians know very little

More crucially, it is one of the first indisputable instances of art conjured in the imagination of the anonymous human who created it. For lack of any written account by Stone Age peoples – there are none, obviously – art historians can only surmise the rationale behind the Hohlenstein-Stadel statuette, conjecturing as to what the artist had in mind. This is the paradoxical vexation and sheer delight of art history: studying a period so far away in time that we have to work incredibly hard to make sense of what remains. As we'll see in Chapter 2, virtually every new Palaeolithic discovery causes art historians to reconsider what had hitherto been substantiated.

This book provides those interested in art history with a selection of the core topics taken on a BA degree course. The art historical discipline is highly varied, and it does not seek to cover in any depth architecture, or postmodern subjects such as pop art, world art histories or a particular specialism such as photography or sculpture. Each chapter gives prominence to a particular genre, including portraiture, still life, religious subjects, landscape, genre and history painting. These are the kinds of images and subjects that students will repeatedly encounter on any art history course, and the reason for their prominence throughout this book. The key ideas, images, histories, artists, writers and thinkers introduced here will point the way to a more rounded and complete study of the discipline of art history.

about the origins or *raison d'être* of artworks (*see* Chapter 2). It is not known, for instance, if the mammoth ivory figure from the Hohlenstein-Stadel cave in Germany (c. 32,000–28,000 BCE, Ulmer Museum) is a 'lion-man' or 'lioness-woman'. The statuette can depend-ably be termed 'art', but offers strong evidence that it had a more utilitarian, social or arcane religious function for Stone Age peoples.

As the reader will see, art history is a highly challenging interdisciplinary field. It is also a lifelong interest and is highly fulfilling and beguiling.

Chapter One
'WAYS OF SEEING': INTRODUCTION TO THE VISUAL ANALYSIS OF THE ARTS

Engaging with Art – Visual Politics – Formalism: the Styles of Art History – 'The Art of Describing': Iconography and Iconology

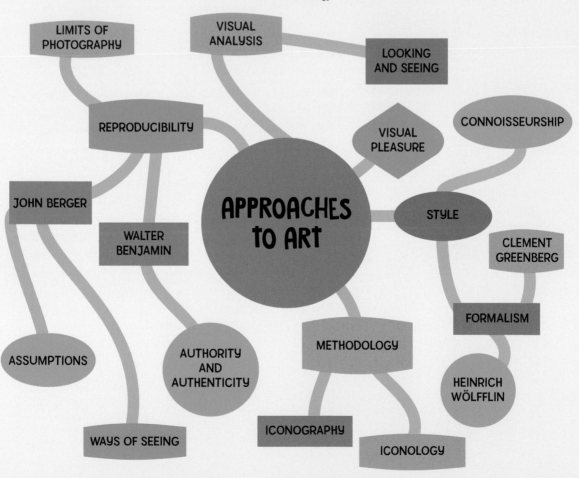

ENGAGING WITH ART

The visual analysis of the arts involves a considered type of looking. It is an essential tool of the art historian: a way of looking through and thinking about art. The visual analysis of the arts is a subjective, interpretive discipline; so, observing art for oneself is just as valid as the reflections of others. Great works of art change over time, through historical study, new interpretations and probing analysis by scientists, archaeologists and conservators. This occurs largely in tandem with the adept visual analysis used by art historians.

Whereas art is essentially scrutinized from the perspective of history, the visual analysis of the arts puts the emphasis on looking. Here is John Berger describing Paul Cézanne's watercolour of *Trees by the Water* (1900–04): 'In his later works [Cézanne] … left a large area of the canvas or paper blank. This device served several purposes, but the most important is seldom mentioned: the blank white spaces give the eye a chance to add imaginatively to the variations already recorded; they are like a silence demanded so that you can hear the echoes.'[1]

Trees by the Water *(1900–04) by Paul Cézanne. In addition to the use of white space, the limited tonal palette adds to the atmosphere of the work.*

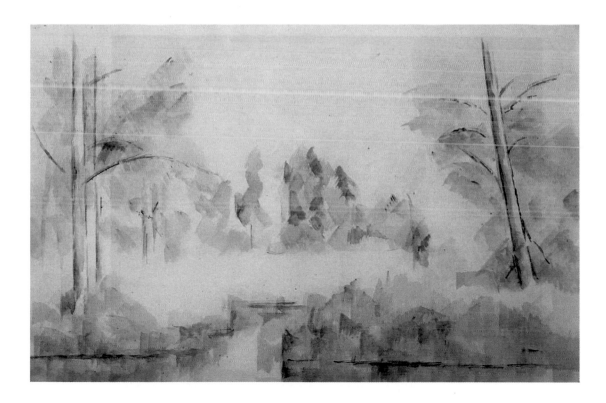

This skill can completely change the way in which we think about an artwork. And it is crucial to developing our art historical skills. Visual theorists have shown that looking at art is based not merely on visual pleasure, but is also influenced by our own assumptions, preconceptions and the judgements that encompass the act of seeing. It's fundamentally about finding new ways of reading the complex languages of art. These skills appear to be ever more vital in the digital era, where images are

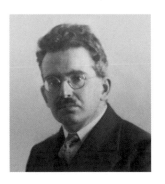

The philosopher, critic and essayist Walter Benjamin, who argued that a work of art loses impact when it is seen as a reproduction instead of in its original state.

so readily accessible in mass-produced formats. Photography seems to be a base currency for all art historians, for this is how most works of art are known and compared. But can the objects of art really be known in this way? Is photography a substitute for a real physical encounter with a work of art?

Before discussing the topic of reproducibility, it is important to make a few straightforward points about our engagement with artworks. Our experiences shape the act of looking, so we all account for art in our own way. But this does not necessarily mean that our interpretations of art are always uniformly convincing. They are not. If we have strong visual analyses underpinning our thought process, however, our arguments will be additionally cogent and more thought-provoking. The better your methodology, the more you will reveal about the artworks you are studying. Every art historian adopts certain approaches or methods, and these completely affect the way we look at art and what we find. So let's turn our attention to the act of looking by using a few methodological examples, trying to put these in context to determine how they fit into the ongoing historical discourse.

VISUAL POLITICS

The inherent problem with photography in relation to art is its inherent reproducibility. It's a subject that the German philosopher and art critic Walter Benjamin (1892–1940) tackled in his seminal essay 'The Work of Art in the Age of Mechanical Reproduction'. The impact of Benjamin's theory is such that some art historians have seen fit to adapt it to their own work. In *Ways of Seeing*, John Berger argued that there is something larger at stake when we think about artworks in relation to mechanical reproduction. Berger, like Benjamin, saw the reproduction of art as a deeply political issue, its undiminished authority validating many other types of cultural and political authority. 'The bogus religiosity which now surrounds original works of art, and which is ultimately dependent upon their market value, has become the substitute for what paintings lost when the camera made them reproducible. Its function is nostalgic [...]. If the image is no longer unique and exclusive, the art object, the thing, must be made mysteriously so.'[2] The point is, 'ways of seeing' are never, politically speaking, innocent or neutral when it comes to looking.

Berger's main thrust in *Ways of Seeing* was to prioritize the act of looking. 'Seeing comes before words. The child looks and recognises before it can speak.' The opening lines to his text illustrate his key concept. 'The relationship between what we see and what we know is never settled. The way we see things is affected by what we know or what we believe.' The key to this idea is how looking is always influenced by our learned preconceptions. Berger labels these 'assumptions', and here they are:

The Lower Basilica of St Francis of Assisi in Assisi, Italy, which features frescos by Cimabue, Piero Lorenzetti and Cesare Sermei among others.

Beauty	Genius	Form	Taste
Truth	Civilization	Status	

Via photography and Berger's television, 'the painting now travels to the spectator, rather than the spectator to the painting ... its meaning ... diversified At the same time it enters a million other houses and, in each of them, is seen a different context.' Berger talks about the democratizing effect of the camera on the frescos in the Basilica of St Francis of Assisi in Italy: 'The uniqueness of every painting was once part of the uniqueness of the place where it resided. Sometimes the painting was transportable. But it could never be seen in two places

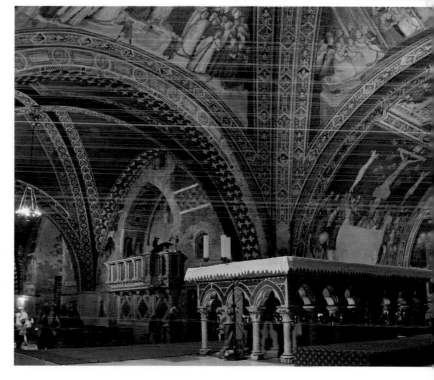

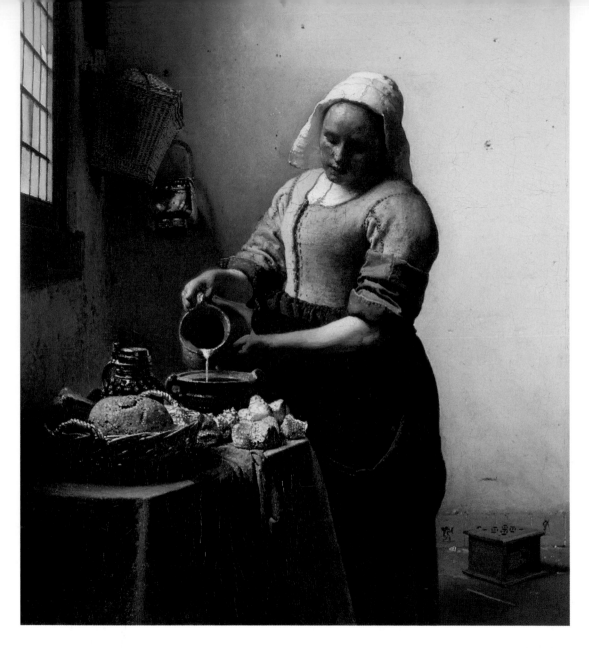

The Milkmaid (c. 1658) by Johannes Vermeer. For a long time, a yellow-tinged image of the work that was often seen on the Internet was thought to be the original, until a better-quality image was released.

at the same time. When the camera reproduces a painting, it destroys the uniqueness of its image. As a result its meaning changes. Or, more exactly, its meaning multiplies and fragments into many meanings.'[3]

This seems like a good place to start thinking about the implications of reproduction, especially in relation to specific artworks. Walter Benjamin suggests that within capitalism lies the seed of the destruction regarding art's 'authenticity'. The process of mass production, including images, he argues, causes the demise of the original artwork. In turn, reproduction liberates the art object from its dependence on ritual or religion. Mechanical reproduction (or its contemporary equivalents) therefore is a democratizing process. Regardless, art's authority, value and 'the quality of its presence is always depreciated' by photography and other methods of replication. Its authenticity, or 'aura', is interfered with and threatened. While Benjamin argued that mechanical reproductions do not 'touch' the work of art, he nonetheless contends that the art of the past no longer endures as it once did. Its 'authority' is misplaced and substituted by its other – the mechanically reproduced image.

So what precisely makes an artwork, according to Benjamin, 'authentic'? As Benjamin explains, 'Even the most perfect reproduction of a work of art is lacking in one element: its presence in time and space, its unique existence at the place where it happens to be.'[4] The presence of the original, its location, the experience of it spatially and temporally, contributes to an artwork's authenticity. This is where the 'aura' resides and also leads to its decay. Benjamin's concept is full of complexity and contradiction. A possible interpretation

might be that the aura is able to maintain its distance, despite its proximity; i.e. a sense of itself, its uniqueness and its completeness. To experience an aura is to have a deeply personal and close interaction with the artwork. John Berger describes this effect in visual terms. 'Original paintings are silent and still in a sense that information never is. Even a reproduction hung on a wall is not comparable in this respect for in the original the silence and stillness permeate the actual material, the paint, in which one follows the traces of the painter's immediate gestures. This has the effect of closing the distance in time between the painting of the picture and one's own act of looking at it.'[5] As Benjamin likewise maintains, mechanical reproduction challenges this authority when 'The cathedral leaves its locale'.[6]

In its severance from tradition and the 'cult of beauty', Benjamin's optimism concerning the emancipation of art is obvious. The author views it as a catalyst for 'a tremendous shattering of tradition [and…] the renewal of mankind'. Illogicality and wistfulness inhabit the text. Mechanical reproduction has a 'destructive, cathartic aspect': 'To pry an object from its shell [is] to destroy its aura' and 'overcoming the uniqueness of every reality' are inconsistently iconoclastic and democratizing statements. Benjamin's text appears purposefully open-ended, the impact of mechanical reproduction leaving us with countless questions in relation to art. For both Berger and Benjamin, it seems, 'mechanical reproduction emancipates the work of art from its parasitical dependence on ritual [and…] the total function of art is reversed. Rather than ritual, the artwork begins to be based on another practice – politics.'[7]

FORMALISM: THE STYLES OF ART HISTORY

Style is a vital part of distinguishing artworks. A charge often levelled at formalism and formalist art historians (and its counterpart, connoisseurship) is that it considers artefacts without significant consideration to the cultural environment that engendered them. This once pivotal concept has fallen out of fashion, but the fact remains that comparative methods in art history to explain another culture's perspectives have continued unabated. Heinrich Wölfflin (1864–1945), Alois Riegl (1858–1905) and their heirs in America in the twentieth century greatly expanded formalism within the discipline of art history. Few art historians even

now succeed in explaining a painting without referring to formalist principles in some such way. Wölfflin's practice of evaluating 'forms of representation' and 'the Zeitgeist […] spirit-of-the-times-explanation of artistic style' in his *Principles of Art History* (1915) is still accepted as a fitting means to carry out art history. It is often explained to students when teaching Wölfflin's *Principles* that his dual system of contrasting images side by side on a projection screen has remained largely unchanged in today's lectures and tutorials.

The latter technique – adopted from Wölfflin's contemporary Hermann Grimm (1828–1901) – uses style to explain what gave rise to changes in art during different centuries. We will explore Wölfflin's dual system of pairing 'type-with-type' in greater detail in Chapter 7. To get a sense of how much Wölfflin's philosophy of style is at odds with his contemporaries, however, let's compare the writer's description of Raphael Sanzio's (1483–1520) tapestry cartoon *The Miraculous Draught of the Fishes* (opposite) with Grimm's own description.

The Swiss art historian Heinrich Wölfflin, who taught in Basel, Berlin and Munich, helped to raise the study of art history in Germany to new levels in the early part of the twentieth century.

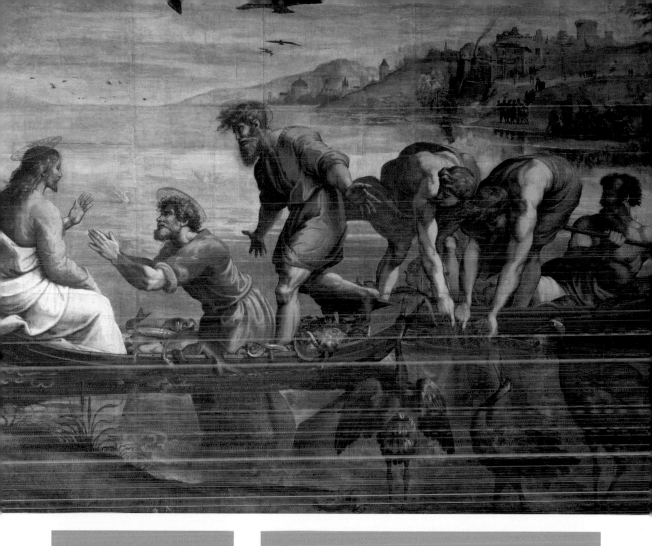

It is astonishing what Raphael has done here only with the aid of drawing; he lets the lake expand under clouds that lose themselves in the distance and awakes a feeling of loneliness and being abandoned.[8]
Hermann Grimm

Every part, down to the last detail, is related to the whole; each line is calculated to fit in with its counterparts elsewhere.... The shapes of the landscape are also created with a pictorial purpose: the line of the river bank exactly follows the ascending contour of the figure group, then there is a gap on the horizon, and only above Christ does a hilly bank recur, so that the landscape gives emphasis to the important caesura in the figure composition.[9]
Heinrich Wölfflin

Grimm's method essentially continues Giorgio Vasari's (1511–74) approach in his *Lives of the Most Excellent Painters, Sculptors and Architects* (1550–68) of prizing artistic personality, genius and the transcendent nature of art above all else (*see* Chapter 4). He fills his description with poetic sentiment, stressing the heroic nature of the artist. By contrast, Wölfflin is only interested in the way in which formal elements play a part in the stylistic aspects of the 'whole' picture. This approach is common to formalist approaches in the twentieth century.

After Wölfflin, art history continued to have its formalist successors, including Henri Focillion (1881–1943), Roger Fry (1886–1934), Alfred H. Barr, Jr (1902–81) and its defender in chief Clement Greenberg (1909–94). Fry and Focillion argued that political, social and economic factors did little to influence artistic forms; Barr, and Greenberg particularly, built on this argument to provide subtle formal analyses that separated art history from broader assertions about taste and culture. While Barr's jacket cover for the exhibition *Cubism and Abstract* (1936) celebrated the trickle-down effect of Modernism's cross-pollination regarding modern artistic idioms such as **Abstract Expressionism**,

The American art historian Alfred H. Barr, Jr, who became the first director of the Museum of Modern Art (MoMA) in New York in 1929 at the age of 27.

Giorgio Vasari, who as well as being the first historian of art to use the term 'Renaissance' was also a painter in his own right.

Greenberg married formalism with high-end **connoisseurship** to point up the techniques of art – the surface plane, the brush stroke, painterly effects and abstract forms and so forth, asserting that the subject of modern art was art. His 'art for art's sake' approach governed his and other writing in the 1950s and 1960s.

In Greenberg's first important critique, 'Avant-Garde and Kitsch' (1939), he claimed that the 'excitement of [avant-garde] art seems to lie most of all in its pure preconception with invention and arrangement of spaces, surfaces, colors, etc., to the exclusion of whatever is not necessarily implicated in these factors'. The serious aesthetics of 'high' art forms dominate his concerns and those of other critics such as Harold Rosenberg (1906–78), where flatness in painting is an especially twentieth-century dilemma. Modern art and culture (i.e. modern painting), as Greenberg's text indicates, has always had an uncertain connection with 'ersatz' imitation – art for Capitalism's new man or woman, or 'Kitsch'

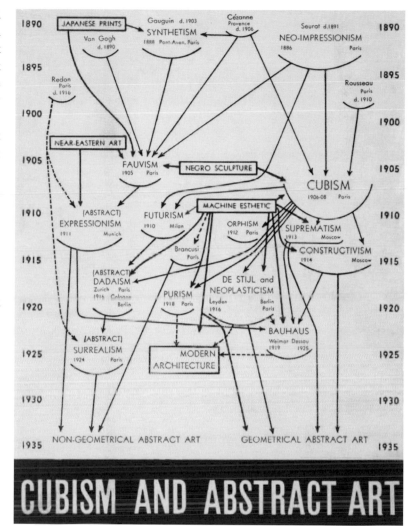

The cover of Alfred H. Barr, Jr's book Cubism and Abstract Art *(1936) that showed the links between the art movements of the late nineteenth century, Cubism and its contemporary and subsequent movements in the twentieth.*

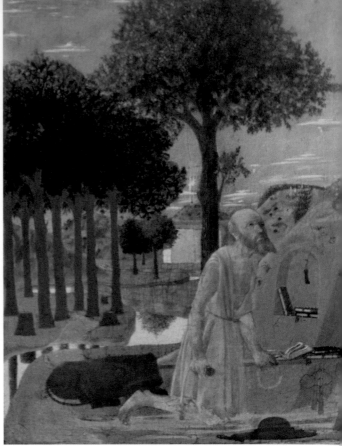

St Jerome in Penitence (c. 1450) by Piero della Francesca. The artist used typical iconography, such as books, associated with Jerome.

as he famously labelled it. Greenberg's text fundamentally identified kitsch as an explicit artistic phenomenon, recognizing it as a fatal nemesis, something profoundly repugnant and from which high art endeavoured to separate itself. Greenberg argued in 'Avant-Garde and Kitsch' that the threatening invasion of 'ersatz' culture meant that 'the arts [had] been hunted back to their mediums … to restore the identity of an art, the capacity of the medium must be emphasised'. His essay 'After Abstract Expressionism' (1962) repeated these problems as regards the purity of medium and vision, feeling that art now approached a kind of Factualism, Neo-Dada or proto-Pop art, which simply sought only to express 'the banalities of the industrial environment'. Preserving art's authenticity, identity and aspirations was, Greenberg felt, the stuff of Modernism; its role was to rescue the fine arts from being consumed whole by the new aesthetic domain of kitsch.

'THE ART OF DESCRIBING': ICONOGRAPHY AND ICONOLOGY

Iconography is the study of images, and involves identifying motifs and images in artworks. In Christian iconography, a man depicted outdoors as a penitent hermit, or as a **humanist** scholar at study, surrounded by books and letters, traditionally represents St Jerome. Moreover, a human skull, a snuffed-out candle and an hourglass are examples of **vanitas** and *memento mori* ('remember you must die'). **Iconography** may focus on the individual fruits on a windowsill, a pair of shoes, or a small lapdog sitting on a bed. Alternatively, the focus may be on the entire painting, such as *The Arnolfini Portrait* by Jan van Eyck. Iconology essentially elaborates on iconography, being the study of visual imagery and its symbolism in a broader cultural context, often in social or political terms. **Iconology** asks why we view certain images as representative of a specific culture. Only when we understand that a work represents St Jerome, for example, can we begin to ask why the artist depicts the saint in this specific environment and way.

Ernst Gombrich, whose books The Story of Art *and* Art and Illusion *contributed much to the understanding of the visual arts.*

Below: *The art historian Professor Svetlana Alpers, whose speciality is the Golden Age of Dutch or Netherlandish painting.*

Under the auspices of Aby Warburg (1866–1929), Erwin Panofsky (1892–1968) developed his ideas on iconography, iconology, symbolic form and 'disguised symbolism', combining the formalist analysis of Riegl and Wölfflin with Warburg's theories on iconography. Warburg contended that a society's art was influenced in various ways by its religious, cultural, political and social circumstances. As Panofsky explains: 'In a work of art, "form" cannot be divorced from "content": the distribution of colour and lines, light and shade, volumes and planes, however delightful as a spectacle, must also be understood as carrying a more-than-visual meaning.'[10] In this text, and his earlier *Studies in Iconology* (1939), Panofsky also saw iconography as a system that allowed art historians to salvage the content 'disguised' within artworks. His studies in iconography and iconology greatly influenced the field and curricula of art history in Europe and America, and were widely applied and adapted by scholars, including Ernst Gombrich (1909 2001), Jan Bialostocki (1921–88), Hans Belting (1935–) and Leo Steinberg (1920–2011).

Together, art historians such as T. J. Clark (1943–) and especially Svetlana Alpers (1936–) met Panofsky's iconographic analysis head-on, as well as the belief among other Netherlandish art scholars (particularly Wayne E. Franits and Eddy de Jongh) that visual symbols predictably have or communicate meaning. In *The Art of Describing* (1983), Alpers challenged the extent to which 'the study of [Dutch] art and its history has been determined by the art of Italy', her intention being to restore 'the descriptive aspects of Dutch art [and] of Holland and Dutch life'. In her analysis, Dutch artists were part of a very idiosyncratic type of culture, their paintings of everyday life not simply a form of disguised moral symbolism but rather a way to make sense of the wider world. 'What I propose to study then is not the *history* of Dutch art,

but the Dutch *visual* culture. In Holland the visual culture was central to the life of the society.' Alpers viewed Dutch art within the context of the production of maps, optical technologies, letters and books – all forms of 'visual culture' and central to Netherlandish life, art and society. She also used the term 'art of

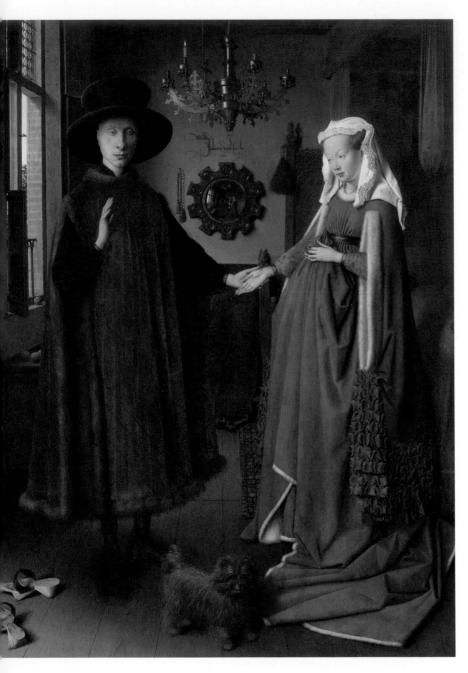

The Arnolfini Portrait (1434) by Jan van Eyck. The couple are presumed to be Giovanni di Nicolao Arnolfini and his wife.

Opposite: Shoes (1886) by Vincent van Gogh. Van Gogh painted the work over an earlier one, a view of Paris from his brother Theo's apartment.

describing' to oppose a long-standing tradition of disparaging descriptive works of art, rejecting what she saw as the prevailing view of Dutch art by commentators such as Joshua Reynolds and Eugène Fromentin, who described them as purely 'barren entertainment', subject-less and nothing other than 'a portrait of Holland'.[11] Alpers made specific reference to Michelangelo's attributed and scathing comment that: 'Flemish painting appeals to very old women ... also to monks and nuns and to certain noblemen who have no sense of true harmony ... and that is why we call good painting Italian.'[12] Alpers sought a far more heterogeneous view of Dutch art both by investigating its pictorial modes – 'the art of describing' – and by placing Dutch art in a broader cultural context.

Looking at art is the very stuff of art history. However, it is something we historians often ignore or miss completely when building a framework for our own theories about art and history. This is something pointed out by the historian Geoffrey Batchen (1956–) in his brilliant essay, 'What of Shoes: Van Gogh and Art History' (2009). Here, the author focuses on a single painting: *Shoes* (1886) by Vincent van Gogh, a work that has garnered great attention from historians and philosophers concerning the function, role, interpretation and the nature of being in art. It has 'become one of the most significant works in the history of art'. In Batchen's eyes, *Shoes* becomes a tool to discuss, analyse and deconstruct a much wider subject – the discipline of art history itself. Yet Batchen alerts us, via the French philosopher Jacques Derrida, to the self-interested nature and ulterior motives behind the 'grand edifices' of interpretation, where each and every author 'projects him [/her] self into the picture'. In short, *Shoes* 'is a kind of trap for the unwary ... the curling laces to the right ... a snare waiting to catch our own feet, trapping us in our projected desire for the political certainties of order'. As Batchen further indicates, *Shoes* is, for Derrida, 'a discourse on painting' and a painting as much about painting as it is about shoes.

Ultimately, the sheer number of subjects and varying approaches to art history may entice us to believe that there is no golden thread unifying the discipline of art history. Possibly, as John-Paul Stonard puts it, 'there is really no such thing as art history ... only art historians ... and the books that they write. Together [books] provide a picture of the field, and an argument for its vital importance in changing times as a way of understanding and preserving the most important objects in human history.'[13]

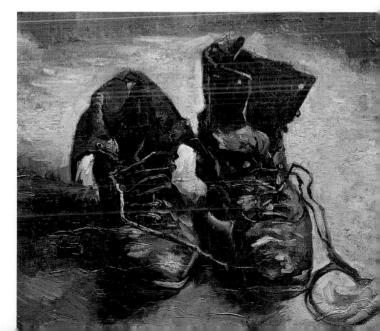

Chapter Two
THE ORIGINS OF ART IN ICE AGE EUROPE

AURIGNACIAN

GRAVETTIAN

SOLUTREAN

CHÂTELPER-RONIAN

VENUS FIGURINES

WALL ART

MAGDALENIAN

UPPER PALAEOLITHIC

PORTABLE ART

PARIETAL ART

PALAEOLITHIC ART

CARVINGS AND STATUETTES

FRANCO-CANTABRIAN TRIANGLE

SHAMANISM

EARLY HUMAN ART

BLOMBOS CAVE

HOMO ERECTUS AND HOMO HEIDELBERGENSIS

HOMO SAPIENS AND THE PALAEOLITHIC REVOLUTION

CHAUVET

LASCAUX

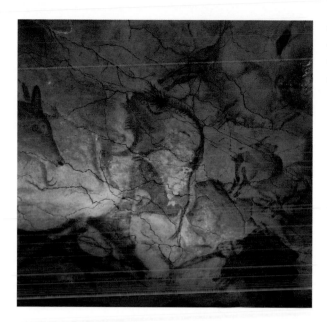

A spectacular sequence showing deer and bison at the Altamira cave in northern Spain. The excellence of the observation and detail, particularly of the female deer, and the mane and head of the central bison, is notable.

WHAT IS PALAEOLITHIC ART?

Coined in 1865 by the English archaeologist John Lubbock – a friend of Charles Darwin – the word *Palaeolithic* denotes the 'Old Stone Age' (from the Greek *palaeo*, 'old', and *lithos*, 'stone'), a period in time when stone tools were crafted by the technique of flaking. The Palaeolithic period was afterwards subdivided into different eras, each indicating various types of stone tools stretching back to the first known European toolmakers.

The first era is Acheulean, associated with the new material culture of *Homo erectus/Homo heidelbergenis*, and with the rise of cultural practices by the Mousterian Neanderthal, beginning some 400,000 years ago. In Europe, the Upper Palaeolithic is the acon of *Homo sapiens*, commencing with the first indication of modern humans roughly 45,000 years ago, and throughout the Ice Age. Archaeologists also subdivided the Upper Palaeolithic period further to better typify the various stone tool-making technologies. Later on, similar sequential subdivisions were (and still are) applied to other kinds of cultural materials, including transportable art objects such as bodily adornments and designs on cave walls, but these subdivisions do not tally precisely with the stone artefacts category. In order to make sense of what is termed the Upper Palaeolithic Revolution – around 50,000 years ago – we have first to identify key chronological time periods for this sudden revolution of creative development. (This sudden blossoming happened very quickly, which is why archaeologists refer to it as the 'Revolution'.) So let's roughly identify these individual phases before going on to analyse the various arts of Palaeolithic peoples.

UPPER PALAEOLITHIC CHRONOLOGY

CHÂTELPERRONIAN ▶

c. 45,000–40,000 years ago

This first phase of the Upper Palaeolithic indicates an overlap between the earliest modern ancestors (*Homo sapiens*) and the concluding Neanderthal species. It is a fierce area of debate in prehistory studies and with regard to artistic production, particularly by the Neanderthals. Some artefacts include a blend of late Mousterian (Neanderthal) 'toolkits' and new types produced by *Homo sapiens*, such as worked stone blades and other artefacts created out of shell, bone, teeth and ivory (below).

AURIGNACIAN ▶

c. 45,000–30,000 years ago

This period evidences countless innovations and clear signs of art making during the Ice Age. As well as the shaping of antler points, of sharp, long bone and of elongated stone blades, we find the oldest European Palaeolithic '**parietal** art' by *H. sapiens* at Chauvet Cave in France. Jean Clottes argues that the term parietal art, or 'wall art',[1] is wrongly described as cave art because far more paintings and engravings were almost certainly created in shelters above ground than in underground caves. Regardless, Palaeolithic peoples did crawl deep into large caves and leave representations on the walls and floors. Here, we encounter the oldest-known stone and ivory figurines, such as the anthropomorphic lion figure found in the Hohlenstein-Stadel Cave in Germany (right).

GRAVETTIAN ▶

c. 30,000–22,000 years ago

This period evidences a proliferation of stone burins – small, chisel-like engraving tools (below) – struck to create a narrow ridge at the tip. The Gravettian saw the creation of the now famous anthropomorphic figurines made from ivory, bone or smooth stone, which show evidence of a wide range of body shapes. These figurines have stimulated endless diverse interpretations as being 'mother goddesses', fertility symbols and 'Venus' figurines.

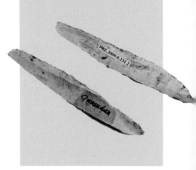

SOLUTREAN ▶

c. 22,000–17,000 years ago

The Solutrean period is considered by many specialists to be the pinnacle of artistic accomplishment in the Upper Palaeolithic Revolution. The Solutrean epoch saw the production of finely carved and fragile 'laurel leaf' or 'teardrop'-shaped points (below) that signal something more than functional tools or weapons. Bifacially flaked, they are likely to shatter on impact, suggesting that these intimate objects were for show and had some form of social value. The period likewise saw an explosion of raw materials and new technological approaches regarding the manufacture of carved and perforated antler batons, beads and bone pins, as well as countless different sorts of intricate arrowheads and throwing spears.

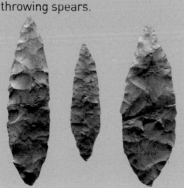

MAGDALENIAN ▶

c. 17,000–12,000 years ago

The Magdalenian period resumed the tendency of creating superb objects out of animal bone, ivory and antler. Intricate weapon heads and carved spear throwers – *bâtons de commandment* as French archaeologists call them – as well as sophisticated sculptures of bison modelled in clay (at Tuc d'Audoubert, France, below) or animals whittled from reindeer antlers and mammoth tusks are typical of the period. It coincided with the height of the Ice Age, a time when hunting reindeer became ever more important to Palaeolithic hunters. As global temperatures increased, glaciers thawed and sea levels climbed, and Western Europe's Ice Age and its art drew to a close.

PALAEOLITHIC PARIETAL ART: PROBLEMS OF INTERPRETATION

As the Interglacial period began to bite around 40,000 years ago, we begin to see the first signs of Palaeolithic parietal art in Western Europe. Ice Age people penetrated deep into caves to enact mystifying rituals, leaving behind images on the rocks, walls and floors. They also covered selected shelters with representations – engravings, paintings and sculpture – mostly of wild beasts. Sometimes this was done on individual rocks in the open air, or near riverbanks. What thought processes drove the conception and production of this imagery? This question raises all kinds of problems because the 'why' at first appears to be unanswerable. How can we get near to peoples so far back in time and seemingly so alien to us? We can, as Jean Clottes suggests, start with the idea that 'all art is a message'. Art can address the wider community or individual concerns consistent with membership: 'Age, sex, degree of initiation, social status, and many other individual factors may also play a part.' Art can be used for the following:

- To ward off people, whether friends or foe.
- To tell stories that are 'profane or sacred, or externalize real or mythical facts'.
- To assert individual or collective presences – art as a kind of Palaeolithic

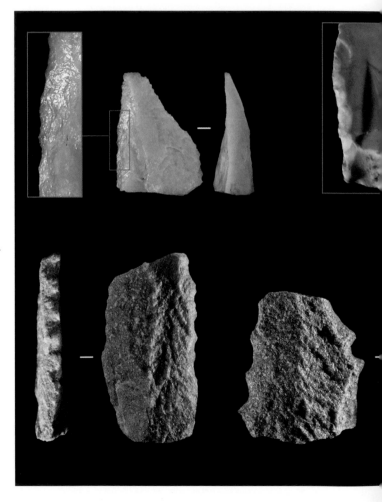

A series of stone points, from Blombos Cave, South Africa. Made from slicrete, quartzite and quartz, they are of differing shapes and sizes that clearly indicate that they were intended for a variety of uses, including engraving. The quantity and diversity found seems to indicate that Blombos was used as a centre for the making of tools of this kind.

graffiti that indicates 'I/we are here'.
- To be directed towards otherworldly beings (spirits and gods) believed to 'inhabit the rock or in the mysterious world beyond the permeable boundary that the rock wall forms between the universe of the living and that of fearsome supernatural powers'.[2]

The study of prehistoric art ultimately boils down to one very important factor in archaeological studies: the hunt for meaning. It is under this premise that we shall consider the question of why Palaeolithic art happened.

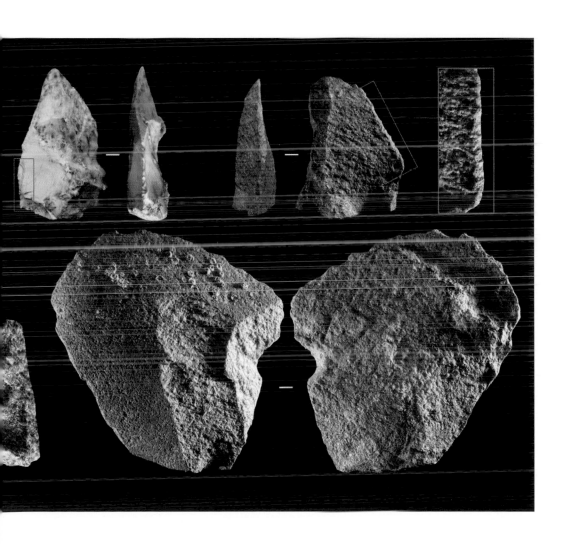

Around half a million years ago, a Homo erectus, *an ancestor to modern humans (*Homo sapiens*) scratched a motif into this shell. The design is complex and suggests a deliberate design and a person with an aesthetic sense: clay shells, stones and beads found with similar motifs are among the first recognized pieces of jewellery. Whether the lines are for decoration only or whether the shell had a separate function is unknown, but they could point to value or ownership.*

THE BEGINNINGS OF ART: THE HUMAN STORY

Roughly 50,000 years ago, something magical transpired in the brains of our ancient ancestors. Bipedalism, a large brain and the ability to fashion sophisticated tools appear to be key markers of humanity. Mastery of fire by *Homo erectus* may similarly have played a crucial part in human development and sociability. In *Homo sapiens*, fortuitous genetic mutation in the brain of our ancestors allowed them to think, communicate and share information in far more clever, subtle and sophisticated ways.[3] Archaeologists have provided material evidence that *Homo erectus/ Homo heidelbergenis* and Neanderthal species made efficient tools, and that ancient *H. sapiens* gathered up untreated 'curios'. As Bruno David has pointed out, 'most researchers think that there is older art out there waiting to be found or dated, and certainly artworks were being made long before the earliest examples we know about, as shown by the 100,000-year-old Blombos Cave paint-making toolkits that testify to a much more ancient ability to make

paintings.'[4] For example, archaeologists have pointed to an engraved shell from Trinil on the island of Java, Indonesia, made 500,000 years ago. The surface has zigzagging markings that show clear evidence of high-quality manual dexterity and a facility to engineer detailed linear, geometric and entoptic patterns. This shell is thought to be the creation of another early human species. So it is difficult to say who should be deemed the first artists, because it's neither Neanderthals nor us, but Java Man, better known as *Homo erectus*, who etched the design. As Robin Dunbar remarks, 'Perhaps we might be better advised to see the history of our species as one of increasing degrees of humanity which only finally came together as a unique suite a mere 50,000 years ago with the Upper Palaeolithic Revolution'.[5]

Across the globe in Africa, Europe and the Near East, modern humans during the Stone Age began to create objects and representations that explored the order and patterns of their

world. In sum, they were creating 'art'. They deliberately decorated themselves and painted and carved representations of their immediate environment. This is when art properly originates. The oldest European cave art in Asturias and El Castillo in Cantabria, northwestern Spain, show Upper Palaeolithic paintings, hand stencils and engravings that are probably between 40,800 and a minimum of 22,000 years old. In northern Spain, at the cave of Morin, the deposits of biological modern humans have been carbon-dated to 41,000 years ago. However, Neanderthals also inhabited this area, leading specialists to ponder whether the earliest art at El Castillo was created by modern *H. sapiens* or by our Neanderthal counterparts. The latter is highly likely since we now have scientific evidence of Neanderthal cave painting at sites in La Pasiega

(Cantabria), Maltravieso (Extremadura) and Ardales (Andalucía) in Spain.[6] We have evidence, too, that the art of the Chauvet cave in south central France was not, as originally thought, Magdalenian or Solutrean, but from the much older Aurignacian period, 'dating back to between 37,000 and 35,500 years ago'.[7]

THE CONNECTIONS BETWEEN PORTABLE AND PARIETAL ART MAKING

It is during the Aurignacian that we come across finely carved '*art mobilier*' – portable art, as it has come to be known For example, at Vogelherd and Hohlenstein-Stadel Cave in southern Germany we find carvings of horses, mammoths, felines and the remarkable therianthropic figure with a human body and a feline head (*see* page 26). The fact that it was found far inside the rock shelter intimates that this sort of object was not involved in day-to-day, routine events. Subsequently, 'The Aurignacian sites, or areas within them, may also have been special places, entrances to the spiritual realm.'[8] Moreover, the creators of such objects aimed at a restricted bestiary. Reasons other than diet seem to be behind the choice of animal species in portable statuettes. The selection is much like that found in Upper Palaeolithic wall art, but with Aurignacian carvings placing a statistical prominence on big cats. This is fascinating given the fairly large

The main cave at El Castillo showing examples of hand stencils in red ochre – thought now to have been made by women – as well as a clear drawing of a bison.

numbers of wall art paintings of felines in the Chauvet Cave, 'an Aurignacian site that was more or less contemporary with the southern German Statuettes'.[9] Was there a shamanistic function associated with carved felines and other dangerous wild animals?

It appears that certain species of animals held special significance and properties for Palaeolithic peoples, their shamans harnessing the powers and essences of portable animal statuettes. So when entering the spirit realm of the cave, the shaman took on a persona much like the Hohlenstein-Stadel therianthrope. In 'hunting magic', the power of the subterranean world likewise existed in animals made from ivory, teeth and antlers in pendants and throwing-spears. Portable art was not simply decoration, but embodied the spirits of animals with all their attendant powers of protection. Portable art must have had a more public meaning in early shamanistic societies. As Lewis-Williams posits, three-dimensional statuettes were not manifestly different from two-dimensional parietal art, the same philosophies relevant to both, with Palaeolithic art having equivalent aesthetic underpinnings.[10]

FEMALE FIGURINES: THE PROBLEM OF INTERPRETATION

The later Gravettian era saw the fabrication of supposed 'Venus' figurines, anthropomorphic carvings formed from soft limestone, bone or ivory. These portable objects are found far and wide, from the Pyrenees in Western Europe to Siberia in Russia. Female carvings have been given the popular but misleading title of 'Venus figurines'. The most famous example is the Venus of Willendorf, named after the site where the oolitic limestone was excavated in a river terrace by the Danube near Willendorf, Austria, in 1908. Conventionally, the popular term 'Venus figurine' is given to female statuettes with shapely 'attributes' – frequently the breasts, stomach or buttocks – as well as a small head and tapering arms, but no feet or hands. In actuality, Upper Palaeolithic figurines have a variety of body shapes. Interpretations of these small objects (the Willendorf sculpture is just 11 cm/4.4 inches high) have generated countless readings – they are children's toys, ritual objects, fertility symbols, magical charms, images of women's bodies by and for male appreciation, or female deities or 'mother goddesses'. In reality, we know very little of what these figurines meant to their Upper Palaeolithic makers. Today, such interpretations, traditionally the territory of art historical study, are more likely to be the subject of interdisciplinary research and scientific study.

Lynn Meskell argues that the dominance of female figurines in our writing about prehistoric art and society is something of a misnomer and invariably our own fiction. As she contends, 'figural research need not be trapped in the discourse of religion and ritual, nor should discussions of gender be linked to fertility and divinity.'[11] In the past, archaeologists have offered a wide range of other uses or rationales for figurine making, drawing distinctions between their function and meaning. Outdated approaches have tended to filter out specific figurines from an entire corpus and context, designating them as female and excluding all other bodily forms. In fact, genderless bodies, male figurines and phallocentric imagery are more often the norm. As Ian Hodder observed

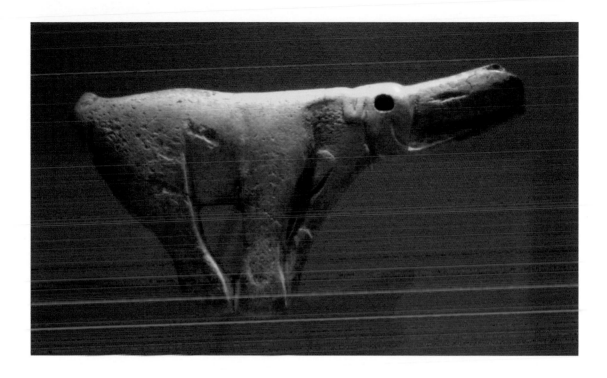

of the 11,000-year-old Ain Sakhri Lovers Figurine (British Museum, London):

> *At one time it would probably have been thought that these notions of sexual coupling, and sexuality itself, were linked to ideas of mother goddesses [but] the evidence doesn't really support this idea very early on, because there are now exciting new discoveries that really have no representations of women at all – most of the symbolism is phallocentric – so my view at the moment is that sexuality is important ... but not in terms of reproduction/fertility, children and mothering and nurturing. It's really more clearly about the sex act.*[12]

Carved from a reindeer antler, this spear thrower is in the form of a mammoth and was made c.12,500 years ago at Montastruc in the French Pyrenees.

Given the ubiquity of figurines and evidence of their 'processing' at various production sites, Meskell posits that figurine making was typically a public, possibly even a communal affair. It is likely that figurines were sported about the body as pendants, or carried in pouches or by hand. Meskell observes that many prehistoric figurines have no feet, cannot properly stand, are not shown seated and have flat backs, suggesting that the figures were intentionally meant to recline and must have been circulated and handled repeatedly. As Meskell

further observes: 'areas such as the stomach and buttocks were often clearly delineated and emphasized, whereas demarcation of primary sexual characteristics was typically downplayed.'[13] So these body types might mediate other social concerns relating to flesh, sustenance, survival, maturity and the ageing body.

Perhaps more important than any individual interpretation has been the power of the so-called Venuses to draw out and reflect Western prejudices and preconceptions regarding Palaeolithic art over the last 150 years. From the 'gaze' within a male-oriented and phallocentric order in the first half of the twentieth century, to more subtle, psychoanalytic, self-reflective/determining feminist viewpoints, the fictitious Venuses have become a means to critique our modern-day cultures.

'THE MIND IN THE CAVE': FIXING SHADOWS ON THE WALLS

Apart from Antarctica, Palaeolithic parietal art exists on every continent. In northern Australia, the United States, India and South Africa, for example, there are hundreds, if not thousands, of sites, and there are certainly many more discoveries out there waiting to be found. There are numerous Palaeolithic sites around Europe, with an important handful concentrated in the 'Franco-Cantabrian triangle' that stretches from the north of Spain to southwestern France. That Western Europe continues to be a magnet for the study of Palaeolithic art probably reflects its longer research tradition and the subsequent greater depth of available material. One of these is the cave at Altamira in Spain, first discovered

The Venus of Willendorf is thought to date from more than 30,000 years ago and is carved of oolitic limestone. There are various theories as to her purpose and form, though she is often thought to be a fertility fetish. Others have argued that such figures may be self-portraits of the women who made them.

The Ain Sakhri Lovers was carved from a single calcite 'pebble'. It was made by a member of the Natufian people, a farming culture whose stability may have given them the time and wherewithal to create art.

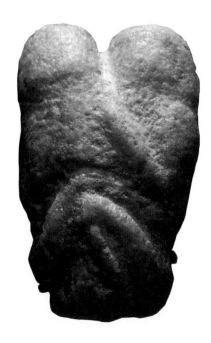

in 1879 by the amateur archaeologist Don Marcelino Sanz de Sautuola (1831–88) and his young daughter Maria (1871–1946). At the time, few could comprehend that prehistoric peoples were able to create such rich depictions of bison, deer and horses, and the works were subsequently dismissed as a hoax by distinguished antiquarians of the day. It was not until 1902 that the paintings were largely accepted as being of true Palaeolithic origin. Eventually, more widespread investigations revealed area after area of wall paintings, sketches and

drawings extending more than 200 m (656 ft) into the limestone hillside of Santillana de Mar. Subsequent discoveries at Lascaux, Niaux, El Castillo, Chauvet and Cussac cave in Dordogne, and other sites across Spain and France, display similar elaborate bestiaries adorning the walls, and painted many millennia ago.

A painting of a large group of cave lions from the Chauvet Cave in southwestern France with superb detail and a sense of three dimensions in some of the heads.

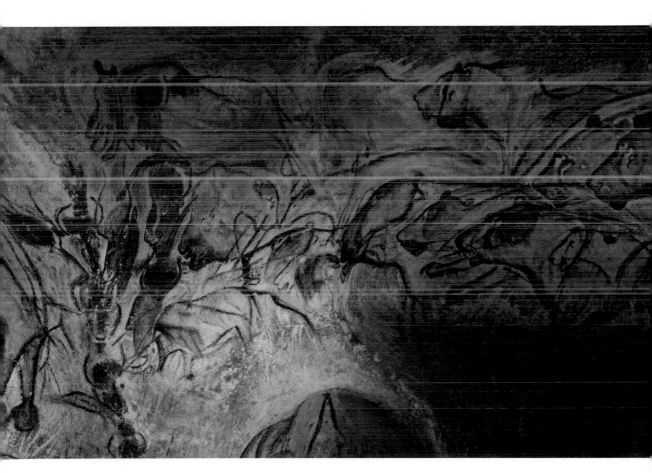

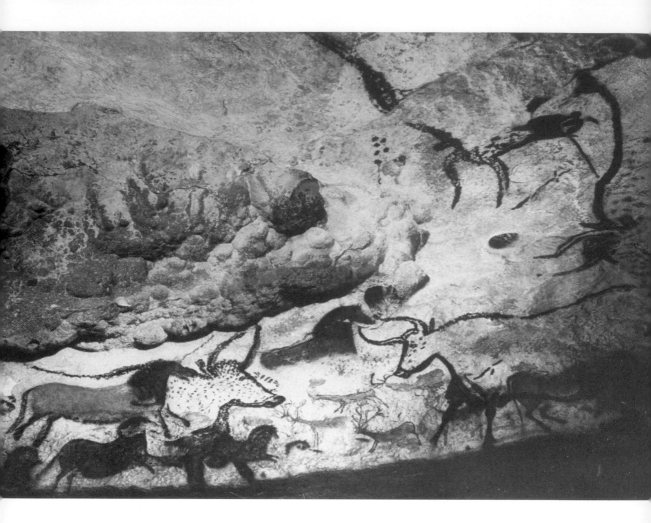

Chauvet Cave was decorated with magnificent paintings, revealing a total familiarity with the 200 or more wild animals that are represented. Some are engraved, but most are painted across walls, ceilings and chambers, running roughly 500 m (1,640 ft) underground. The styles and techniques exhibit a mastery of abstract and naturalistic representation. It is testimony to their great skill that the Chauvet artists manufactured sophisticated compositions using delineation, movement, curvature and perspective. Rare for Upper Palaeolithic parietal art is the employment of shading to enhance form, especially on the heads of the lions and horses, or to create the texture of fur and mane with **chiaroscuro** effects. Fauna in the background enhance depth, whereas the overlapping heads of horses, lions and concertinaed rhino horns indicate large herds or packs moving in unison.

At Lascaux Cave – which Abbé Henri Breuil (1877–1961) dubbed 'The Sistine Chapel of Prehistory' – we find a zoological garden of painted bulls, horses and countless other creatures. The wall paintings are decorated in comprehensive colours sourced from natural minerals: ochre and haematite create reds, yellows and brown; black, violet and dark brown are obtained from manganese. From this we can conclude that raw colours were ground to a powder and applied directly to wet walls. Outlines were first etched with charcoal or painted using wads of fur or moss. Makeshift brushes were probably fashioned from bird feathers, masticated sticks or just a hand or a finger. Powders were sprayed through bone tubes to fill in the outlines. (Tubes with paint residues have been found in a number of caves, and thick red paint has been discovered in abalone shells at the Blombos Cave in South Africa.)

The natural configurations of the cave were also manipulated by Ice Age artists, including the paw of a bear portrayed in relief by painting directly over a protrusion in the wall. This is a technique used elsewhere in many other European caves, where human and animal forms are defined by the natural concretions of the chamber surface. Whether parietal art started out this way by simply observing configurations in rock surfaces and walls can never be known.

With relative ease, however, the cave painters at Chauvet seemed to capture the fundamental nature and animalism of their world. So it is enticing to surmise that Palaeolithic cave art began when hunters or shaman identified the shape of a known creature hiding mysteriously like shadows on the wall and then marked it out for others to see.

So what do we know, or think we know, about parietal Palaeolithic art? There is, of course, far more to cave paintings than just pictures on a wall. Many of these images were created due to the collective power of the subterranean world upon Ice Age artists. These accumulative effects included shamanistic visions, hallucinations or altered states of the mind. Strange sounds also echoed from the passages and chambers, while flickering lamps produced shadows and the interplay between light and dark, all of which combined to create multi-sensory experiences within the cave. As David Lewis-Williams has shown, 'If we see the caves as entities, as natural phenomena taken over by people, and try to place then in a social context … we can begin to sense something of the role that they must have played in Upper Palaeolithic communities.'[14]

In 1947, LIFE magazine photographer Ralph Morse was the first professional to record the cave artwork at Lascaux. His images show the caves in their most pristine form before human incursion had caused any damage.

THE ITALIAN RENAISSANCE: ART IN TUSCANY, 1260–1490

What is the Renaissance? – Italy in the Middle Ages – Making Art: Early Workshop Practices – Making and Meaning: Christian Worship and its Imagery in Early Renaissance Italy

– Feature: The Florentine Church of Orsanmichele – Whose Renaissance is it Anyway? Women Artists and Subjects

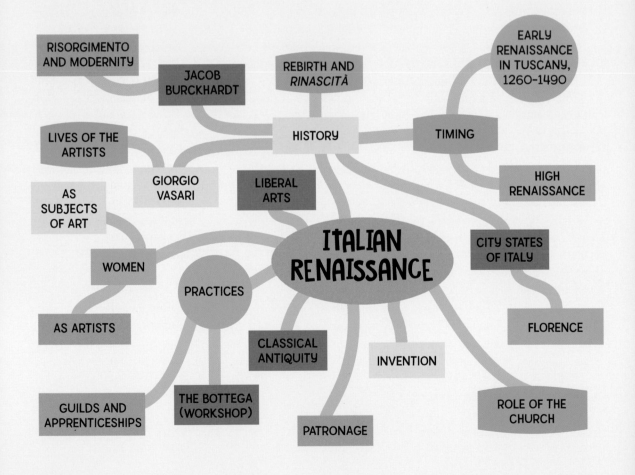

RISORGIMENTO AND MODERNITY

JACOB BURCKHARDT

REBIRTH AND *RINASCITÀ*

EARLY RENAISSANCE IN TUSCANY, 1260–1490

LIVES OF THE ARTISTS

HISTORY

TIMING

AS SUBJECTS OF ART

GIORGIO VASARI

LIBERAL ARTS

HIGH RENAISSANCE

WOMEN

ITALIAN RENAISSANCE

CITY STATES OF ITALY

PRACTICES

AS ARTISTS

FLORENCE

CLASSICAL ANTIQUITY

INVENTION

GUILDS AND APPRENTICESHIPS

THE BOTTEGA (WORKSHOP)

PATRONAGE

ROLE OF THE CHURCH

WHAT IS THE RENAISSANCE?

The Italian Renaissance is a key subject in art historical studies. No student can study it without understanding the discipline of art history in general. This is because, at its root, the Italian word *rinascità* (translated as 'rebirth') is traditionally associated with the concept of an inexact but resplendent new beginning in Western art and culture. For historians, the concept is often set in opposition to the correspondingly nebulous idea of the Dark Ages. The term was first employed and identified by Jules Michelet (1798–1874) for his sixteenth-century French history, the multi-volume *Histoire de France* (*History of France*, 1855), where he explained that *La Renaissance* is 'the discovery of the world and the discovery of man. The sixteenth century … went from Columbus to Copernicus, from Copernicus to Galileo, from the discovery of the earth to that of the heavens. Man refound himself.'

The term was later appropriated as an Italian fifteenth-century phenomenon by the Swiss historian Jacob Burckhardt (1887–97), who used it in his seminal text *Civilization of the Renaissance in Italy* (1860). In a letter defining its methodology, Burckhardt was totally unambiguous regarding its intention: 'The Renaissance was to have been portrayed in so far as she was mother and the source of modern man.'

How we understand the era is intricately bound up with these attempts to classify what we now call the Renaissance. For historians, the term is, on the whole, positive. 'The Renaissance marks the rise of the individual, the awakening of a desire for beauty, a triumphal procession of joyful life, the intellectual conquest of physical realities, a renewal of the pagan pursuit of happiness, a dawning of consciousness of the relationship of the individual to the natural world around him.'[1] If we append the notion of looking back to classical antiquity, and the use of perspective to add depth to artworks, we perhaps identify what most of us think of as the hallmarks of the Renaissance – namely the intellectual and artistic triumph over the physical world.

ITALY IN THE MIDDLE AGES

The term *Risorgimento*, 'to rise up again', implies that Italy had an earlier life as an individual country, akin to the Italy we understand today. As one writer has characterized it, however, 'Italy was nothing more than a sentiment … the reality was not unity but a mass of divided cities, lordships and towns, dominated by particularistic sentiments and local interests.'[2] Diversity was therefore ubiquitous, stretching to dialects, legal codes, calendars, weights and measurements, different coinage, social customs and so on. Geographically, the Italian peninsula was not totally isolated or fragmented, but allowed for free travel and trade across boundaries.

Subsequently, few historians today would accept Burckhardt's notion, which links Italian art and culture to a burgeoning modernity, to nation-formation and to the ascendancy of 'Renaissance Man … the first-born among the sons of modern Europe'[3] – at least, not without a few misgivings. Burckhardt's methodology has nonetheless proved hard to extricate from ideas concerning heroic individualism and triumphant progression in Italian art,

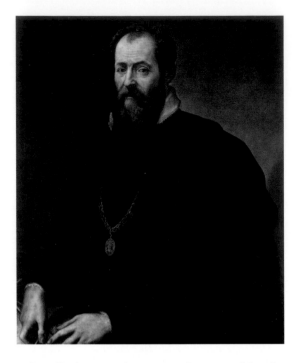

primarily because it was vastly swayed by the writings of fifteenth- and sixteenth-century artists and critics, particularly Giorgio Vasari (1511–74). His biography, *Le Vite de' più eccellenti Pittori, Scultori, e Architetti* (better known as *The Lives of the Artists*, 1550–68) has proved critical in the development of the history of art (*see* Chapter 4). The upshot is now a Renaissance survey that typically begins with the revival of classical motifs in Pisan and Sienese sculpture (Nicola Pisano, 1258–84, and his son Giovanni, 1265–1319, in particular) and the paintings by the Florentine masters Cimabue and Giotto di Bondone (1301–37), or the Lorenzetti brothers (active in Siena 1319–48). Traditionally, the survey goes on to chart the accomplishments of fifteenth-century painters, sculptors and

architects such as Filippo Brunelleschi (1337–1446), Masaccio (born Tommaso di Ser Giovanni di Simone, 1401–28) and Donato de Niccolò di Betto Bardi (better known as Donatello, 1386–1446), before climaxing with the heroic achievements of Leonardo da Vinci (1452–1519), Michelangelo Buonarroti (1475–1564) and Raphael Sanzio (1483–1520).

This alluring – and in no way entirely erroneous – linear narrative is highly problematic, however. Evelyn Welch forcefully argues that looking at art in Italy in terms of a visual progression and style, or focusing on the development of perspective and the adoption of classical motifs has advantages but also severe drawbacks for the art historian. Take her analysis of two paintings from the early–mid-fifteenth century: Masaccio's **fresco** of *The Holy Trinity* (*c.* 1427) and Giovanni di Paolo's *Birth of John the Baptist* (*c.* 1453). With help from his fellow Florentine architect Brunelleschi, Masaccio developed mathematical principles to infer a convincing three-dimensional space for his work. Following Sienese traditions, however, di Paolo employs no rules of mathematical perspective, but rather inverts them in order to overthrow logical notions of space. (Note how cleverly the lines of the bed and footboard point us directly to the Baptist's head and halo.) As Welch further asserts, di

Paolo's style 'is not defined by ignorance, it was formed as a deliberate contrast to the work produced in the rival town of Florence. In these terms, linear perspective was an important part of Italy's visual culture, but not invariably the most dominant.'[4]

With its emphasis on the restoration of classical antiquity and the imitation of nature, Vasari's approach in the *Lives* is habitually detrimental to art that does not reflect Renaissance concepts of stylistic progression and continuity. It also routinely overstresses the distinction between the Middle Age Gothic style and the Renaissance. Traditionally, art historians insist upon a strict date of *c*. 1420 for the beginning of the Renaissance. However, Vasari himself dated the illustrious *rinascità* in Italian art from the late thirteenth century, and directly associated it with the Florentine artists Cimabue and Giotto. Vasari used the word 'rebirth' to assert his belief of continuity in terms of the evolution of art.

Vasari was not the first to recognize Giotto's part in the *rinascità* and his role in the major period of Italian art. Boccaccio (1313–75) and Lorenzo Ghiberti shared his assessment of the Florentine master. As Rolf Toman has explained, writing in his introduction to the art of the Renaissance: 'Both praised Giotto's fidelity to Nature, and in doing so, highlighted a formal characteristic of art in the late Duecento and early Trecento that was to be a prominent feature of fifteenth-century Renaissance art. The point is that one should talk of a series of renaissances rather than of the Renaissance.'[5] Even in contemporary accounts seeking to define the ages of Italian art, Giotto's work is hardly questioned. Subsequently, this chapter introduces

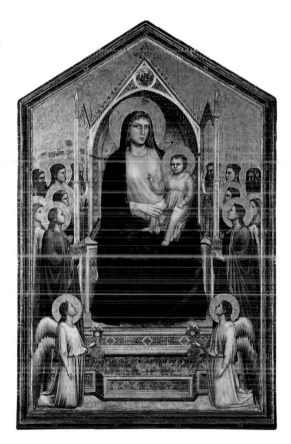

Ognissanti Madonna (c. 1310) by Giotto. The painting is one of Giotto's later works and shows a number of influences, including that of Byzantine art, along with the medieval hierarchy of scale.

students to a much earlier Renaissance in Italy, specifically the arts in Tuscany *circa* 1260–1490 – a time before the traditionally heroic or High Renaissance. It examines not only the religious, philosophical and literary contexts that inspired renewal in Italian art, but also the everyday activities of artists. Their skills and techniques, not to mention their contractual obligations in relation to important commissions, are key to helping us understand, interpret and give a small taste of one of the most magnificent eras in art.

Below: Birth of John the Baptist *(c. 1453) by Giovanni di Paolo. Working mainly in Siena, he was a painter and illustrator of manuscripts including Dante's* Paradiso. *The panel is one of four paintings and probably part of a predella, the lowest part of an altarpiece, made for the Augustinian church in Cortona, southern Tuscany.*

Opposite: The Holy Trinity *(c. 1427) by Masaccio. It is painted on the wall of the Dominican church of Santa Maria Novella in Florence.*

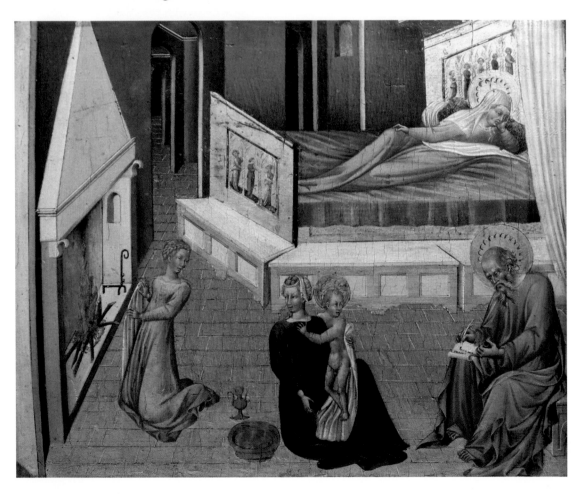

MAKING ART: EARLY WORKSHOP PRACTICES

Today, we tend to think of artists in garrets and intellectual outcasts working alone and struggling to create individual works of genius. In the Italian *bottega*, however, this was not the case. The bottega was the studio or workshop in which artists cooperated in the execution of commissions, and it relied heavily on the principle of apprenticeship. Members of the workshop included trainees, journeymen and assistants, and sometimes associate masters. The relationship between master and apprentice was regulated by the local trade group known as a **guild**, and both the master and apprentice, or the trainee's parents, entered into a contract relating to working conditions and obligations with respect to both parties. Trainees tended to start out more as servants, employed to carry out menial tasks such as cleaning the studio, and thus allowing more advanced trainees to concentrate on their art apprenticeships. Assistants were sometimes employed around the master's home, doing the shopping, cooking and cleaning, and only later beginning their training in the workshop.

As specified by the guild, apprenticeships could vary from town to town, but were usually around four years, and could be as few as two or as many as ten. We know very little about the training of artists, but we are in possession of Cennino d'Andrea Cennini's famous artistic discourse *Il Libro dell'Arte* (*The Craftsman's Handbook*), a major source of information concerning apprenticeships and working practices in fourteenth-century Italy. Cennini initially recommends adherence to drawing (one year), followed by grinding colours,

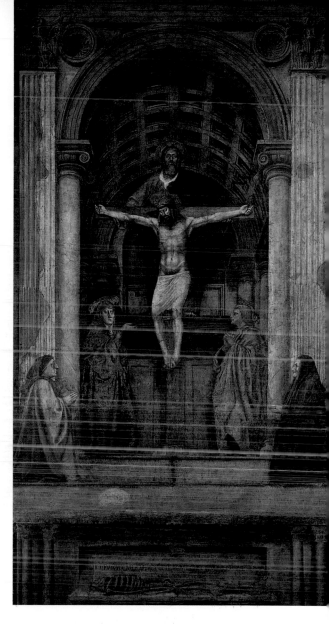

priming panels and the technique of gold and silver leaf (six years), urging that the apprentice keep 'drawing all the time, never leaving off either on holidays or workdays'. Only then can the apprentice begin to attempt **fresco, secco** and **tempera** painting (a further six years).

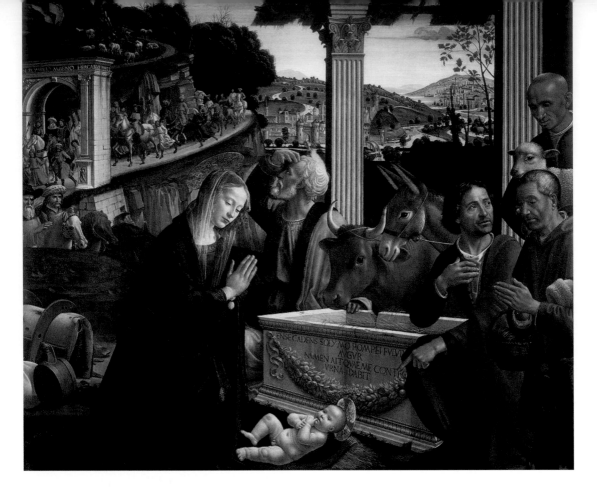

The Adoration of the Shepherds *(1485) by Domenico Ghirlandaio. This is the altarpiece of the Sassetti Chapel in Santa Trinità, Florence.*

He himself claims to have been 'trained in the profession for twelve years by my master, Agnolo di Gaddi of Florence', indicating a train of students 'christened under Giotto'. Cennini's timescales are probably greatly exaggerated, but his rhetoric as regards an extended period of apprenticeship goes a long way to interpreting many workshop practices and hierarchies in medieval Italy.

No images exist of the Italian painter's workshop during the period, but illustrations show that, for the medieval crafts at least, artisans' premises opened out onto the street – in order to facilitate sales and provide both good lighting conditions and suitable access for large altarpieces. The medieval workshop was highly functional, the master painter probably having a number of commissions in progress and at different phases of execution. Outside this environment, when working on a sizeable altarpiece or fresco cycle, a section of the church was portioned off to provide space for a temporary workshop. This part of the building was probably

fitted with straw mats laid on the floor to keep at bay dust and dirt, which could ruin any painting. On a day-to-day basis, apprentices and assistants carried out a multitude of repetitive and highly arduous tasks, including making glue, sizes, cements, brushes and varnishes, as well as boiling oil, crushing eggshells, grinding and mixing pigments, preparing surfaces of wood and cloth, and gilding.

So we have to imagine the expertise and skill – as well as ordinary, manual labour – required to manufacture anything from a small **triptych** to a large fresco cycle. Painting a whole church also involved the painstaking process of creating life-size drawings, which had to be transferred onto wet plaster (fresco) and painted quickly before the surface dried. The work was not only backbreaking but also at times extremely hazardous. Climbing and standing on rickety scaffolding made of narrow planks to access high walls and ceilings (probably under dim candlelight) must have occasionally proved fatal (This is not to mention the unseen effects of toxic paints; the colour white was made alchemically from lead.) Correspondingly, the sculptor's studio had its own hazards, involving volatile, hot and sometimes explosive furnaces and boiling molten metals. This reality is a world away from the artistic individualism of Burckhardt's concept of the ideal Renaissance Man.

In Italy, towards the late fifteenth century, there appears to be a change of emphasis in the training of painters, with contractual agreements specifying the teaching of subjects such as perspective, foreshortening and the study of the human anatomy. Largely, though, the path trod by artists in the Middle Ages followed a similar trajectory in the later Renaissance periods.

Renaissance art and culture involved a delicate balancing act between the continuity of previous artistic traditions and a desire to promote invention and rebirth using literary ideals and examples from classical antiquity.

MAKING AND MEANING: CHRISTIAN WORSHIP AND ITS IMAGERY IN EARLY RENAISSANCE ITALY

In fifteenth-century Italy, the laborious work of the Tuscan *artista* was not considered to be a part of the liberal arts (*artes liberales*), but rather an ordinary craft associated with the mechanical arts. The liberal arts were subjects taught in medieval universities. This involved the study of geometry, arithmetic, the theory of proportion in classical architecture, music, astronomy and the introductory subjects of logic, grammar and rhetoric (termed the *trivium*). Reliance on the *artes liberales* lent a greater nobility or dignity to the architect, but not to the painter or sculptor. Artists soon began to discover, however, that a more academic education would go some way towards promoting and liberating the artist and their productions. For example, the sculptor Lorenzo Ghiberti (1387–1455) was the first to advocate that Italian painters and sculptors should learn the *trivium* as well as philosophy, medicine, perspective and 'theoretical design'. Ghiberti was one of the first artists to argue for a high degree of autonomy over his designs, even acquiring certain rights contractually. But the status and social circumstances of artists occurred very gradually and only as a result of changes on the part of the patron and the functions required of art. From the start, the Church was always the principal client for art – a survey of Italian paintings between 1420 and

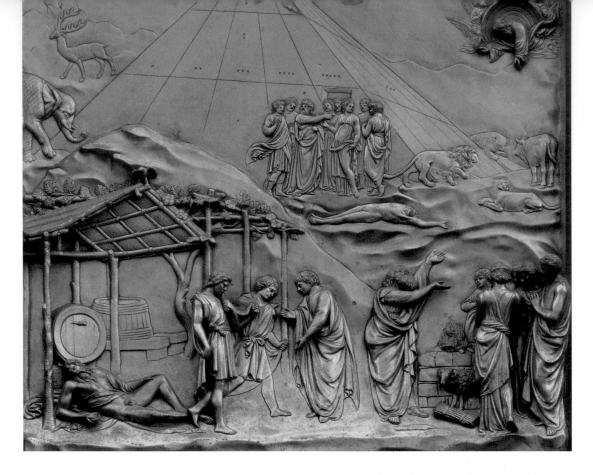

The Story of Noah *(1428) by Lorenzo Ghiberti. The*
third relief from a series of ten scenes from the Old
Testament, this is part of the Gates of Paradise of the
Baptistry of St John in Florence.

1539 evidencing that the lion's share of painting
dealt with religious subjects.

How, then, does an artwork happen to acquire a
distinct form within Italian society? This question
also pertains to Baxandall's highly influential
concept of the 'period eye' – the proximate
collective and visual background in which
paintings were both produced and experienced.[6]
We tend to think of the conventional Italian
patron as a duke, prince, merchant or, perhaps, an
educated member of a religious order: all able to
view paintings with an awareness of classical art
and the concept of mathematical perspective. As
Patricia Rubin observes, however, 'the reading of
pictorial style or social experience as envisioned
and viewed need not be restricted to the notional
Renaissance man of the picture-buying class.'
We should remember 'the eye of the beholder
also; the peasants and urban poor who were
also witnesses to public religious spectacles
and equally able to respond to sacred church
rituals and its imagery'.[7] In the earlier Trecento
period, the function of art involved a less certain
distinction between progressive Renaissance

ideas and those adopted by religious orthodoxy. As students of Renaissance art in Tuscany, we want to investigate both the conditions of production – i.e. the location, patronage, contracts, materials and workshop practices – and the contexts for a work's conception and the ways in which it met cultural, religious, social and political demands.

WHOSE RENAISSANCE IS IT ANYWAY? WOMEN ARTISTS AND SUBJECTS

One of the problems thrown up by Vasari, Michelet and Burckhardt's writings is that their delineation of the Renaissance acclaims the accomplishments of Italian society to the detriment of all others. Burckhardt insists that 'women stood on a footing of perfect equality with men ... [And] the education given to women in the upper classes was essentially the same.'⁰ But did women really have a Renaissance? And, if so, was it on an equal foundation? Leon Battista Alberti (1404–72) defined a woman's place in Italian Renaissance society in his treatise *Il libri della famiglia* (*On Family*, 1444):

> *The smaller household affairs, I leave to my wife's care ... it would hardly win us respect if our wife busied herself among men in the marketplace, out in the public eye. It also seems somewhat demeaning to me to remain shut up in the house among women when I have many things to do among men, fellow citizens, and worthy and distinguished foreigners.*

Alberti's new humanist ideas 'on family' pertain to men, not women. The Renaissance intellectual is most anxious about his wife getting her hands on his 'books and records' that, he claims, 'she could not read'. The architect and intellectual also chastises women 'who try to know too much about things outside the house' and about 'the concerns […] of men in general'.

In spite of talk about education, individualism and humanist principles, women had few intellectual, social or artistic opportunities

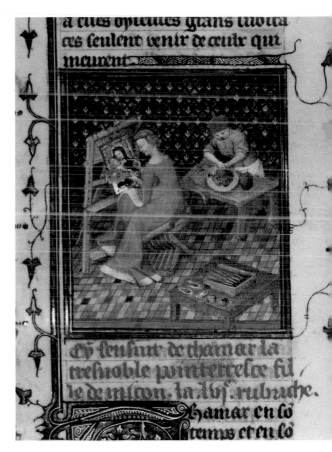

A miniature from Boccaccio's text, On Famous Women, *showing the woman painter Thamyris.*

Joseph and Potiphar's Wife (c. 1520) by Properzia de' Rossi. The artist was unusual in coming from a non-artistic background, although she did have training at the University of Bologna, and with master engraver Marc Antonio Raimondi. This panel was among a number of sculptures commissioned for the façade of San Petronio in Bologna.

during the period. As Kelly-Gadol identifies, women of the Renaissance had far fewer legal entitlements, scarcer economic control and virtually no, if any, political sway compared to their medieval counterparts. So the Renaissance was most definitely not an occasion of equality, revolution and boundless creative possibilities for women. When we ask the question, 'Did Women Have a Renaissance?' as Kelly-Gadol does, the reply is a categorical 'No'.[9]

If educational or artistic opportunities were made available to women, it was only to a tiny minority of privileged individuals. Humanist writings on the schooling of women promoted aristocratic learning so that they might attain the Christian paradigms of motherhood, modesty and compliance, while laying down appreciably diverse morals for men.

At an élite level, a small number of women patrons and artists were able to make their mark as professionals in European society. The French writer Christine de Pisan (c. 1365–c. 1431) in her Cité de Dames (1405) recalls a certain Anastaise, painter of miniatures in the borders of illuminated manuscripts for King Charles VI. Scholars are yet to identify this particular artist, but de Pisan claimed that no man could outshine her in this type of imagery.

Boccaccio's treatise *De Claris Mulieribus* (*On Famous Women*, 1355–59) also depicts an artist from antiquity, Thamyris, painting her likeness with a small mirror and dressed in the fifteenth-century attire of the kind Anastaise may have worn. While recognizing the achievements of ancient women artists, Boccaccio nonetheless observes that 'art is very much alien to the mind of women.'

As W. Chadwick notes, Vasari's *Lives* allows for the identification of the first women artists of the Renaissance period, but regardless 'draws its vision from … antique sources to medieval literature and contemporary treatises on female deportment.'[10] In his discussion of the sculptor Properzia de' Rossi (c. 1490–1530), Vasari tells us that the sculptor 'was not only excellent in household matters, but also very beautiful and played and sang better than any woman in her city'. He describes de' Rossi's *Joseph and Potiphar's Wife* (c. 1520) as having all the required feminine attributes: 'A lovely picture, sculptured with womanly grace and more than admirable.' Vasari identifies 13 women artists in Renaissance Italy, but surmises that artists such as Properzia de' Rossi risk overstepping the bounds of 'femininity' and giving the impression 'to wrest from us [men] the palm of supremacy.'[11]

Patricia Simons has likewise shown that Italian portraiture during the Quattrocento creates a paradigm of 'women in frames' – an 'object' in profile to be gazed upon by men. Here, women's femininity, wealth, lineage and dowries

St Francis of Paola Blessing the Son of Louisa of Savoy *(1590) by Lavinia Fontana. Fontana is considered the first professional female artist since she was paid for her work.*

are carefully catalogued in the form of jewels, brooches and emblems and crests embroidered on clothing. It's a 'stamp' of ownership, authority and family allegiance on the part of her husband's family.[12] The famous portrait by Domenico Ghirlandaio (1448–94) of *Giovanna Tornabuoni* (née Albizzi, 1488) literally inscribes her husband's ancestry all over Giovanna's dress – his initial L and the family crest, a triangular shape, emblazoned on her shoulder and stitched into the intricately woven fabric. Ghirlandaio's memorial portrait (Giovanna died in childbirth) was painted at a time when women were forbidden from showing themselves at windows, and repressive laws ironically prohibited such sumptuous and extravagant attire.

It was not until the sixteenth century that a select number of women began to use Renaissance ideals of decorum and goodness to their own advantage when pursing a professional career in art. Well-bred and well-educated women, many of whom were born into artist families and learned the skilled training that came with their background, included Sofonisba Anguissola (1532/5–1625). The daughter of Cremonese aristocrats, she was famous for her miniature portraits, which bought her acceptance socially, artistically and internationally. Despite only three years of private tuition, as opposed to the minimum four years of standard workshop practice, Anguissola was the first Italian woman artist to become renowned, her work influencing Lavinia Fontana (1552–1614), a more professionally trained and exceptionally gifted painter of portraits and large altarpieces for churches in Bologna, Rome and at the Escorial Palace in Spain. As painters, women became more numerous, usually undertaking portraiture and still life subjects, excluded as they were from studying the human body in life classes and at artistic academies. Anguissola and Fontana's decision to dedicate themselves to art appears to have set a precedent, their work influencing and encouraging a number of important Bologna-based artists in the late sixteenth and seventeenth centuries. As Geraldine A. Johnson has astutely pointed out, examining works of women and by women from the perspective of gender helps the art historian to reach a subtler estimation – of their art individually and of the artistic environment and society in which these works were created.[13] And in turn, this affords us new understandings and often obliges us to pose very different questions about the nature of the Renaissance.

Above: Self-portrait (1556) by Sofonisba Anguissola. She painted at least 12 self-portraits in an era when it was not usual for artists to paint portraits of themselves.

Opposite: Portrait of Giovanna Tornabuoni (1488) by Domenico Ghirlandaio. Giovanna, a Florentine noblewoman, died in childbirth and her husband commissioned the portrait two years after her death.

ARS VTINAM MORES
ANIMVMQVE EFFINGERE
PVLCHRIOR IN TER
RA NVLLA TABELLA FORET
MCCCCLXXXVIII

Chapter Four
THINKING THROUGH ART: WHY USE THEORY IN ART HISTORY?

Theory, Methodology and Interpretation in the Visual Arts – The Real and the Ideal in Art – Art as Instruction: Alberti, Vasari, Bellori, Winckelmann and Reynolds

PLATO'S *REPUBLIC*

METHODOLOGY

ADDING BEAUTY

REAL AND IDEAL

INTERPRETATION

ALBERTI

REPRESENTATION

KAUFFMANN

BELLORI

THEORY

HISTORIES OF ART

WINCKELMANN

THE ACADEMY

THE SUBLIME

ART AS INSTRUCTION

REYNOLDS

VASARI

NATURE

IMITATION AND INVENTION

THEORY, METHODOLOGY AND INTERPRETATION IN THE VISUAL ARTS

Theory and methodology are at the heart of art historical study and debate. The two approaches are frequently cited in the same breath, but there are distinct differences. While theory helps us formulate a plan of attack regarding a specific area of study, methodology is the manner in which we try to solve those questions. In the previous chapters, I followed a clear set of procedures and theoretical practices to make my arguments. So using theory requires the student to gather all their research material into an additionally

TERMS TO KNOW:

Methodology – n. the branch of logic dealing with a particular project, discipline etc.

Theory – n. a supposition explaining something, especially a speculative idea of something; mere hypothesis; speculation; abstract knowledge; an exposition of the general principles of science etc.; a body of theorems illustrating a particular subject.

Concise English Dictionary, *Dorling Kindersley Ltd*, *London, 1998*

Venus de' Medici *(1st century BCE). This Hellenistic marble sculpture of the goddess of beauty is most likely a copy of a statue that would have been originally cast in bronze.*

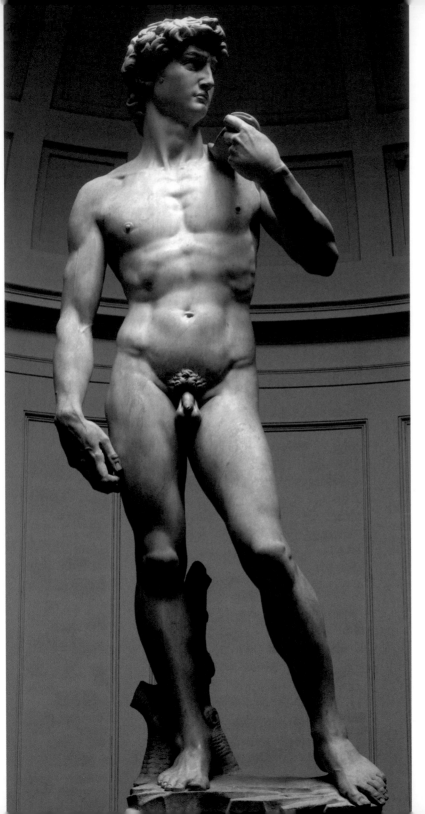

David (1501–04) by
Michelangelo. The 5-m
(17-ft) marble statue of
the Biblical hero came to
epitomize the strength of
Florence as an independent
city-state.

centred investigation, covering a specific set of enquiries. As opposed to simply asking, 'What is a Palaeolithic wall painting of running bulls trying to communicate?' we might ask, 'What does a piece of Palaeolithic parietal wall art tell us about the early society in which it was created?' Essentially, we need to do more than pursue the formal characteristics of the painting, for that would be connoisseurship, but rather we need a more considered analysis involving the context for the work(s) produced – i.e. its social, religious or cultural concerns. Now we have moved from a more general type of questioning regarding the depiction of an artwork to something far more critical. Working in a theoretical way will help the art historian become attuned to the idea that art history is a precise theoretical discipline – one of elucidation as opposed to being merely connoisseurship. So how do we use theory in art history?

Listed in the panel on the previous page is the dictionary definition of a theory, the term associated with the attempts by scientific researchers to support their hypotheses. Scientific researchers might use trials or laboratory procedures to identify certain cures and causes, or to arrive at a specific answer or 'truth', and to a certain degree there is a natural point of conclusion to the process. Theory in art history functions differently, but it is nonetheless akin to experimental science. Namely, it helps us to ask the correct questions and to put the most accurate framework around our object of study. It expresses a whole host of ideas to do with art, culture and human experience, so there is no single scientific objective. In art history, ideas are constantly laid open to revision and

so lead to further hypothesis, analysis and investigation. Given that art historians try to interpret art objects and cultural practices, there is no single or specific 'truth' to be had in the discipline of art history. As one writer has suggested, art history 'is not narrow or limited: it is about expansion, production, creativity, and difference, and fundamentally linked to [the] logic of multiplicities.'[1]

A solid theoretical method will therefore support, frame and make our enquiries far more cogent. Art historians do this by reading broadly on topics that are not directly related to art history. For instance, this chapter includes the subjects of ancient Greek political philosophy, academic treatises on painting, and the sculpture of classical antiquity. In doing so, it complements Chapters 1 and 7, but is intended as an overview of the theory of art in the Renaissance period. More broadly, it expands on methodologies and theories central to European art in later centuries. It will focus on two sets of texts: one from ancient Greece (Plato's *Republic*) and one from the Quattrocento (Leon Battista Alberti's *On Painting*); and four from the sixteenth to the eighteenth centuries: Giovanni Pietro Bellori's *The Lives of the Modern Painters, Sculptors, and Architects* (1672), Giorgio Vasari's *Lives of the Most Excellent Painters, Sculptors, and Architects* (1550), Johann Winckelmann's *Reflections on the Imitation of Greek Works of Art in Painting* (1775) and Joshua Reynolds's *Discourses on Art* (1769–70).

THE REAL AND THE IDEAL IN ART

Although Plato sought banishment for the arts from his ideal state over 2,500 years ago, his ideas have nonetheless continued to haunt modern

art history. Plato – and the ancient Greeks, by and large – had a very different view of art. It was certainly not viewed with impartiality or considered as mere visual pleasure. Rather, it was felt to have great power over the soul, representing unruly and threatening forces that 'seemed to [Plato] so great that he thought it could by itself destroy the very foundations of his [ideal] city.'[2] Plato was inevitably obliged to ostracize art from his ideal Republic, 'because it seems to corrode the minds of the audience'. From a modern perspective this is perplexing, but understanding what it meant for Plato, who saw Greek society as under art's incantation, is fundamental to the dilemma regarding modern art historical study.[3]

In this context, Plato developed his concept of *ideas* or *forms* as universal constructs, different from the objects that might correspond to them:

All visible representations
are flawed simulacra of much higher invisible ideas.

For this reason, visual imagery
is merely a copy of a copy. It is *mimesis*, an 'appearance' of the form.
So the more derivative that visual art is, the more misleading and
dangerous its imitations.

Thus, forms made by artists,
such as 'couches and tables', are alternatively described as
'imitations'. So while the manufacturer makes a couch and the painter
copies his/her couch – it is 'god' who is 'the true maker of the
truly true couch'.

In representation there is no veracity – the craftsman, painter, sculptor and poet are all at 'removes from the [philosopher] king and the truth'.[4] As such, art can radically undermine any authoritative, political or religious power. In a manner of speaking, art history has developed along these lines and is caught between the opposing poles of signification and representation.

Leon Battista Alberti was the definition of a Renaissance man, known as an architect, artist, author, poet, priest, linguist, philosopher and cryptographer who made notable contributions in all of these fields.

ART AS INSTRUCTION: ALBERTI, VASARI, BELLORI, WINCKELMANN AND REYNOLDS

Plato's ideas made permissible the prospect that artists might instinctively look outside the mimetic arts – his theory of forms having an enduring hold over subsequent artistic discussion. The statues and carvings from the ancient world that lauded a physical and moral perfection, copied throughout the Roman Empire and rediscovered during the Renaissance, greatly influenced later European artistic practice and theory. Treatises and histories by Leon Battista Alberti, Giorgio Vasari and those used for instruction in academies in later centuries by Giovanni Pietro Bellori (1613–93), Johann Joachim Winckelmann (1717–68), Sir Joshua Reynolds (1732–92) et al. took direct inspiration from the ideas of Plato, Aristotle and other Greek and Roman writers. Theorists of art were particularly interested in adapting ancient ideas of idealized beauty, especially Platonic concepts regarding the original forms of men and women – who, it was argued, should be depicted not as they are but as Nature envisioned them to be.

The Beginnings of Artistic Theory: Alberti's *De Pictura*

Alberti laid the rudiments of Renaissance art theory in his treatise *De Pictura* (*On Painting*) in 1435, squaring the Christianized Stoic viewpoint of art in his own age with the reverence for beauty and order found in ancient antiquity. The aim of painting, he outlined, is to represent 'things that are visible', but artists should also idealize or 'add beauty' to their

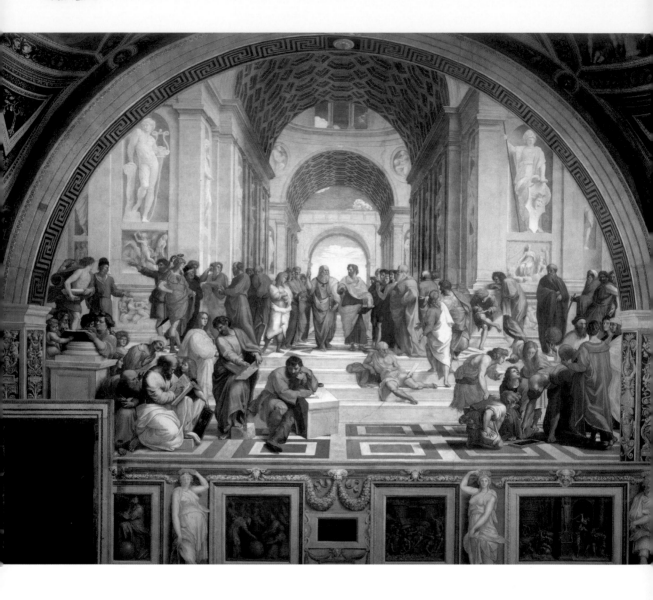

paintings by 'taking from all beautiful bodies each praiseworthy part'. Alberti references the tale of 'Zeuxis [who] far excelled all others in painting the female body.'[5] Here, Alberti is referencing the painter's famous use of five models for a representation of Helen of Troy.

The School of Athens (1509–11) by Raphael. The fresco is one of a number commissioned to decorate the Stanza di Raffaello, in the Apostolic Palace of the Vatican.

Book I of Alberti's *De Pictura* (the first treatise on painting)

- Seeks to classify mathematically the laws of linear perspective, allowing both material objects and architectural spaces to be represented analytically and persuasively on a flat surface using equilateral lines receding to a single point, and at eye level.
- Perspectival rules in Books I and II may be understood as an attempt to bestow upon the painter practical skills and instruction as regards a mathematical foundation to demonstrate how 'the art of painting [arises] from the basic principles of nature.' This mathematical rule, as all others, underlies God's order and intention seen in nature, but expressed through man's endeavours, and citing Virgil, who declared, 'man is the mean and measure of all things.'[6]

Book II

- Deals with the exacting schema for making art as well as the tangible tenets and techniques of representation.
- Asserts Alberti's idea of *virtù* in painting, drawing on commentaries by mostly Greek scholars who saw its 'divine' power, moral value and noble social standing.
- Aims to 'instruct the painter [as to] how he can present with his hand what he has understood in his mind.' Here, composition is central to Alberti's idea of *historia*, a word that defies a clear-cut translation yet represents the highest goal for the painter: beauty, expression and import in painting. Although human gestures should be potent and dramatic, moderation, decorum and 'avoiding disorder' is likewise essential to the *historia* of any work. Painters should endeavour to demonstrate 'movements of the soul' via 'movements of the body': to represent the inner self through external bodily or facial signification.

Book III

- Reviews the personal character of the painter and the requirements and ideals particular to this vocation, which specifies artistic and moral *virtù*, 'diligence, study and application.'
 A painter must:
- First of all 'be a good man and well versed in the visual arts.'
- Needs 'a good knowledge of geometry'.
- 'Be learned in all the liberal arts and have an acquaintance with the ancient 'poets and orators', 'literary men' – all helping to replenish the painter's 'inventions' regarding the *historia*. Although invention – the creation of a captivating subject – is praiseworthy in its own right, this must go hand in hand with the repeated process of addressing Nature itself: 'the gifts of Nature should be cultivated and increased by industry, study and practice.'

Annunciazione (Annunciation) *(1435) by Donatello. The sculpture reflects a new direction for Donatello with a renewed emphasis on classical forms.*

De Pictura was not widely available until 1540 (and published in the Italian vernacular only in 1557). It was used by artists seeking to establish painting as a liberal art. It seems likely, however, that most practising artists learned of Alberti's treatise by word of mouth and by detailed examination of works by Masaccio, Donatello and Brunelleschi, who carried out their own mathematical experiments with perspective and illusionistic space in painting, sculpture and architecture.

The Emergence of Art History and the Foundation of Modern Artistic Theory: Giorgio Vasari's *Lives*

Giorgio Vasari's *Lives of the Most Excellent Painters, Sculptors and Architects* (first published in 1550; second, expanded edition published in 1568) is perhaps the most prominent history of art ever penned. Artistic status had begun to be acknowledged in the mid-fifteenth century thanks to texts such as Lorenzo Ghiberti's *I Commentarii* (*Commentaries*, c. 1447), but Vasari's *Lives* gave a new sense of stature to the artists of the Renaissance. The *Lives* is now seen as highly problematic in its approach to the work of the period. Nonetheless, the text remained a major source of information for the following five centuries of art historical study, and is still the basis of modern art history today. Vasari's principal concern in the three sections of the *Lives* is a reassessment of the quality, style and inventiveness of the previous two and a half centuries of Italian art: in other words, after the 'earlier perfection and excellence' in classical art and subsequent to the arts' 'fall into disastrous decline' during the Middle Ages.

Vasari compared artistic growth and its deterioration to the natural life cycle. Large portions of the *Lives* are devoted to the specific traits of painters, sculptors and architects, marking out art as a series of progressive movements that follow a clear linear trajectory. His concept of development on the basis of style and the appropriation of classical Greek and Roman art runs through the entire text. His purpose is to illustrate the restoration of the arts – mainly in Renaissance Italy and, unsurprisingly, heavily Florentine in origin. It's a story of artistic genius, increasing naturalism, the conquering of space or perspective, set out as a teleology (a kind of domino effect), with each artist or period superseding the previous qualities, innovations and styles.

The champion of the *Lives* is Michelangelo di Lodovico Buonarroti Simoni (1475–1564), a 'genius universal in each art'. Vasari's intention is to link one artist to another, physically and spiritually, or over time and space, so as to suggest that 'either the spirit of Donatello moves Buonarroti, or that of Buonarroti first moved Donatello'. Vasari's description of Donatello's *Annunciation* (c. 1435, Calvacanti Chapel, Santa Croce, Florence) neatly bridges the first and second sections of the *Lives*, praising the sculptor's 'striving to recover the [lost] beauty of the ancients'. The drive behind Vasari's approach is to raise the status of the artist and their surpassing of the classical arts. More importantly, Vasari's *Lives* stress that the arts could once again fall into decline, a goal that later artists should strive to prevent.

The Real and the Ideal: Artistic Theory in the Academy – from Bellori to Reynolds

By the mid-eighteenth century, it was believed that the arts had once more fallen into a state of dereliction, but it was also believed that they might be restored to good health if contemporary artists were to show proper respect and attention to the moral principles of Greek art. These new artistic tenets would form the starting point of instruction for the young artists in the lately founded European academies. In 1664, Bellori delivered a lecture at the Academy of Saint Luke entitled 'The Idea of the Painter, Sculptor and Architect', and later published it in his preface to *The Lives of Modern Painters, Sculptors and Architects* (1672). Here, the writer expanded on the ancient Greek concept of perfect forms, although reassigning it to the everyday sphere and stationing the philosophical 'idea' in the artist's psyche or mind's eye as 'the perfection of natural beauty, [uniting] the truth with the verisimilitude of what appears to the eye'.

For Bellori, there were certainly many ways to fail as an artist. Derelictions included blindly copying nature and habits that might be flawed, including subscribing to the opinions of others or following an inadequate master: 'thus the art of painting is degraded by those painters to a matter of personal opinion and a practical device.' Worse at any rate was plagiarizing other artists by 'creating works that are not legitimate children but the bastards of Nature'. In the newly founded academies of art, students were encouraged to draw from the nude, supplemented by plaster casts of the most famous antique sculptures.

The Academicians of the Royal Academy (1771–72) by Johann Zoffany. The two female Academicians were only shown in portraits (far right).

Women of the day were excluded from studying the live nude model, which formed a key part of academic artistic training. Even Angelica Kauffmann (1741–1807), who was elected to the esteemed Academy of Saint Luke in Rome in 1775 and was also among the founding members (alongside Mary Moser, 1744–1819) of the British Royal Academy in 1786, is relegated to a portrait on the wall to the right and at the back in Johann Zoffany's male group portrait which celebrates *The Academicians of the Royal Academy*, then an entirely male preserve.

Such was Kauffman's standing in 1779, however, that she was tasked with creating one of four oval paintings to decorate the ceiling for the Royal Academy's lecture room, where cohorts of students would be taught. She certainly knew both Winckelmann's theories and Sir Joshua Reynolds's discourses. However, Kauffmann's designs (all allegorical self-portraits) represent her personal understanding and concept of the rudiments of painting: colour, design, composition and genius or invention. *Colour*, in unfastened attire with her right breast exposed, holds a paint brush up to the air to both fashion a rainbow in the blue and cloudy skies, or to mix its optical prism on her artist's board.

Nature, Imitation and Invention are key and oft-repeated concepts used in Bellori's text and related academic treatises – terms that are radically distinct from those used today.

- Nature denotes the creative force functioning in the world outside (the real world that artists are repeatedly encouraged to imitate, the human form especially).
- Imitation is not blind copying but the capturing and interpretation of a certain fundamental rule: 'The painters and the sculptors, selecting the most natural elegant beauties, perfect the *idea* and their works go forward and become superior to nature.'
- Invention is not equated with originality, but rather the correct choice or staging of the subjects of history painting: pictures of demonstrably moral and suitably inspiring disposition, preferably sourced from the Bible, classical myth or ancient history.

Colour (1778–80) by Angelica Kauffman.
Kauffmann identified herself primarily as a
history painter, the genre at the heart of teaching
at the Royal Academy.

Most notably, Bellori's *Lives* allocates some
30 pages to the ceiling fresco created between
1597 and 1600 at the Palazzo Farnese in Rome
by Annibale Carracci (1560–1609) – inspired

by Raphael, Michelangelo and the sculpture of ancient antiquity. Art, for Bellori, is hence manufactured by means of composite studies, the scholar conjuring up Zeuxis by way of Raphael. Other like-minded treatises followed Bellori's *Lives*, notably those penned by Jean-Baptiste Colbert (1619–83), Charles-Alphonse Dufresnoy (1611–68), Charles Lebrun (1619–90) and André Félibien (1619–95), all of which helped to create a more or less intelligible academic canon and a hierarchical artistic system of genres:

STILL LIFE SUBJECTS *(ordinary Nature)* ▶ LANDSCAPE ▶ PORTRAITURE ▶ HISTORY PICTURES

Johann Winckelmann, like Vasari, referenced the development of classical art to suggest stylistic progress, efflorescence and inevitable demise. The German scholar put down the grounds for a contemporary methodical approach to iconography in ancient art in *Reflections on the Imitation of Greek Works of Art in Painting* (1775) and the later *History of Antiquity* (1764). Winckelmann is both lionized and loathed for his highly influential chronological schema that identifies stages or periods for classical art history:

CLASSICAL ART
▶ **Older Style, shadowed by the High (or *Sublime*)**
▶ **The Beautiful**
▶ **The Style of the Imitators**

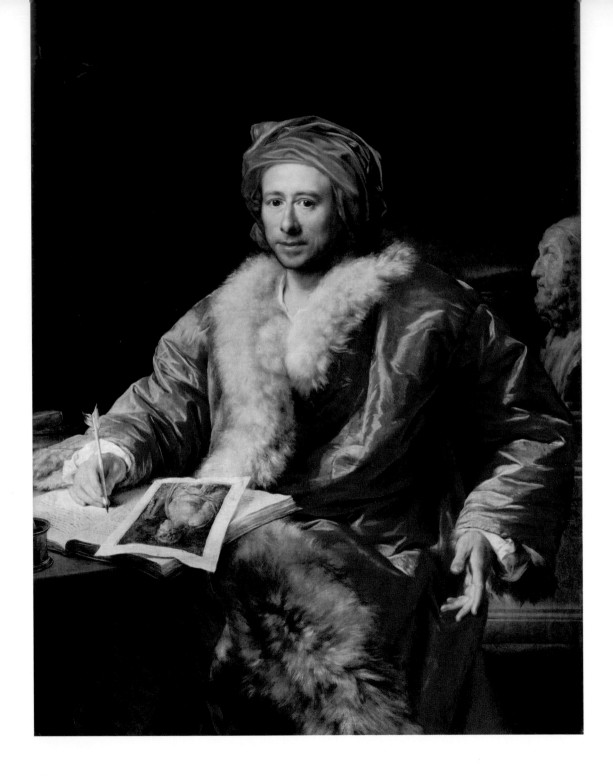

Each period of art coincided with a form of government that Winckelmann thought to exist in times of great political Liberty. All of modern scholarship (including art history and classical art history) is now stuck with this schema, or can be traced back to it. Somewhat contradictorily, Winckelmann interpreted classical art as the embodiment of Greek ethical concepts, its antiquities expressive of a type of moral good or liberty, for which all societies strive. 'The only way to become great and, if possible, inimitable,' Winckelmann thus asserted, 'is by imitation of the ancients' – not by copying antiquities, but by imitating their creative and ethical excellences. As Michael Hatt and Charlotte Klonk have identified: 'The paradox here … is that if particular aesthetic and moral values are, as Winckelmann had argued, dependent on the unique cultural context of the production, how could they be realised again under different circumstances at a different time and place?'[7]

As with Bellori, Winckelmann emphasizes the 'grafting' or selection of the most beautiful parts from different figures – warning, however, that something may be ideal without being beautiful, as in Egyptian figurative art. Winckelmann's theories about Greek art and culture were clearly influenced by, and amalgamated with, Enlightenment ideas (*see* Chapter 8).

Johann Joachim Winckelmann (1767) by Anton von Maron. Winckelmann, whose work on defining the differences between Greek, Graeco-Roman and Roman art was pioneering, is often considered to be the father of the discipline of art history.

The latter was equally relevant to the art and scholarship of Sir Joshua Reynolds (1723–92), a central figure in British portraiture and in artistic culture generally in the mid-eighteenth century; he became the first president of the Royal Academy of Arts in 1768. His trip to Italy in 1753 allowed him to absorb not only the work of great Italian masters but also the classical tradition, including important Greek sculptures such as the *Apollo Belvedere* in the Vatican museum. Reynolds's paintings borrow directly from the past (in fact, some contemporaries have accused him of plagiarism): the poses for his sitters are founded on the close study of ancient antiquity or are based on the work of the Old Masters. In portraiture, Reynolds sought to idealize, dramatize and ennoble the sitter with a moral dignity and status. As he made evident in his *Discourses on Art* (1769–70) – a series of lectures aimed at aspiring pupils – he saw portraiture as being as much about enrichment and 'dignity taken from general nature' as it was about representation.

It was the responsibility of Reynolds as an Academician to instil a grasp and respect for the idealized classical forms of antiquity. He believed that:

- Classical art was founded on an indebtedness to Nature and her rules.
- Painters should be highly knowledgeable, be taught the subjects of the history of painting, and be guided by a process of 'invention', by which he meant 'forming in his imagination the subject', and not simply manufacture a story, but gather together in a work of art of the subjects

with which the viewer should be entirely familiar.

- Painters do not solely imitate one master; nor do they copy nature too closely: 'A mere copier of nature can never produce anything great; can never raise and enlarge the conceptions, or warm the heart of the spectator.'

- A true painter must wish to improve his audience by capturing their imagination: 'to furnish with his mind this perfect idea of beauty.' As Reynolds reiterates: 'all the arts receive their perfection from an ideal beauty, superior to what is to be found in individual nature.'

- The painter must ennoble subjects with intellect and dignity, lifting both art and artist above the ordinariness of manual craft – a topic much debated in European academies since the sixteenth century. In doing so, Reynolds suggests that the ideal is to be found on the earth but that the artist must also be able to rise above the local, the singular and the particular.

- Artists must contemplate and observe in order to distinguish the malformed or the tarnished, and so correct and improve on nature. Genius combined with observation and experience, not to mention a close study of the ancients, helps achieve the ideal in painting.

Reynolds suggests that art and taste cannot be taught, and that faults in style also lead to a basic error of decorum: 'The neglect of separating modern fashion from the habits of nature, leads to that ridiculous style which has been practised by some painters who have given to Grecian Heroes the airs and graces practised in the courts of Lewis [sic] the Fourteenth.'[8]

This kind of academic discourse governed the teaching of art up to the eighteenth century. And it was not outdone until easily into the nineteenth. Such theories were to have far-reaching consequences, too. An idealized vision of the human form modelled on Greek and Roman sculpture set a norm for the Western artistic canon – a norm of beauty and perfection that would dangerously harden the attitudes of European art and society to the supposed 'Other'. To this day, it has fortified a conviction in the superiority, right and 'eternal law that first in beauty should be first in might', as John Keats characterized it in his Romantic poem *Hyperion* (1818).

Self-portrait (c. 1780) by Joshua Reynolds. Reynolds painted more than 30 images of himself. Like Rembrandt, whom he much admired, Reynolds painted himself to practise a variety of facial expressions. He also used the genre to control his image and cement his status.

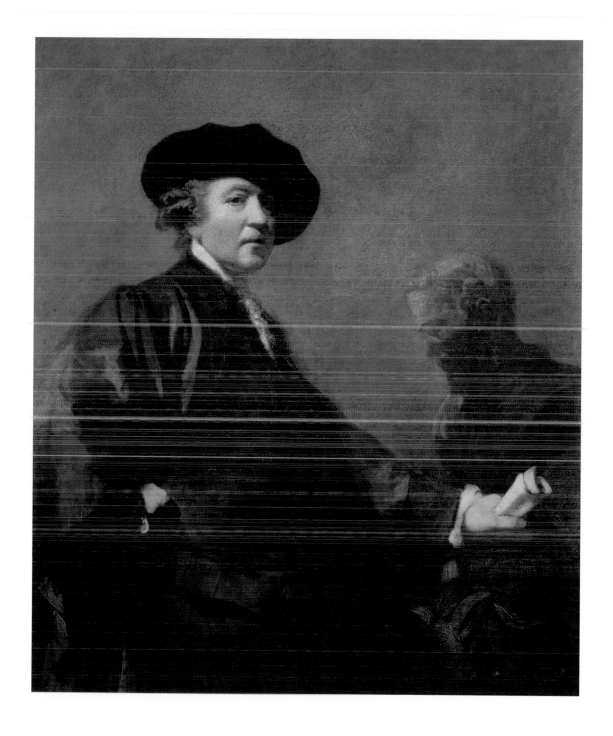

INTERPRETING DUTCH ART AND CULTURE IN THE SEVENTEENTH CENTURY

The Birth of the Netherlands: War, Water and the Beginnings of Nationhood, 1481–1600 – 'The Embarrassment of Riches':

Art, Affluence and Charity – Training and Labour: Artistic Social Status – 'The Art of Describing': Painting in the Golden Age

LAND RECLAMATION

THE CHANGING DUTCH LANDSCAPE

SCIENTIFIC DEVELOPMENT

DE GHEYN

MERIAN

CANALS, WINDMILLS AND LAKES

RISE OF THE UNITED PROVINCES

SOCIAL STATUS OF ARTISTS

ART FOR AN EMERGING NATIONAL IDENTITY

17TH–CENTURY DUTCH ART

ART AS CRAFT

GUILDS AND APPRENTICES

GENRE PAINTING

ART OF DESCRIBING

STILL LIFE

RUYSCH

PORTRAITURE

REMBRANDT

LANDSCAPES AND SEASCAPES

VANITAS

VERMEER

MEMENTO MORI

THE BIRTH OF THE NETHERLANDS: WAR, WATER AND THE BEGINNINGS OF NATIONHOOD, 1481–1600

From 1481 until 1597, members of the Austrian Hapsburg family governed the kingdom of the Netherlands, a series of provinces (excluding the southeastern areas of the modern country). In 1597, the provinces joined somewhat half-heartedly to declare their independence from the Hapsburg King Philip II of Spain (1527–98), brother to the Holy Roman Emperor

The Sitting Leo Belgicus (c. 1611) by Claes Janszoon Visscher. The use of the lion shape in both heraldry and map design was aimed at enforcing the belief in the might of the Low Countries.

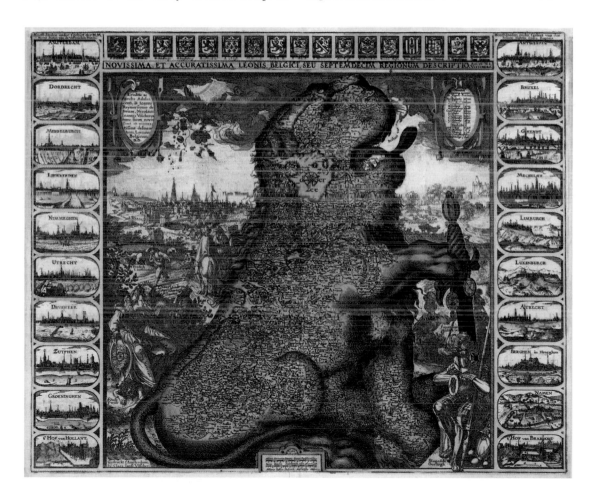

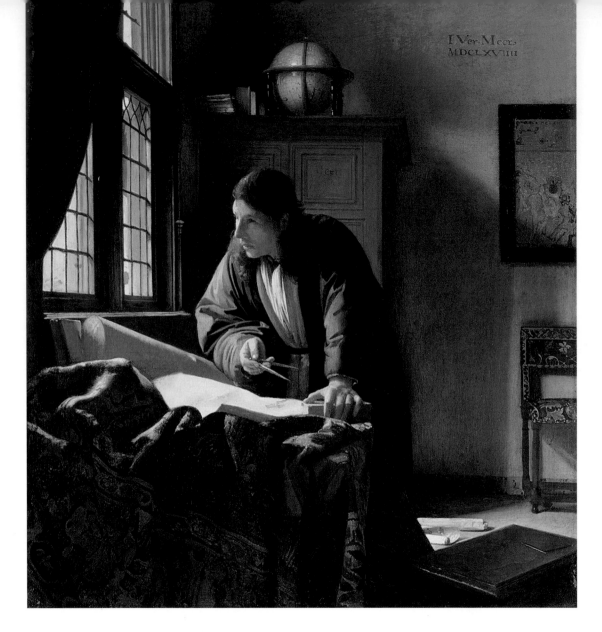

The Geographer *(1668–69) by Johannes Vermeer.*
The artist has gone into great detail in depicting the
maps, instruments and globe that such a man of
learning might need.

Ferdinand I (1503–64). The Spanish belief in a
single faith had led to the merciless persecution
of Protestants, who fled from their tyranny
within the boundaries of the seven northern
United Provinces: Holland, Zeeland, Utrecht,
Gelderland, Overijssel, Friesland and Groningen.

The Dutch and their Spanish rulers fought the long and embittered Eighty Years' War (1568–1648), interrupted only by the Twelve Years' Truce signed at Antwerp and eventually ending with the Treaty of Münster. In general, the United Provinces sought to hold on to the traditional devolved form of government, and in doing so, to retain their comparative independence from any centralized power in The Hague, where courtly life for the House of Orange and the Stadholders resided. The immediate descendants of the House of Orange were highly capable leaders and endowed with extraordinary military and political prowess, but they did not play the same part in Dutch cultural life as their predecessors.

With their naval vessels tried and tested by war, the burgeoning United Provinces came to prominence as a sea-faring power. Merchants benefited from the commercial fleets commanding extensive trading posts in the East and West Indies (the former including the Indonesian archipelago), South America and Africa, bringing tremendous wealth and prosperity to the Dutch nation. This astonishing rise to power was helped by the country's geographical position – on the sea and crossed by two of Europe's most vital waterways, the Rhine and Meuse – which quickly made the Netherlands a centre of trade and a worldwide empire. Aiding commerce were new navigational charts, atlases and globes, which were acknowledged by sea-going nations to be among the best.

The Dutch became famous for scientific developments, designed to gain a better grasp of the material facts of the world. They were

A page from The Wonderful Transformation of Caterpillars and Their Singular Plant Nourishment *by Maria Sybilla Merian.*

the leading manufacturers of optical lenses for elementary microscopes and telescopes.

Dutch artists, likewise, used this new scientific device. Jacques de Gheyn II (1556–1629) and Maria Sibylla Merian (1647–1717) created astoundingly intricate watercolours and hand-coloured engravings depicting tiny insects such as beetles and butterflies, and the indigenous plants upon which they fed. Merian published a number of volumes on European insects, illuminated with her own engravings in *The Wonderful Transformation of Caterpillars and Their Singular Plant Nourishment* (1679), which were passionately received by her scientific peers. Perhaps this is why Dutch art is labelled 'a worldly art'. It is something illustrated by the terrestrial and celestial globes in Vermeer's *The Geographer* (1668–69, Städelsches,

Kunstinstitut, Frankfurt), *Allegory of Faith* (c. 1671–1774, Metropolitan Museum of Art, New York) and *The Astronomer* (1668, Louvre, Paris).

At home, engineers manufactured dykes, windmills and hydraulic systems, enabling wetland to be pumped dry and requisitioned from the sea, creating vast swathes of new agricultural land between 1607 and 1640. Canals and lakes provided effective transport systems, helping to move people, livestock and trade goods in a relatively short space of time, as evidenced by Esaias van de Velde's (1587[?]–1630) *Cattle Ferry* (1622, Rijksmuseum, Amsterdam).

It cannot be stressed enough that the period 1550–1650 was one that profoundly altered the Dutch landscape. Traditionally, the Dutch have preserved a distinctive and palpable relationship with their geography: 'God created the world, but the Dutch created Holland' is a common proverb.

The act of separating the land from the sea was naturally laden with biblical symbolism. Vierlingh wrote: 'The making of new land belongs to God for He gives to some people the wit and strength to do it.'[1] That is to say, the Almighty had not only aided the Dutch in their struggle against the sea, but had also licensed their miraculous act of parting land from the waters in the creation of new territories.

'THE EMBARRASSMENT OF RICHES': ART, AFFLUENCE AND CHARITY

The social makeup of the Netherlands was to a certain degree democratic in the first 20 years of the seventeenth century. Initially, the Republic displayed little evidence of a militarist or aristocratic nature. But as the nation became more affluent, especially following the 1609 armistice, wealthy families began to take on patrician propensities and ways. Middle-class citizens, called burghers, bought the most art. The art market in the mid-century was exclusively devoted to modestly scaled canvases depicting an accepted range of subjects: still life, landscape, seascapes, single and group portraits, and genre scenes. When Rembrandt moved from his native Leiden to the highly prosperous city of Amsterdam in 1631/32, the

Cattle Ferry (1622) by Esaias van de Velde. Van de Velde later became court painter to Prince Maurits and Prince Frederick Henry of Orange in The Hague.

The Lacemaker (c.1669–70) by Johannes Vermeer. It is likely that Vermeer used a camera obscura in composing the work, giving it a photographic quality.

centre of Dutch commercial power, he was able to gain lucrative commissions for single and large group portraits, and was soon recognized as the leading painter of his day. As Wayne E. Franits further explains, the genre subjects of his contemporary, Vermeer, were tailored to the partialities and whims of privileged buyers 'in a culture captivated by female pulchritude',[2] driven by Dutch amatory literature and testified by Vermeer's *The Lacemaker* and other

paintings. Pieter Claesz van Ruijven (1624–74) – the moneyed Delft inhabitant who was Vermeer's patron – probably had first pick of his works. The patron owned around 20 paintings, including *The Lacemaker,* so 'probably found this aspect of the artist's work immensely appealing and trendy'.[3]

The Dutch collected avidly, hanging their pictures throughout large and often newly purchased homes. According to the *Description of the Widely Renowned Commercial City of Amsterdam* by the Dutch historiographer Melchior Fokkens in 1662: 'Amsterdam has become the greatest and most powerful merchant city in all Europe ... that our neighbours and foreigners are struck with wonder that in so few years has grown to such glorious riches.'[4]

In Amsterdam and Leiden, art collectors lived in the famous canal houses built in fashionable styles by the likes of the municipal architect Willem van der Helm (c. 1625–75). Well-heeled families additionally bought houses in the countryside and used their wealth and status to monopolize higher offices in the provinces and boroughs. The disparity between rich and poor widened, but charitable organizations sprung up in the wake of this 'embarrassment of riches',[5] filling the economic gap left by the disestablishment of Catholic churches and monasteries. The countless founders and Regents (Governors) of charitable organizations and institutions commissioned art and buildings by important artists and architects of the period. The group portraits that currently hang in our museums formerly hung in the boardrooms of said institutions. Unsurprisingly, the Regents and Regentesses commissioned biblical or symbolic subjects that refer directly to the benevolent nature of their organizations. As Seymour Slive has pointed out: 'It is not astonishing to learn that an inventory complied in 1786 of the contents of the chamber of the Regentesses of Haarleem's Old Men's Almshouse lists a painting of *The Good Samaritan*.'[6]

Most scholars argue that Vermeer's *Woman Holding a Balance* (1662–63, National Gallery of Art, Washington) is a popular vanitas allegory, meditating on worldly treasures. The scale pans are empty, but a jewel box, pearl necklace and gold coins lie on the table, and the fateful weighing of souls, indicated by the picture of the *Last Judgement* hanging on the wall, possibly exemplify the subtle ethical equilibrium between spiritual goodness and worldly avarice. In a country filled with wealth and luxury, 'the continuous pricking of the conscience on complacency produced the self consciousness that we think of as embarrassed.'[7]

Most painters came from the middle class social structure, earning a living (though some just barely) because art was in such great demand among all classes of Dutch society. During his travels in Holland in 1640, the British merchant Peter Mundy noted that 'pictures were very common here, there being scarce an ordinary tradesmen whose house is not decorated with them.'[8]

As Simon Schama notes: 'At the cheapest end of what was, in effect, the first mass consumer's art market in European history ... and in the Dutch Republic it was common for burghers' families to own works of art. It seems likely that they were thought of as works of craft, just as most painters were thought of as craftsmen and rewarded accordingly.'[9]

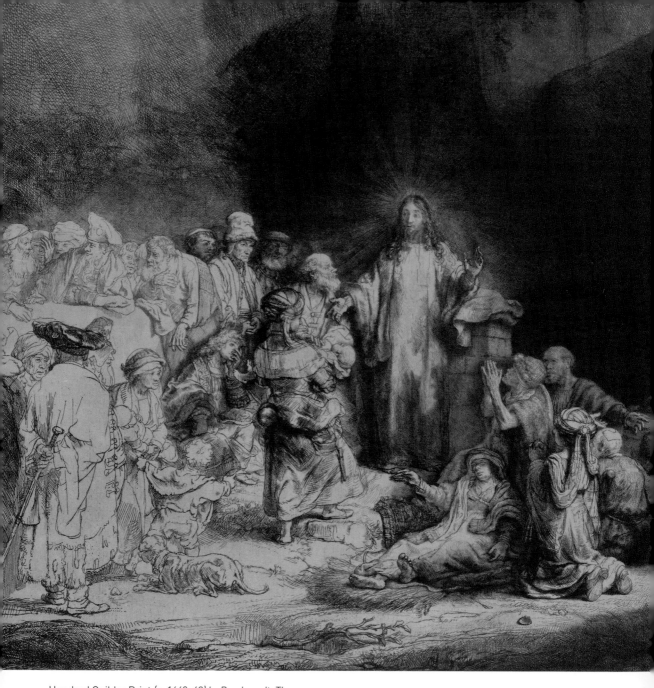

Hundred Guilder Print (c. 1642–49) by Rembrandt. The
artist worked on this etching for many years and it was
hailed as a technical masterpiece.

TRAINING AND LABOUR: ARTISTIC SOCIAL STATUS

As Simon Schama acknowledges, Dutch painting was not elevated to the status of a liberal art, with the sort of claim made for it as for works of the Italian Renaissance.[10] Much like medieval practitioners, artists of the Republic were artisans, the production paintings having an emphasis on craft and manual skill. The creation of art bore a resemblance to the other business industries. Trading in luxury items such as Rembrandt's *Hundred Guilder Print* (c. 1642–49) nonetheless gave art a special individuality. Training in the arts was carried out under a master practitioner. As with their Renaissance counterparts, who sought a separate status from lowly craftsfolk, Dutch artists were keen to establish and belong to a Guild system. As Mariët Westermann pointed out: 'This development was in keeping with the increasing specialisation of production in most industries, but also registered a growing self-consciousness on the part of painters and printmakers about their own craft as art.'[11]

The painting of the studio of Adriaen van Ostade (1610–85) shows the apprentice engaged in the age-old practice of grinding pigments on a stone block (*see* illustration overleaf), having been employed to do this and various laborious tasks such as cleaning the studio, preparing and maintaining various artistic paraphernalia, as well as learning the everyday business of making art. Students (boys and, infrequently, girls) would first learn to draw after their master's works, then from antique casts, anatomical figures and, finally, mannequins of the kind depicted in Ostade's painting. Life drawing was atypical, but probably practised after a

The Painter in His Studio *(1663) by Adriaen van Ostade. Adriaen and his brother were reportedly pupils of Frans Hals, and he was heavily influenced by the work of Rembrandt.*

male nude model. Models were more readily available in informal drawing academies, which first sprung up in Haarlem in 1583 and Utrecht in the early 1600s, then later in Amsterdam and The Hague. These were effectively small and informal groups of painters seeking additional drawing lessons. Instruction in drawing was probably supplemented by informal discussions on perspective, theory and subject matter. Artists had a two-to-four-year period of training, then sat an exam to demonstrate their skills to Guild members, and then (if they were

Margareta Maria de Roodere and Her Parents (1652) by Gerard van Honthorst. Portraits of well-to-do painters, such as Margareta Maria de Roodere, contributed greatly to an appreciation of art by women as an acceptable intellectual and social pursuit.

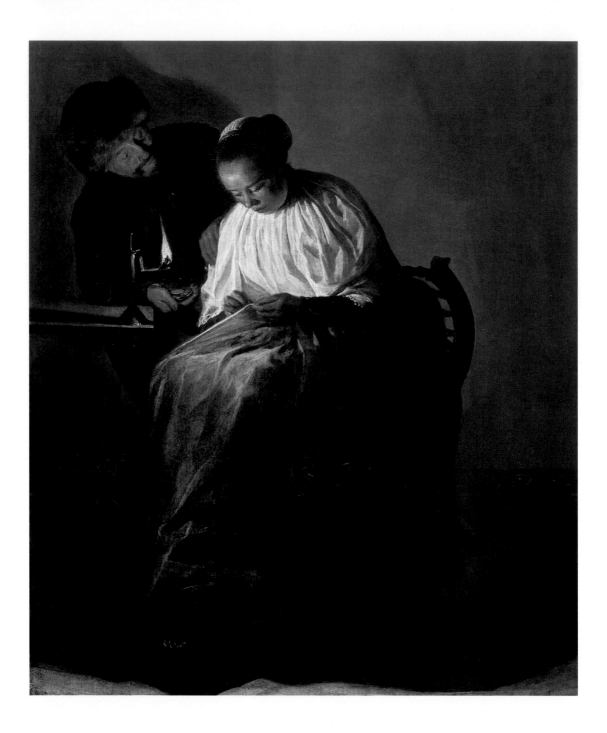

financially able), they might go on to become masters themselves. Most, however, continued to operate as journeymen in the service of a master painter. The social status of a painter hence varied from artisan/tradesman through to independent masters and well patronized and official court/society portraitists such as Gerard van Honthorst (1590–1656).

There were a sizeable and formidable number of Dutch lay practitioners of the arts. Gerard van Honthorst's painting of Margareta Maria de Roodere and Her Parents (1652) shows an additional class of artist – the affluent amateur painter. In this way, a number of middle-class women developed into successful artists in their own right. More than a dozen women are chronicled as having achieved the standing of Master. Most impressive is the brewer's daughter and Haarlem genre painter Judith Leyster (1606/9–60). Naturally, the material conditions and social status of women as artists were very different to those of men – as was true for all women, a point the female artists were not afraid to make. As Firma Fox Hofrichter forcefully argued, Leyster's *Man Offering Money to a Young Woman* deviates from the traditional tendency to see women as 'embarrassed victims' or alacritous accomplices. In Leyster's hands, the young woman being proffered coins remains attentive and steadfast in her task. The emphasis

is on physical female labour under strained candlelight, or accompanied by the additional burden of looking after children rather than freedom, reverie or male Calvinist moralizing.[12] In Leyster's painting, the smiling man may offer money as a proposal of marriage, or to proposition the virtuous young woman. Her total indifference evokes a popular Dutch saying recorded by the contemporary poet Jacob Cats: 'No pearl should be bought at night/no lover should be sought by candlelight.' Although Cats's poem was penned a year after Leyster completed her painting, this was a commonly known saying during the era.[13]

History Painting

Vermeer's *The Art of Painting* (c. 1670) is a celebration of Netherlandish art, but might be an allegory of painting itself. It is also a fine example of history painting. The map on the wall acknowledges the Netherlands prior to the political schism that followed the Dutch uprising against Hapsburg rule. The chandelier retains the two-headed Hapsburg eagle, but without candles, its light has been snuffed out. The daylight from the window highlighting the map and the fancy costumes worn by the painter (Vermeer?) and Clio, muse of history, intimate that the clear northern light of Truth is greater than any artifice, however beguiling. Was Vermeer crafting a declaration for painting as a liberal art, as the Spanish painter Diego Velázquez did with his famous *Las Meninas* (*see* Chapter 6)? Like Italian painters before them, Dutch and Spanish artists were pursuing the acknowledgement of their artistic status and endeavouring to distance themselves from the ordinary crafts of the Guild.

Man Offering Money to a Young Woman *(1631) by Judith Leyster. Also known as* The Proposition, *the work has been the subject of much scrutiny and reassessment by male and female art historians.*

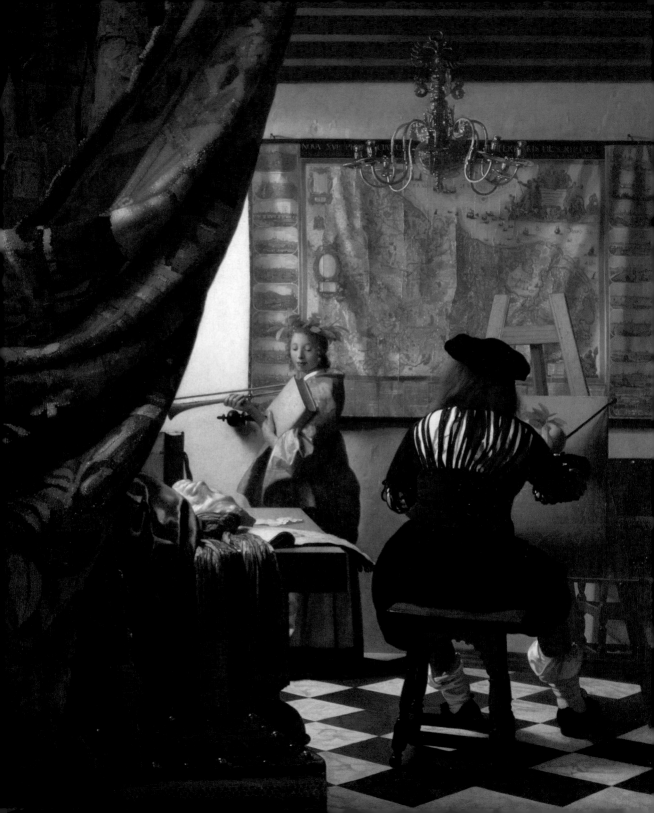

'THE ART OF DESCRIBING': PAINTING IN THE GOLDEN AGE
Still Life

The subject of still life was also popular in Dutch art. Still life painters would often restrict themselves to a limited area of specialization. For example, Maria van Oosterwyck (1630–93), Rachel Ruysch (1664–1750) and Clara Peeters (*fl.* 1607–21) appear to have had a steady clientele for their chosen genres of flowers and still life. Ruysch's talent was such that she gained an international reputation for beautiful and elaborate flower pieces. (The word 'still life' did not emerge in Holland until *circa* 1650; instead, the terms 'little breakfast', 'little banquet' or 'flower piece' were used.) Moreover, of the 50 or so compositions by Clara Peeters, only five comprise *Bouquets* – the rest being the 'little breakfast' genre, with precious objects and exotic foodstuffs, and occasionally individual flowers added. As with landscape painting, still lifes sometimes seem to acknowledge the pride, self-assurance and national identity regarding trade, commerce and the triumph of the Dutch Empire. Subsequently, the still life genre included objects from all over Europe and the wider world.

A fascination for luxury goods and consumer items led to the production of paintings celebrating worldly possessions and wealthy standards of living, and illustrating the decadent Dutch taste for extravagance. Willem Kalf's *Still Life with a Late Ming Ginger Jar* (1669) reveals luxurious household objects and foodstuffs such as Chinese porcelain,

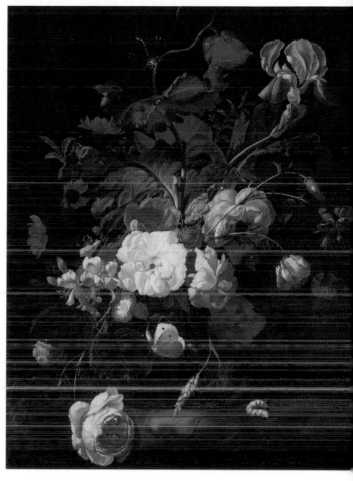

Opposite: The Art of Painting *(c. 1670) by Johannes Vermeer. Its alternative titles are* The Painter in His Studio *and* The Allegory of Painting.

Above: Flowers in a Glass Vase *(1698) by Rachel Ruysch. The artist's career lasted more than six decades.

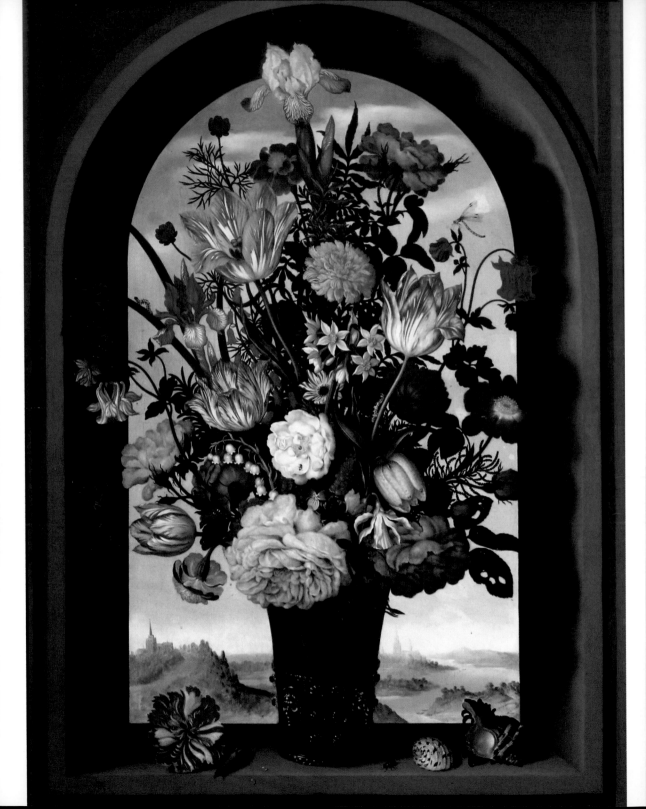

Dutch silver, stem ginger, Mediterranean peaches and a juicy lemon, all of which are set out on a decorative Indian carpet. In the centre, a gilt *putto* and a horn of plenty prop up a half-full glass of wine. Kalf's still life is a well-dressed digest of Dutch riches and tastes. Even the requisite vanitas allusion – a gold timepiece – is a finely crafted instrument. Perhaps the watch intimates the timeless qualities of painting (and the hours spent labouring over its construction) or the transience of time, injecting a note of disquiet into Kalf's composition. Here, the conciliation between cornucopia and the subject of vanitas (a standard of Dutch thinking during the century) depicts what Simon Schama has labelled 'the embarrassment of riches': prosperity with a moral conscience.

Vase of Flowers by a Window by Balthasar van der Ast (1593/4–1657) depicts an elaborate flower arrangement by a window and also includes a Wan-li vase imported from China, as well as expensive shells, exotic fruits, bugs and decomposing leaves. These elements invest the work with a symbolic complexity that reveals earthly pleasures and the transitory nature of life. Like Ambrosius Bosschaert's *Vase of Flowers in a Window Niche* (c. 1618–20), it displays flora that were available in the Dutch Republic, but which could not have bloomed together in the same season – and Bosschaert's Bruegelesque landscape is hardly topographical, either. Examination of bouquets painted by Bosschaert and other flower specialists of the era reveal that they were rarely executed from

Opposite: Vase of Flowers in a Window Niche (c. 1618–20) by Ambrosius Bosschaert. His flower paintings are renowned for their botanical accuracy.

Right: Vase of Flowers by a Window (c. 1645) by Balthasar van der Ast. The artist trained with Ambrosius Bosschaert and in turn helped to train Bosschaert's three sons after their father's death.

PABRITIVS 1654

The Goldfinch *(1654) by Carel Fabritius. Formerly a pupil of Rembrandt's, Fabritius died tragically young at the age of 32.*

Vanitas *(c. 1640) by Harmen Steenwyck. The shaft of clear light falling from the upper left and highlighting the skull marks this still life out as a vanitas.*

life. Bosschaert's vase displays some 30 flowers, including rare tulips. Bosschaert and Van der Ast's flowers could symbolize earthly folly, the 'Great Tulip Mania' that took hold in Holland in 1636–37, and which led to the economic ruin of many Dutch families when the market finally crashed. Unsurprisingly, Romer Visscher's emblem book of proverbs, *Sinnepoppen* (Amsterdam, 1614), recites the motto: 'A fool and his money are soon parted.'[14] During the period, a single bulb of *Semper Augustus* could easily fetch a thousand guilders, so Visscher's words are extremely apt as regards a warning of economic foolishness.[15]

The arched frame over Bosschaert's flowers recalls the age-old tradition of holy images, in which the Madonna and Child or saints invite religious observation. Flowers have long been associated with transience, and Dutch viewers with didactic tendencies would have perceived cut and wilting flora as reminders of the ephemerality of existence.

Other artists explored the ability of realism to fool the eye. *The Goldfinch* (1654) by Carel Fabritius depicts a tiny bird tethered by a chain to its feeding box, Fabritius inserting 'the small panel in a fake window, cabinet opening, or wall to create a *trompe-l'oeil* [trick of the eye]

effect.'[16] The image might also affirm social and religious ideas regarding domestic fidelity, modest homeliness and the virtue of the woman at home. To be loyal in seventeenth-century Dutch society was to be the queen of domestic sovereignty. A popular wedding song of the period, 'The Little Holland Goldfinch', warbled that 'a house-guardian's [*huis-voogd*] realm … is like a kingdom, … her children their happy subjects.'[17]

In art, memento mori are artistic or symbolic reminders of our mortality. In a strictly Christian sense, they are symbols intended to remind us of heaven, hell and salvation after death. A typical

memento mori subject includes a skull, but other symbols commonly included are skeletons, crosses, books, hourglasses, clocks, burned-out or fluttering candles, rotting fruit (often crawling with insects) and flowers losing their petals. These symbols closely relate to the vanitas still life. In addition to symbols of mortality, vanitas include objects such as musical instruments, wine and food to remind us explicitly of the ephemeral aspects of worldly pleasures and possessions. For example, Philippe de Champaigne's *Vanitas* (*c.* 1671) is reduced to three rudimentary objects: Life (fresh flowers), Death (a skull) and Time (an hourglass). The vanitas and memento mori subjects were particularly popular in seventeenth-century Holland. In Harmen Steenwyck's *Vanitas* (*c.* 1640), empty pipes, a tumbled glass, the unplayed flute (to represent the dying sound of music), a lamp petering out, the books on the table (including the Bible), an empty shell and, most importantly of all, the skull – a key symbol of Christ's crucifixion at Golgotha – purposefully remind us of the impermanence of life, the futility of human endeavour and the recognition that salvation comes only through Christ. The expression is found in the Old Testament Book of Ecclesiastes (12:8): 'Vanity of vanities, saith the Preacher, vanity of vanities, all is vanity.'

Vanitas (c. 1671) by Philippe de Champaigne. Virtually all Dutch still lifes introduce – to a greater or lesser degree – the character of vanitas, a lament regarding the transience of worldly existence. Nil omne ('Everything is nothing') was a popular artist's message, often written above an hourglass .

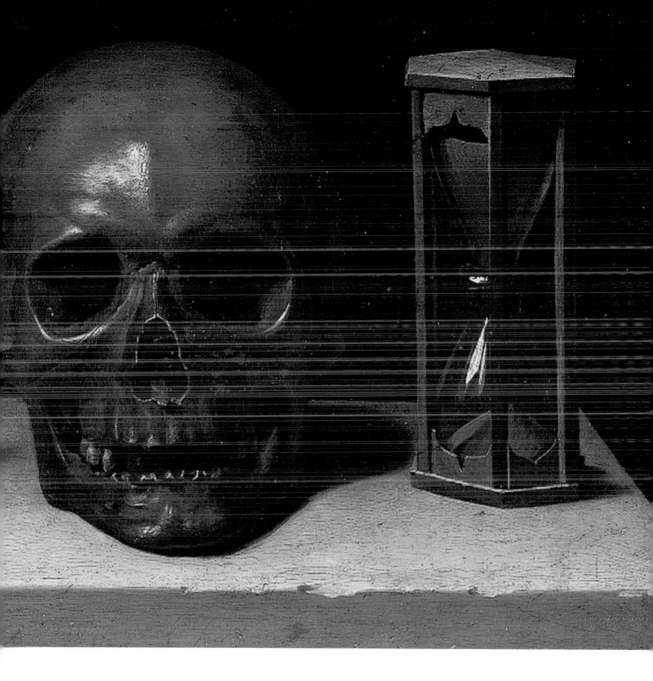

Landscape

Quickly after the establishment of the Republic, artists began to create entirely new ways of depicting their lands, its ubiquitously low, water-logged and unremarkable topography becoming by mid-century the subject for many wide panoramic views of Dutch scenery. Landscape paintings flourished in the Netherlands, although their marketing was typically aimed not at the Dutch aristocracy, who favoured Italianate views, but at the wider public, and they were sold on the open market

Opposite: View of Haarlem with Bleaching Fields (c.1665) by Jacob van Ruisdael. Considered to be one of the greatest landscape painters of his generation, van Ruisdael's work was much in demand during his lifetime.

Below: Windmill at Wijk bij Duurstede (c. 1665) by Jacob van Ruisdael. Wijk bij Duurstede was close to Utrecht. Only the foundations of the windmill are still visible today.

for relatively modest sums. As evidenced by François van der Noordt's bankruptcy sale of February 1681, landscape paintings were widely produced and collected, making up one of the most affordable genres in Dutch art. They appealed to city-dwellers, tradespersons, merchants and other professionals. Dutch landscapes depict everyday urban scenes, cityscapes and the countryside, as well as

The Avenue at Middelharnis *(1689)* *by Meindert Hobbema. Considered* *one of the finest Dutch landscapes* *of the era, it is believed to have* *influenced Camille Pissarro to paint* The Avenue, Sydenham.

villages, pastoral scenes, waterways, vessels at sea, coastal views, windmills and so on. Dutch landscapes might appear accurate copies of nature, with recognizable areas of land, but they are hardly ever geographically truthful.

To treat the landscape *View of Haarlem with Bleaching Fields* by Jacob van Ruisdael (1628/9–82), or indeed any other Dutch painting, as simply anecdotal would be a mistake. Ruisdael's image suggests a view from a steep hill, but the geography of the Netherlands is exceptionally flat, so it's not topographically accurate in any real sense. But its highly realistic details suggest a careful observation of the surroundings. Note the white bleaching fields dotted with tiny workers, and the 'flat' Bloemendael countryside with the church and town of Haarlem in the distance. The scene certainly looks ordinary enough, part of the daily Dutch work routine, and it is exactly this type of familiarity that gives the painting a sense of moral significance. Can it be a coincidence that bleaching garments was one industry much denounced in the *Black Register of a Thousand Sins* for flouting the Church's Sunday trading laws? Look closely at the clouds that dominate two-thirds of the composition, fostering an ominous and omnipotent presence and serving as a warning to those who work on Sunday and violate the Sabbath.

In *The Avenue at Middelharnis* by Meindert Hobbema (1638–1709), two parallel lines of pruned alder trees framing an endless stretch of road perhaps have a similar spiritual significance. And it would, to the religiously inclined, intimate the long and straight path of righteousness that leads to salvation: the church of St Michael indicates the journey's end. In Ruisdael's famous

Windmill at Wijk (c. 1665), reinforced river palings and powerful sails harness the forces of nature, draining and protecting the land from flood. In contemporary religious literature or emblem books, sails are sometimes equated with Christ's cross, and while the billowing clouds are evidence of God's power, the sails are also a symbol of Dutch ingenuity, might, industry and uniqueness, representative of a burgeoning national identity. Ruisdael's modern mill has a heroic stature (the painter significantly enlarged the structure and its crossed sails), while *The Maas at Dordrecht* by Aelbert Cuyp (1620–91) includes a fishing fleet in the harbour and the Dutch flag flying from the tall mast of an ocean-going ship, both serving as reminders of the prosperity of the Dutch Republic and its fast-expanding empire. As one author has rightly suggested, '[Dutch landscapes] are symbolic in that they form part of an iconography of nationhood, part of a shared set of ideas and memories and feelings that bind people together.'[18]

Next page: The Maas at Dordrecht (c. 1650) by Aelbert Cuyp. The artist was influenced by many sources, including his own father and Jan Both who was familiar with the work of the French artist Claude Lorrain.

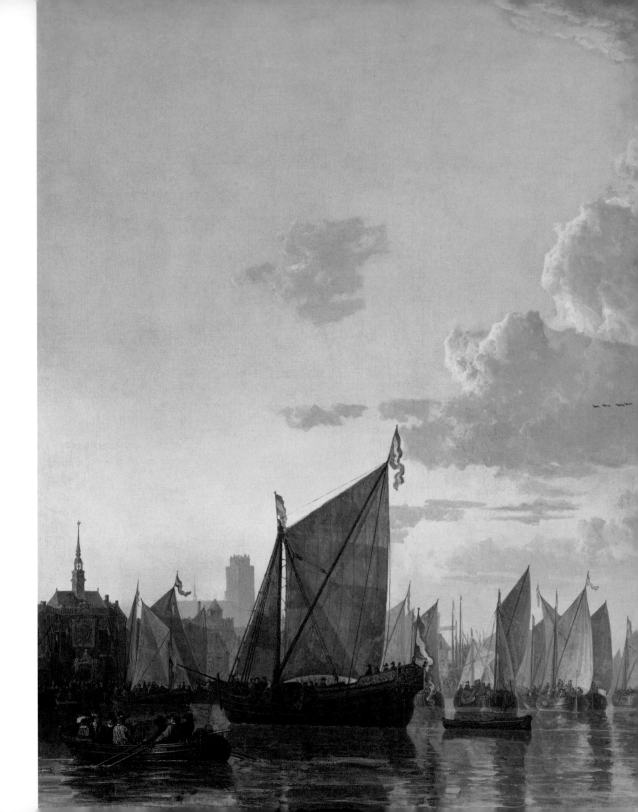

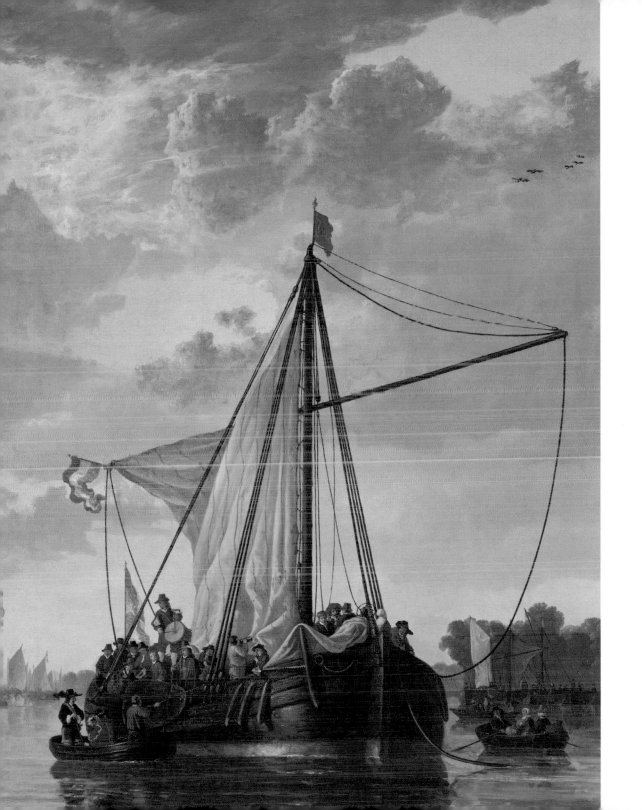

Chapter Six
SEVENTEENTH-CENTURY SPANISH ART: THE GOLDEN AGE

Economics, Colonization and the Politics of Faith:
Art, Church and State in Spain – Painting as Doctrine: Art in
the Facility of the Catholic Faith – El Greco: Art as Spirituality
– Training, Subjects and Genres: Artists' Changing Status

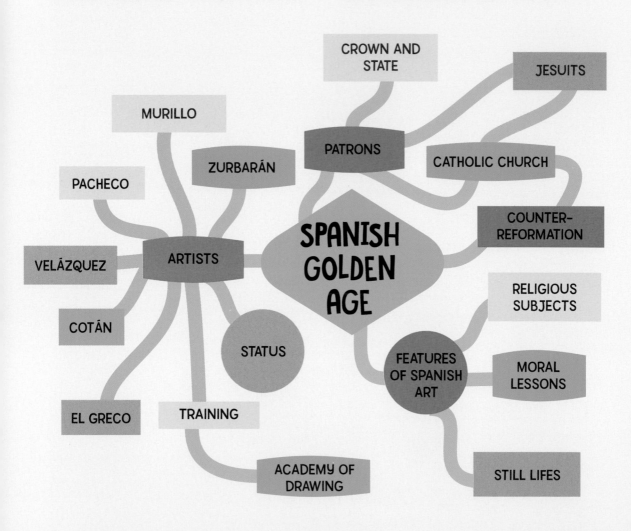

CROWN AND STATE

JESUITS

MURILLO

ZURBARÁN

PATRONS

CATHOLIC CHURCH

PACHECO

COUNTER-REFORMATION

VELÁZQUEZ

ARTISTS

SPANISH GOLDEN AGE

RELIGIOUS SUBJECTS

COTÁN

STATUS

FEATURES OF SPANISH ART

MORAL LESSONS

EL GRECO

TRAINING

ACADEMY OF DRAWING

STILL LIFES

ECONOMICS, COLONIZATION AND THE POLITICS OF FAITH: ART, CHURCH AND STATE IN SPAIN

The dissolution of the Holy Roman Empire in the seventeenth century created important geopolitical changes throughout Western Europe. While parts of the Netherlands, Flanders, Spain and France began to form their own geographical boundaries, the territories of the empire's eastern half remained a collage of warring princedoms, dioceses and kingdoms. Among the states of Italy, Spanish exarchs governed and trod all over the territories of Naples and Sicily, as well as the duchy of Milan – for an extended period at least – and held a *de facto* position over Genoa, Mantua and Tuscany.

In the late sixteenth century, Spain was the pre-eminent power in Europe, with colonies extending from the lowlands of Europe to Mexico and Peru. The Spanish controlled territories in India and large areas of Europe, but defeat by the English in 1558 and the sacking of Cádiz in 1596 reduced lucrative trading routes and began the nation's demise, evidenced by territorial and economic losses. Spanish silver mines in South America no longer yielded the revenue they once had. The Dutch revolt and the creation of its seven provinces saw the economic decline of the Spanish Netherlands, transforming the Dutch Republic into the wealthiest nation in seventeenth-century Europe. Although Spain's economic decline was merely exacerbated after 1600, the Spanish still played a vital role in political matters in northern Europe.

The Spanish establishment was notoriously corrupt and self-interested. Its chief ministers, political agents and diplomats were obsequiously visible in many European courts, sent both to please allies and to buy off enemies, thereby protecting the dominion of His Catholic Majesty. What they could not do, however, was protect his finances. Despite the punitive *alcabala* tax levied by Philip II on food and the sale of manufactured goods, the Crown was in serious financial arrears. In 1596, Philip announced his bankruptcy (for the third time), and on his death in 1598 left a sizeable debt of some 100 million ducats to his heir, Philip III.

The pecuniary weakening of Spain did not, conversely, prevent the Crown or the Church from erecting magnificent palaces and churches, and beautifying them extravagantly after that An assessment of Spanish architecture in the Golden Age – exclusive of more famous Moorish and medieval structures such as the Alhambra in Granada – discloses numerous building projects devoted to the Crown's political, religious and social ambitions. Philip II's Palace of El Escorial (1563–84) demonstrates that the Spanish monarchy acknowledged the power of great architecture to endorse its ideological goals. The economic downturn meant that it was court members who sponsored many of Spain's new structures: buildings that sought to enhance the authority and might of the Spanish Empire. With its mix of Italian motifs and severe classical forms, the hybrid architectural style for El Escorial created by Jan Gómez de Mora (1586–1648) came to illustrate the power and strength of the Spanish Crown, despite the style subsequently appearing in palaces, church buildings and municipal structures.

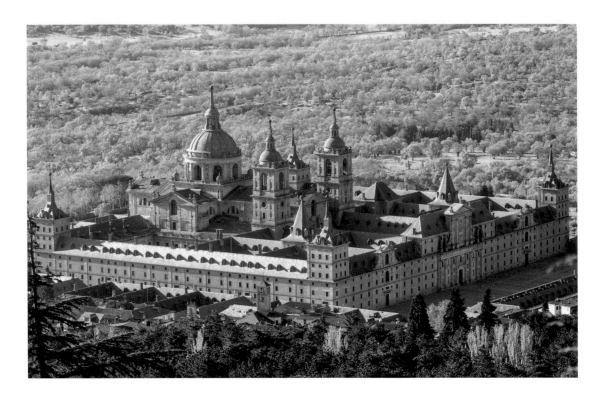

Economic decline in Spain meant that a lack of readily available income among the aristocracy and merchant class resulted in fewer private patrons and artists. By 1650, we find that only around 150 artists were active in Spain, compared to 850 within the Dutch Provinces. Of the three successors who governed Spain after Philip II's death, from 1598 to 1700, all are remembered for extensive collections of art and their patronage, rather than for any judicious forms of government. Indeed, Philip IV is most known for his remarkable passion for art collecting and his support of the painter Diego Velázquez (1599–1660). Between 1633 and 1635 Velázquez, Francisco de Zurbarán (1598–

1664) and other artists were commissioned to depict Spain's military victories for the Hall of Realms in the Palacio del Buen Retiro, Madrid – obviously in support of Hapsburg propaganda. Velázquez's *The Surrender of Breda* (1634–35) celebrates a military achievement whose impact had been entirely reversed by the date of the painting, which depicts an event that is purely fictional – no keys were ever handed over by Justin of Nassau (1559–1631) to the victorious Spanish general Ambrogio de Spinola (1569–1630). This highly poetic work summons up lines from *El Sitio de Breda*, the famous theatrical work by Pedro Calderón (1600–81): 'Justin, I accept them [the Keys] in full awareness

Opposite: *An aerial view of El Escorial, around 45 km (28 miles) north-west of Madrid, displays in its detail and grandeur the ideals of the Spanish monarchy and its great empire.*

Below: *The Surrender of Breda (1634–35) by Diego Velázquez. The artist visited Italy with General Spinola, who had conquered Breda on 5 June 1625. The painting depicts the key of Breda being handed over by the Dutch to their Spanish conquerors.*

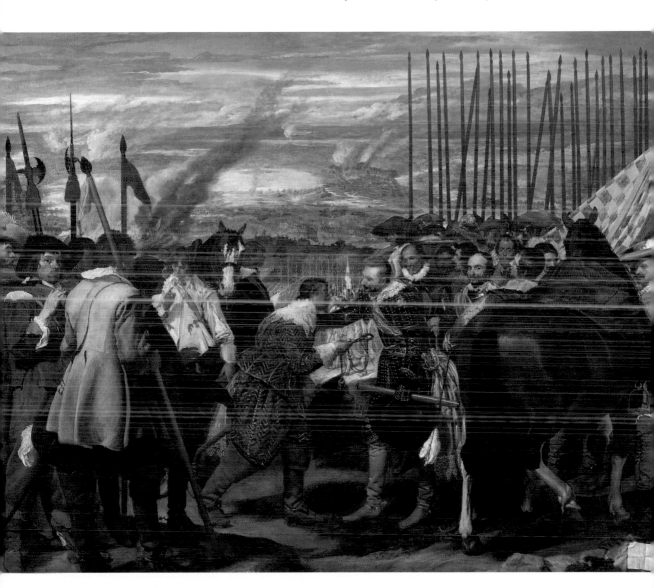

of your valour; for the valour of the defeated confers fame upon the victor.'[1]

As Anne Sutherland Harris has shown, 'Political machinations undertaken to try and reverse political and religious changes in Spain sometimes involved artists, among them Peter Paul Rubens [1577–1640], Anthony van Dyck [1599–1641], Diego Velázquez, Gian Lorenzo Bernini [1558–1680], and Charles Le Brun [1619–90].'[2] As Harris explains, politicking in Rome on behalf of a bellicose Catholic faith bore a rich vein of artistic patronage, with the Catholic Church an important protagonist. It also created a cogency in art found across Europe. As a diplomat to the crown and court painter to the Hapsburg regent of the Netherlands, Rubens created numerous religious paintings, including for Jesuit churches. A cycle of works for a Jesuit church in Antwerp depicts the first saints Ignatius Loyola (1491–1556) and Francis Xavier (1505–52), glorifying their Jesuit Missions with its Eurocentric view of the New World. In the canvas, which is 5.2 m (17 ft) high and depicts *The Miracles of St Francis Xavier* (1617–18), the light of God topples pagan idols while the saint cures the blind,

Opposite: The ceiling in the Jesuit church of St Ignatius in Rome (1685–94) is considered to be Andrea Pozzo's masterpiece, displaying his breathtaking control of perspective.

Below: The Miracles of St Francis Xavier (1617–18) by Rubens. This large altarpiece, created for the Jesuit church of St Charles Borromeo in Antwerp, was commissioned before Xavier attained sainthood in 1622.

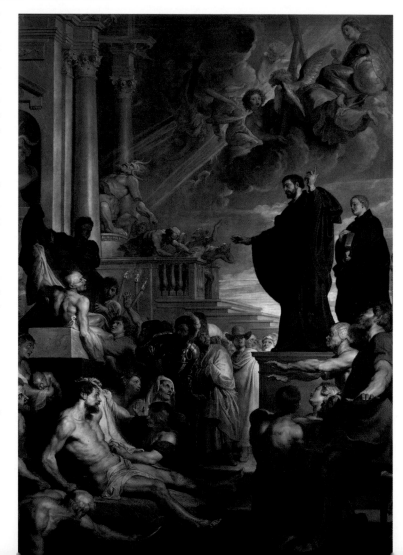

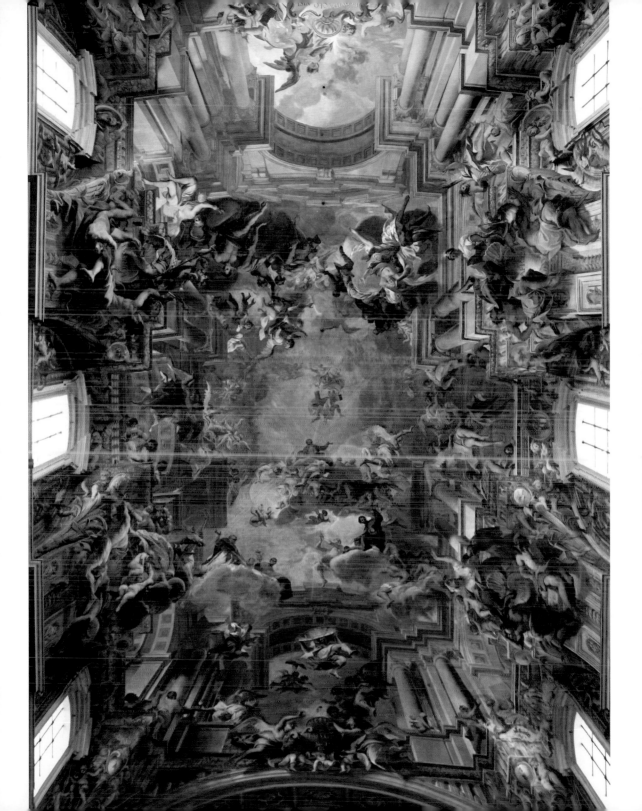

heals the sick and raises the dead. Abandoning the original soberness of the mother church in Rome (1559), the Jesuit patrons spare no effort to astonish the devoted by turning thoughts to the representation of faith in the heavenly sphere. The altarpiece for the same church is decorated with a colossal ceiling fresco by the Jesuit lay brother Fra Andrea Pozzo (1642–1709), depicting *The Glorification of St Ignatius* (1691–94). As one contemporary biographer described, it illustrates the religious vigour of the great saint wishing to bring the Catholic word to the wider world.' In the very centre of the painting, the light of Christ is dispatched to St Ignatius and thereby deflected by St Francis Xavier and other Catholic missionaries to the four continents. Meanwhile the heathen enemies and heretical masses – the Catholic Church was then notoriously intolerant of nonconformist worship – tumble away from heaven. The characterizations of the continents fully illustrate the European viewpoint at the time: all are presented as women, with Asia astride a camel, Africa dark-skinned and riding a crocodile, America bare-breasted, brandishing an arrow and adorned with feather headband,

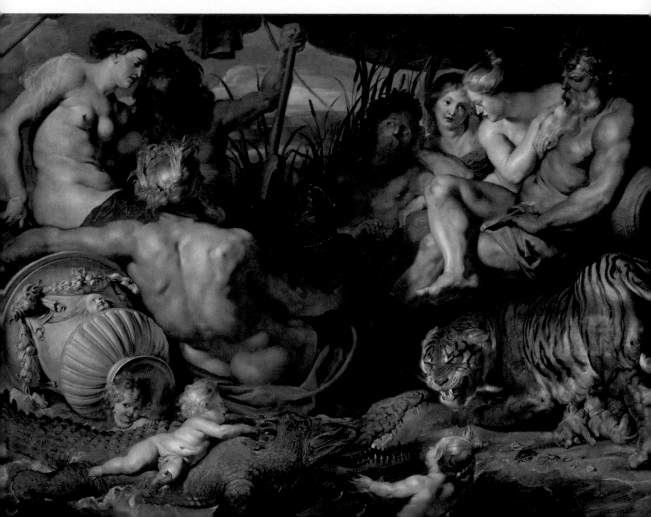

and Europe holding a sceptre and orb, with a regal circlet atop her blonde hair.

The fashion for allegorical depictions of the continents in art was not restricted to painting, but is also found in prints, sculpture, tapestries, furniture, silvers objects and ceramics. Rubens's symbolic interpretation of *The Four Continents* (1615–16), like others in later centuries, is intimately connected with European Christendom and its annexation of the Americas, Africa, India and East Asia. In 1509, the Spanish Jesuit in Peru, José de Acosta (1539/40–1600), separated various non-European cultures and its peoples into a tidy system of racial categorization – from erudite Chinese and Japanese cultures to the supposed 'savages' and 'wild beasts' within rudimentary societies. This process served the specific purposes of instilling in European minds a social evolution, from supposed barbarism to civilization, and was used to justify colonization, Christianization and the commercial exploitation of non-Western lands. The fundamental taxonomic system, adopted by colonial European nations and their overseers, continued hardly abated into the late nineteenth and early twentieth centuries (*see* the following chapters).

Opposite: The Four Continents (1612–15) by Rubens. It shows Europe, Asia, Africa and America depicted as beautiful women with their great rivers, the Danube, the Ganges, the Nile and the Río de la Plata shown as men. The tiger, protecting her cubs from a crocodile, represents Asia.

PAINTING AS DOCTRINE: ART IN THE FACILITY OF THE CATHOLIC FAITH

The economic impoverishment of Spain during the era greatly affected the development of its art. Unlike in Holland and France, there was insufficient wealth for art to flourish, patronage in Spain relying upon the pillars of Church and State. As a result, patronage was based upon a need for religious imagery, with very little requirement for the commissioning of mythological, historical, landscape and genre subjects. Still-life painting enjoyed a relative degree of popularity, particularly in the Spanish-controlled city of Naples, but genre scenes by Bartolomé Esteban Murillo (1617–82) and Velázquez were exceptions to the rule in Spanish painting. As was true for many artists of the period, most work by Murillo was of a stringently religious nature. He painted *The Immaculate Conception of El Escorial* (1660–65), a quintessential subject in Spanish art, many times, with four transcriptions of the theme hanging in the Prado alone. Following the example of Francisco Pacheco (1564–1654) and Velázquez, both made highly comparable renderings *c.* 1616–18 the young Virgin stands on a half moon and is enveloped by a golden mist intimating the ethereal mysteries. As directed by Francisco Pacheco's *Arte de la pintura* (*The Art of Painting*), Murillo's interpretation follows strict doctrinal conformity: the Virgin's hands are clasped in prayer, surrounded by various objects (a lily, a rose, palm branches and an olive branch) that symbolize her purity and faultless characteristics. As inspector of paintings for the Spanish Inquisition in Seville, Pacheco was responsible for making sure that religious works subscribed to Catholic dogma.

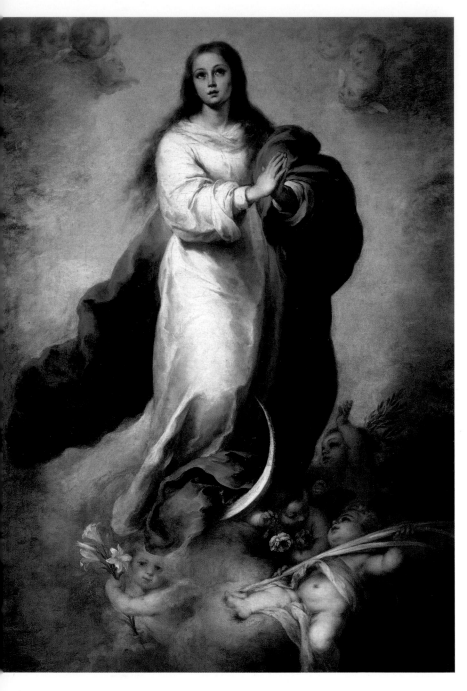

Left: The Immaculate Conception of El Escorial *(1660–65) by Bartolomé Esteban Murillo. The work found its way into the Spanish Royal Collection when it was purchased by King Charles III.*

Opposite: The Disrobing of Christ *(1577–79) by El Greco. El Greco painted it for the High Altar of the sacristy of the Cathedral of Toledo, a commission the artist obtained through his friendship with the son of the Bishop of Toledo.*

EL GRECO: ART AS SPIRITUALITY

Perhaps the most intensely ecclesiastical and important 'Spanish' painter of the late sixteenth and early seventeenth century was Doménikos Theotokópoulos (1541–1614), better known as El Greco ('the Greek'). Born in Heraklion, Crete, he began artistic life as a cultivated practitioner of Byzantine icon painting. In 1563, he achieved the rank of maestro, but abandoned his native home to pursue an artistic career in Venice and, later, Rome. In Rome, between 1570 and 1572, El Greco fell under the spell of the Italian and Venetian masters, including Raphael, Titian, Tintoretto and Michelangelo. *Purification of the Temple* (1567–70) reveals El Greco's attempts to emulate the Venetian style. In 1576/77, at the age of 36, however, El Greco moved to Spain, settling in Toledo.

He secured his first major commission in 1577, for the sacristy of Toledo Cathedral. *The Disrobing of Christ* (1577–79) is a controversial masterpiece, its subject probably chosen in accordance with the function of the sacristy, the room where priests keep and change their vestments. El Greco's composition derives from several episodes in the Gospels of John and Luke, where 'Herod with his men of war set him at nought, and mocked him, and arrayed him in a gorgeous robe, and sent him again to Pilate' (Luke 23:11). Christ gazes heavenwards and offers a questioning gesture by touching his red robe. In the Catholic Church, red is a colour traditionally associated with

blood and martyrdom. In the Gospel of John, however, Christ is scourged, crowned with thorns and delivered in 'a purple robe' to be crucified (John: 19:2). El Greco seems to have chosen a scarlet colour not only to separate the son of God from ordinary individuals in the crowd, but also to emphasize Christ as saviour and martyr – 'the physical and spiritual beauty of Christ as He prepares to sacrifice Himself for the sake of humanity.'[3]

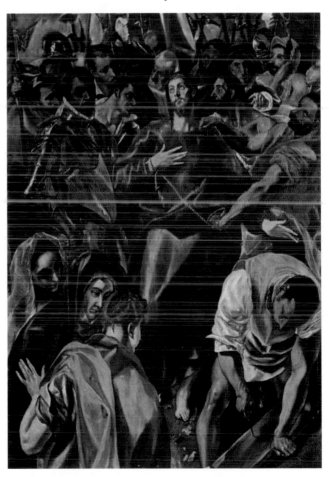

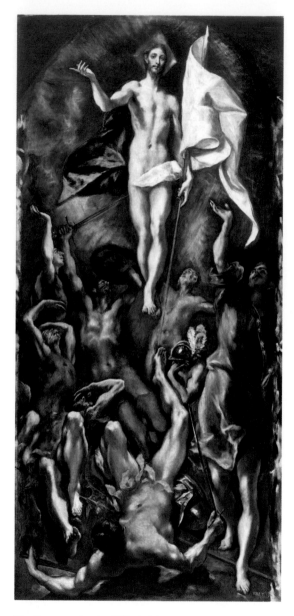

The Resurrection (c. 1597–1604) by El Greco. It was part of the main altarpiece of the church of the Colegio de Doña María of Aragón in Madrid.

In Catholic Spain, the originality of El Greco's composition created great rancour. Two main issues caused this problem: price and propriety, the painter refusing to compromise and thus offending the church canons. In Toledo, the Spanish art market was not especially supportive of unorthodox interpretations of biblical narrative. A charge of impropriety launched by one canon suggested that Christ was not placed uppermost in the picture, while the presence of the three Marys was also seen as irreligious. The Counter-Reformation was no more passionately endorsed than in Catholic Spain, where religious art was closely scrutinized in accordance with the dictates of the Council of Trent. The goal was to abolish images that might be misunderstood as sacrilegious, pagan or unorthodox. El Greco's picture was found to be within the general parameters of Church orthodoxy, however, and thus could not be deemed ungodly.

Painted for El Greco's own parish church of Santo Tomé, *The Burial of the Count of Orgaz* (1586–88) pictures the burial scene of the fourteenth-century noblemen Gonzalo Ruiz de Toledo, Count of Orgaz. The 1586 contract stipulates: 'a procession of priests and clerics and the attendance of St. Augustine and St. Stephen … to bury the body of the knight … and around [which] are many people … and above all of this shall be painted an open heaven of glory.'[4] These instructions – without doctoral indicators – clearly account for the general disposition of El Greco's scene, the work an imaginative rendition regarding the salvation of the soul. Pointing to the burial scene, a young boy signifies that a lesson in faith is being taught, Orgaz's soul delivered

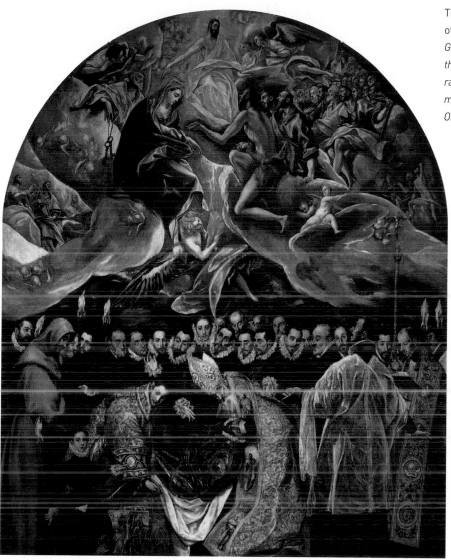

through womb-like clouds for judgement by divine beings in heaven. Here, El Greco imagines the earthly sphere as an incomplete reflection of the heavenly realm. In doing so, he acknowledges the Catholic faith as the sole means to salvation. Art had a divine, otherworldly purpose for El Greco, the last great European painter to articulate such spiritual archetypes. His death brought a grand era of Christian art to an end.

TRAINING, SUBJECTS AND GENRES: ARTISTS' CHANGING STATUS

Lest we forget, El Greco's art was a continuation of the workshop practice of supply and demand, paintings by him and his apprentices delivering on a thriving trade in devotional art. According to Francisco Pacheco (1564–1664), who visited the artist's studio in 1611, examples of major works served as tasters for prospective buyers, who could select from 'the originals of everything that he had painted in oil on the smallest of canvases'.[5] The medieval workshop practice, where young artists paid to be trained under the auspices of the master painter, persisted far longer in Spain than in the rest of Europe. The *Real Academia de Bellas Artes de San Fernando* in Madrid, a fully fledged institution for teaching in the arts, was not established until 1744, unlike its Italian counterpart the *Accademia di San Luca* in Rome, which was set up in the mid-seventeenth century. Pacheco had begun an art academy at his home, where artists and humanist intellectuals could gather for informal discussions on art. However, it did not function like the Italian or Dutch schools, where training organizations subsidized and offered students life-drawing classes and lectures on perspective, composition and painting theory.

Murillo perhaps sought to fill this creative chasm when he founded his own Academy of Drawing in 1660, which held lessons in the evenings. Artists, working in tandem, acted as instructors for a week at a time. Murillo himself initially worked alongside Francisco de Herrera (1622–85), while Juan de Valdés Leal (1622–90) acted as treasurer. The academy lasted a mere 14 years, closing due to insufficient funds in 1674. In Spain, drawing practice seems not to have been part of an apprentice's training, and preparatory sketches and drawings from seventeenth-century Spain are fewer as a result. Drawings by Murillo number less than a hundred, a mere handful are attributable to Velázquez, and there are none at all by Zurbarán. Surviving works by Murillo show him using drawing as a preparatory aid for ideas and as a means to entice clients with full commissions. Murillo's faith in the value of drawing is evidenced by his *Self-portrait* (*c*. 1670–75), showing, on the table beneath him, drawing implements on the left, and a palette, paints and brushes on the right.

As discussed in Chapter 3, Renaissance artists wished to change a general attitude that saw art as aligned with manual labour and craft. A similar problem existed in Spain, with a number of practitioners and literary intellectuals forever trying to resolve parochial attitudes to art. The aforementioned *alcabala* was a tax on all manufactured goods, under which artworks were also categorized. The latter was a pressing issue for artists, not only for fiscal reasons but also because it demeaned art, associating it directly with trade and ordinary crafts. Despite artists regularly employing lawyers to help litigate in defence of painting, among them Bartolomé Carducho (1560–1616) and Eugenio Cajés (1574–1634) in an infamous legal case against the Council of Finance in 1626, the problem persisted throughout the century.

Zurbarán and Velázquez appear to have shared Murillo's goal of attaining an elevated artistic status while cementing art in everyday reality. Still life subjects certainly brought up the artistic rear, but their immense popularity

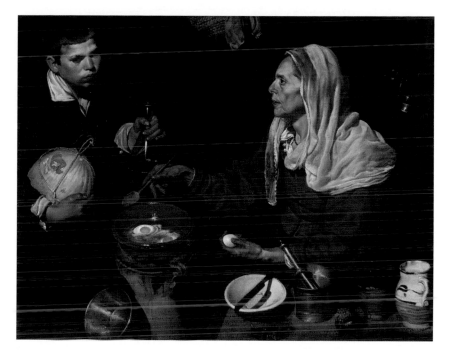

Old Woman Frying Eggs *(1618) by Diego Velázquez. The semi-transparent eggs sizzling in the shiny bowl miraculously set before our very eyes.*

evidences that collectors cared little for critical opinion or for theoretical treatises on art when making a purchase. Velázquez's *Old Woman Frying Eggs* (1618) was painted when he was just 19 in Seville, the artist's early *bodegones* (still life scenes) used to hone the eye as well as promote his skills as a painter. Not only does Velázquez lay stress on the characterization of his figures, he also presents us with a dazzling array of painterly effects specifically designed to challenge our senses. Beyond observations of juxtaposition – old and young, smooth and rough, light and dark, clay, copper, glass, wicker and wood, etc. – there is something deeper to Velázquez's painting. Yet if there is a fable to be found, no historian has thus far recognized it.

The offer of a moral seems to be a quintessential feature of the Spanish still life genre. Take the paintings of Zurbarán and Juan Sánchez Cotán (1560–1627), where the still life subjects hold an erudite religious message. The bizarre and suspended cornucopia of Cotán's *Still Life with Quince* (c. 1602) on the one hand suggests licentiousness and original sin, but on the other pays homage to neo-platonic concepts of theory and proportion, and to traditional Christian ideas of beauty: *Omnia in mensura et numero et pondere disposuisti* (Thou hast ordered all things in measure and number and weight.)[6] By the same token, Zurbarán's *Still Life with Lemons, Oranges and a Rose* (1633) revives the strange and complex nature of Cotán's painting while highlighting Christian rhetoric, its three objects possibly standing for the 'Holy Trinity'; the oranges and lemons with the fruit

of paradise; the water with the sacrament; and the rose with the Virgin Mary.'[7]

Vanitas still lifes drive home moral lessons, particularly Valdés Leal's paintings for the church of the *Hermandad de la Caridad* (Brotherhood of Charity) (1670–72). Created on a grand scale – they are more than 2.2 m (7 ft) high – and designed to accompany Murillo's images of the seven acts of charity, these canvases carry the chastening message that only acts and lives of charity offer the hope of redemption. In one canvas, *In Ictu Oculi*, the spectator is reminded of the fleetingness of life – 'in the twinkling of an eye' (Corinthians 15:52). Death in the form of a skeleton and holding a scythe snuffs out the candle of life and tramples upon the earthly symbols of knowledge, wealth and power. In its companion piece, a bishop's corpse lies in an open coffin, still grasping his staff in his right hand, while a scroll on the ground declares: *Finis Gloriae Mundi* (The End of Worldly Glory), proving that all are finite, even powerful bishops, popes and kings. Visitors to the church would first have encountered Murillo's depictions of

its usual charitable cycle, only to be humbled by Valdés Leal's funereal images where an existence tainted by worldly pursuits and greed leads to the downfall of humankind.[8]

Although Velázquez painted still lifes, religious and occasionally mythological subjects, he was, as a painter to Philip IV, fundamentally employed to create portraits of the King, his family, his court entourage and his various accomplishments. Portraits were at first intended to display a painter's ability to follow the established rules of court portraiture, but once this was achieved, a painter would, within certain guidelines, be given more leniency in terms of artistic interpretation and expression. Velázquez certainly rejuvenated court portraiture with very human depictions of Philip IV and his children, the court and the general aristocratic household. The most famous of these is *Las Meninas* (*The Maids of Honour,* 1656–57), painted four years before Velázquez's death. It was not commissioned for the King, who nonetheless hung it in his office chambers in semi-private display. The fact that *Las Meninas* is an invention of the artist's own making adds an enigmatic air

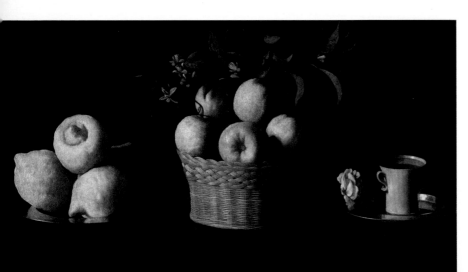

Still Life with Lemons, Oranges and a Rose *(1633) by Francisco de Zurbarán. It is the only still life with a verified signature by the artist and is considered a superlative example of the genre with its masterful composition and brilliant rendering of surfaces and textures.*

to its strategic significance. However, to think of the picture only in such terms would be to ignore the presence of the young Infanta Margarita. Attended by her maids of honour, the picture puts the beautifully attired and pretty blonde Infanta literally and metaphorically at the centre of Velázquez's composition. Margarita's little brother was not born until 1657, and her older half-sister had been made to relinquish her claim to succession, so the Infanta was at the time of the picture's creation Philip IV's sole heir.

As other scholars have argued, Velázquez's future reputation was at stake – among both the aristocracy and other artists such as Rubens and Titian, who had previously been knighted. In *Las Meninas*, the artist depicts himself no longer hiding his wish for nobility: the King and Queen are tactfully reflected in the mirror on the back wall of his studio, the alerted gazes on the faces of the figures implying a visit to confer royal approval on Velázquez and his art. The nobility of painting had become a crucial issue in Golden Age Spain. Like their contemporaries in the rest of Europe, Spanish artists continually strove to alter current opinion about the supposedly ungentlemanly pursuit of painting. Velázquez had previously courted the Pope's support for his knighthood around the time he executed his famous portrait *Innocent X* (1649–50, Galleria Doria-Pamphili, Rome). Although the plan initially met with success, the difficulty in proving his noble heritage by descent proved a sticking point. After the Council of Orders rejected the King's initial requests, two papal dispositions were needed to help elect Velázquez to the military Order of Santiago. It was a victory secured at great cost, his arduous work at court meaning that the exhausted Velázquez died a year later. All was not lost, however, for his masterpiece painting was posthumously decreed a noble work of art. As Jonathan Brown has already shown, 'shortly after Velázquez's death Philip ordered the cross of Santiago to be added to the painter's self-portrait … the gesture … also the king's clever way of acknowledging, and in a profound sense, completing [*Las Meninas*'] meaning.'[9]

Las Meninas *(1656) by Diego Velázquez. It depicts the* Infanta Margarita *with her Maids of Honour.*

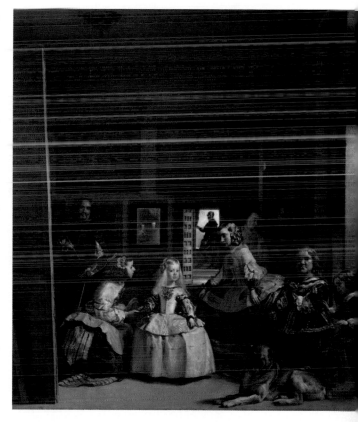

THEORY OF ART: THE FUNDAMENTALS OF MODERN ART THEORY

The Origins of Art Theory – Aesthetics: From Kant to Freud – Erwin Panofsky: Iconography-Iconology –

Psychoanalysis and Art History: Freud's Interpretation of Dreams (1900)

KANT

TASTE

WINCKELMANN

BIRTH OF ART HISTORY

AESTHETICS

BAUMGARTEN

HERDER

ART AS SOCIAL DEVELOPMENT

HEINRICH WÖLFFLIN

ABSOLUTE VS RELATIVE CLARITY

ICONOGRAPHIC INTERPRETATION

THEORIES OF ART

FORM AND STYLE

PANOFSKY

FEMINIST CRITICS

LINEAR VS PAINTERLY

MAN WITH THE HAT

MULTIPLICITY VS UNITY

PSYCHO-ANALYSIS

CLOSED VS OPEN FORM

PLANE VS RECESSION

UNCONSCIOUS

NEUROTIC INSTINCT

FREUD

THE ORIGINS OF ART THEORY

In the Academy, thinking about art involved unanimous concepts concerning the representation of 'ideal beauty'. Making a picture involved the language of forms, invention and order, derived from the ancients. Nothing, it seems, compared so much as to order, says Horace in his *Art of Poetry: 'Singula quaeque locum teneant sortita decenter'* ('Set all things in their own peculiar place. And know that Order is the greatest Grace').

Art theorists such as André Félibien (1619–95) and Roger de Piles (1635–1709) saw art and history as separate entities. Indeed, the history of art did not develop into a notable modern discipline until the nineteenth century, around 1850. Before this, artists, writers and thinkers did not study art from the perspective of the individual artist, country of origin or culture. Vasari was perhaps the first historian of art to see art as part of an organic process of growth and inevitable decline, but he did not appreciate the social or historical circumstances that resulted in the changes he identified in differing artistic eras. Similarly, Winckelmann, who is almost unanimously fêted as the father of art history, viewed classical art as the manifestation of moral concepts. Moral ideas, such as virtuousness or self-determination were, he argued, pertinent to

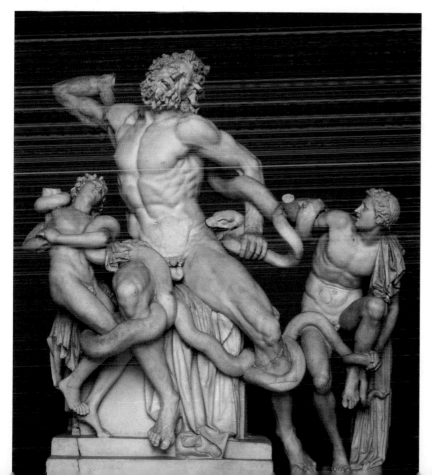

Laocoön and His Sons, *also known as the* Laocoön Group. *Carved in marble and probably a copy of a Hellenistic original c. 200* BCE, *it was excavated from the ancient Roman Baths of Trajan in 1506 and shows the Trojan priest Laocoön and his sons Antiphantes and Thymbraeus being attacked by sea serpents.*

115

AESTHETICS: FROM KANT TO FREUD
Immanuel Kant: *Critique of Judgement*

As discussed in Chapter 4, European philosophers saw sensory knowledge as secondary to rational thought. By the middle of the eighteenth century, a very different notion began to emerge. If there are two distinct and equivalent sorts of knowing – sensual and rational thinking – then there ought to be two theoretical or scientific types of knowledge relating to each – logic and aesthetics. As previously discussed, Winckelmann's definition of art denoted moral values, specifying the distinctive formal manifestations of a culture or epoch. With the introduction of the modern notion of aesthetics, however, this ordered mode of thinking about art began to be challenged. Alexander Gottlieb Baumgarten (1714–62) first used the term in its modern sense in *Aesthetica* (1750).

each and every society and at all times. These theorists perceived the significance of art to be an attempt to accomplish timeless aesthetic principles.

Some of Winckelmann's contemporaries disagreed. In stressing the connection between art and the culture that produced it, the philosopher and theologian Johann Gottfried Herder (1744–1803) demonstrated in his essay on Winckelmann (1777) that art was part of a social development occurring or changing over a period of time. In doing so, Herder established the fundamentals of the discipline we understand today: in other words, tracking the progress, events and changes of artworks over time. Our perspective of art as evolution evolves with this system in place, from which we can establish a history.

> **AESTHETICS** ▶ *the notion that sensory experience has a perfection all of its own, which has no recourse to logic or reason.*

For him and slightly later Enlightenment thinkers, individuals perceive beauty not in any rational sense but in terms of taste, or sensory knowledge.

The thinking of Immanuel Kant (1724–1804) was now affecting the way in which many art historians were appreciating their discipline. In his *Critique of Judgement* (1790), Kant argued for a distinct quality of aesthetic experience, claiming that there was a difference between logical knowledge (concepts) and knowledge gained immediately from sense perception.

Immanuel Kant (1724–1804) was a Prussian philosopher whose doctrine of transcendental idealism suggested that space, time and causation are mere sensibilities.

KANT'S ARGUMENT IN *CRITIQUE OF JUDGEMENT*

We have knowledge of objects in the world only in terms of how they look.

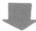

A pure judgement of taste or beauty is achieved without a concept of the object.

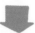

Judgements of taste are universal, as opposed to judgements that were simply decreed by parties: 'gathering votes and asking other people what kind of sensation they are having' can never justify the reality that judgements of taste are unanimous.

What is beautiful is not simply the representation of some inner truth or logical quintessence of nature, but rather is intimately associated with freedom of the mind and imagination.

With respect to ideas of taste and beauty, Kant's *Critique of Judgement* goes against the hierarchical ideas that sensate knowledge is somehow subordinate to rationality and based on idealized forms. Kant effectively invigorated ideas of beauty, expanding the prospect of manifold and simultaneous artistic systems, connected by humanity's capacity to formulate aesthetic judgements.

The implication of Kant's theory that artworks have a distinctive or special aesthetic presence would have radical implications for subsequent aesthetic theory, particularly the idea of *l'art pour l'art* in nineteenth-century writing and art, and **formalism** in later art history (*see* Chapters 1 and 10).

FORM AND STYLE: HEINRICH WÖLFFLIN'S
Principles of Art History

Explanations of form and style were very prominent in the first two-thirds of the twentieth century. Of these, Heinrich Wölfflin's *Principles of Art History* (1915) offered a highly influential and controversial theory regarding the subject of style. The book was straightaway contentious, but by mid-century had become a fundamental statement and approach which generations of art historians have been compelled to address. This comparative approach to art history – one that assesses the work of artists purely from the perspective 'of the cultivation of the eye' – is likely to be the first 'descriptive scheme' encountered by undergraduate students.[1]

Wölfflin argued that works of art have a particular stylistic and historical existence distinct from the forms they imitate. They represented not only expressed individual artistic sensibility or temperament, but four '**expressions**':

Heinrich Wölfflin (1864–1945) developed a comparative approach to art history.

Temperament

School

FOUR EXPRESSIONS

Country

Race

On the basis of these four 'expressions', Wölfflin established one of the 'double roots of style'. The second root, and Wölfflin's most important invention, was to be discovered in 'the most general representational forms', which he typified as 'optical'. Essentially, Wölfflin assumed that there were unchanging principles governing the changing history of Western seeing, and he sought to characterize the difference between the arts of painting, sculpture and architecture of the European sixteenth and seventeenth centuries: art from the High Renaissance and Baroque eras.

As a 'psychologist of style', Wölfflin proposed a method of addressing visual changes and historical evolution in art via a meticulous structural analysis using five pairs of opposing principles – 'the double root of style', as he termed it. They are as follows:

- Linear vs Painterly.
- Plane vs Recession.
- Closed Form vs Open Form.
- Multiplicity vs Unity.
- Absolute Clarity vs Relative Clarity.

Venus of Urbino (c. 1534) by Titian.

Linear vs Painterly

- Typifies the shift from High Renaissance to Baroque painting.
- Describes 'the gradual development of line as a path of vision and guide of the eye' in Titian's *Venus of Urbino* (*see* previous page). By contrast, in Velázquez's so-called *Rokeby Venus*, stress is laid on merging objects so 'the work tends to look limitless'.
 In the former, as Wölfflin explains, 'seeing by volumes and lines isolate objects: for the painterly eye, they merge.'
- In Raphael's sketch for the *Alba Madonna*, the line 'amplifies and clarifies ... the body's volumes', alternatively, the painterly use of light cut[s] loose from the defining forms and spatial relations.'
- Rembrandt's *Adam and Eve* – 'Adam casts a shadow across the belly of Eve and light from her seems to be reflected onto his side; the play of shadows both complicates and establishes the relations between figures.'[2]

Plane vs Recession

- Each period makes use of three-dimensional depth or shallow 'relief'.
- All types of 'classic art' reduce the composition to a sequence of flat surfaces 'presented so they are clearly readable in the plane.'[3]
- Titian's recumbent *Venus* lies on a bed that runs horizontally in front of us, while Velázquez turns his subject away from us so that the eye is drawn into the background and snakes through the space of the painting.
- In Baroque compositions, depth negates the illusion of the picture plane.

Above: Rokeby Venus *(1647–51) by Diego Velázquez.*

Above right: Adam and Eve *(1638) by Rembrandt. The etching shows their temptation by the serpent.*

Opposite: Study for the Alba Madonna *(c.1510) by Raphael. It shows Mary with the infant Jesus and John the Baptist.*

Closed vs Open Form

- Spatial suggestions relate to both the ordering of the picture and how the spectator is positioned in front of the image.
- In Titian's painting, these special indicators are registered by Venus's gaze, which is situated at eye level and meets us head on. Titian's forms are enclosed by the rectangle of depiction – the frame.
- These three-dimensional pointers do not appear in Velázquez's painting, where the figures are positioned diagonally. Velázquez's composition is not fixed but opens itself out to us, encouraging multiple and diverse viewpoints.
- The earlier style represents a deeply enclosed world, whereas the art of the later period is an example of unrestricting painterly expression.

Multiplicity vs Unity

- In 'classic art', it indicates that singular parts maintain a degree of independence with regard to the whole.
- Titian's *Venus of Urbino* seems autonomous and clearly conveyed, based on the juxtaposition of separate forms Titian's Venus, her canine companion and the absorbed minions in the background nonetheless combine to create an amalgamated whole.
- 'In both styles unity is the chief aim', however it is attained in classic art 'by the harmony of free parts, in the other [the Baroque], by the union of parts in a single theme ... the whole with the whole'.[4]
- Baroque art subordinates all other elements to the overall purpose of the painting.

Absolute vs Relative Clarity

- Closely connected to the linear and painterly opposition, but with subtle variations, and is essentially an elaboration of the first three.
- Classic art developed a concept of 'perfect clarity', rendering its subjects with maximum precision, while the Baroque sacrifices clarity for the painterly effect and for the sake of the picture's atmospheric whole.
- Titian's brushstrokes focus on depicting clarity and the richness of elements such as fabrics, objects, textures and skin.
- Velázquez sacrifices these material illusions for the impressions of light, shade, tone and colour. Light and colour no longer seem to serve form, and appear to have a life of their own.

To distinguish between the arts of two distinct periods: the 'High' Renaissance and Baroque art (what Wölfflin terms 'classic' and 'modern' art).

Wölfflin uses a specific language to draw distinctions between these two very different periods in art.

Wölfflin's theory of two roots of style excludes mention of art's surrounding culture, so is it legitimate to criticize his formalist theories that have little to do with context – religious, social, political or otherwise – and perhaps also artistic intention?

Wölfflin states that his objective is only 'to compare type with type'. But does his language or phrasing suggest otherwise?

WÖLFFLIN'S *PRINCIPLES OF ART HISTORY*: THINGS TO CONSIDER

Wölfflin was attempting to find a visual denominator common to all works of art created during a specific period.

Was the first scholarly text to judge the Baroque as an *independent* genre rather than a degenerate example of an earlier 'High' Renaissance style.

Often said to be the most influential text ever written by an art historian.

ERWIN PANOFSKY: ICONOGRAPHY–ICONOLOGY

In a work of art, the 'form' cannot be divorced from 'content': the distribution of colour and lines, light and shade, volumes and planes, however delightful as a visual spectacle, must also be understood as carrying a more-than-visual meaning.[5]

Self-portrait as Saint Catherine of Alexandria (1615–17) by Artemisia Gentileschi. She is seen holding part of the shattered wheel on which the saint had been sentenced to be bound.

ICONOGRAPHY ▶ *the study of images. Entails distinguishing images and ideas in artworks.*

SYMBOL ▶ *indicates a concept, object or body, e.g. a painting of a woman shown leaning on a broken wheel studded with spikes indicates Catherine of Alexandria.*

ALLEGORY ▶ *a narrative or wider story that uses a set of symbols to embody an idea or entity.*

Erwin Panofsky (1892–1968) both engaged with and rejected formalist approaches by historians such as Wölfflin and Alois Riegl (1858–1905), in accordance with a modern iconographic method formulated by scholars working in Europe and America in the early twentieth century. Panofsky articulated his theoretical approach in his essay 'Iconography and Iconology' (1932). It was first developed by the German Aby Warburg (1866–1929) alongside his fellow art historians: Panofsky himself, Fritz Saxl (1890–1948) and the philosopher and historian Ernst Cassirer (1874–1945). Alongside formalism, Iconography and Iconology was the most prominent aesthetic methodology of the era. Called 'critical iconology' by Warburg, it saw art as intrinsically linked to areas of philosophy, religion, literature, science and culture. In a nutshell, iconography and iconology are the means of recovering symbolic or allegorical content concealed in artworks. Often thought to be the total antithesis of formalism, Panofsky nonetheless sought to situate his artistic theories in a solid account of artistic form and to show that an artwork was a symbolic product of its culture.

Erwin Panofsky (1892–1968) was a German-Jewish art historian. His work was significant in the modern academic study of iconography.

Aby Warburg (1866–1929), a German art historian and cultural theorist, founded the Library for Cultural Studies, the Bibliothek Warburg, which became the Warburg Institute.

THREE STAGES OF ICONOGRAPHIC–ICONOLOGICAL INVESTIGATION

1. **Pre-iconographic inquiry** ▶ involves the formal analysis of an artwork, without recourse to any external references.
2. **Iconographic enquiry** ▶ the analysis of its subject matter.
3. **Iconological study** ▶ determines how a particular work might be symbolically expressive of the culture within which it was shaped.

Panofsky's Method: the Man with the Hat

Panofsky approached the arduous task of refining his iconographic-iconological theory by using an ordinary event: what occurs when 'an acquaintance greets me on the street by lifting his hat'. Panofsky immediately dispensed with the notion of formal perception (colours, shapes, lights etc.) to identify some issue or factual evidence. In other words, it is the instant recognition of an object (man) and the realization of an event (lifting of a hat). Treating the event as factual and expressive establishes what Panofsky labels *pre-iconographical description*.

However, the gesture of 'hat-lifting' brings about a second reaction to do with interpreting the expressiveness of this very action, and 'whether his feelings towards me are indifferent, friendly or hostile'. So in deciphering the hat-lifting as a type of salutation, we are now in the domain of iconographical analysis: the 'form of salute ... peculiar to the Western world and ... a residue of Medieval chivalry ... to make clear their peaceful intentions and their confidence in the peaceful intentions of others.' This is to say that we are essentially familiar with the habits, customs and cultural conventions of the society to which we belong. This single cursory gesture, however, leads us beyond a habitual social occurrence to create a larger mental picture that is not reliant on this everyday gesture. By further coordinating in our mind relevant pieces of wide-ranging information regarding 'his personality, nationality, class, intellectual traditions and so forth', we can configure 'a mental portrait' of the man's personality.[6] And this is what Panofsky identifies as iconological interpretation.

Panofsky provides a précis of his systematic method in the chart opposite, but also stresses that his three stages are never solely followed one after the other. Rather, all three levels of analysis are operational simultaneously.

'Bonjour, Monsieur Courbet' *(1854) by Gustave Courbet.*

Objects of Interpretation	Act of Interpretation	Equipment of Interpretation	Corrective Principle of Interpretation
I *Primary* or *natural* subject matter – (A) *factual*, (B) *expressional* – constituting the world of artistic motifs.	*Pre-iconographical description* (and pseudo-formal analysis).	*Practical experience* (familiarity with *objects* and *events*).	History of *style* (insight into the manner in which, under varying historical conditions, *objects* and *events* were expressed by *forms*).
II *Secondary* or *conventional* subject matter – constituting the world of *images, stories* and *allegories.*	*Iconographical analysis.*	*Knowledge of literary sources* (familiarity with specific *themes* and *concepts*).	History of *types* (insight into the manner in which, under varying historical conditions, specific *themes* or *concepts* were expressed by *objects* and *events*).
III Intrinsic *meaning* or *content*, constituting the world of 'symbolical' values.	*Iconographical interpretation.*	*Synthetic intuition* (familiarity with *essential tendencies of the human mind*), conditioned by personal psychology and '*Weltanschauung*'.	History of *cultural symptoms* or 'symbols' in general (insight into the manner in which, under varying historical conditions, *essential tendencies of the human mind* were expressed by specific *themes* and *concepts*).

Imagine finding a small coin or tiny carving buried in the ground. Initially, we identify it as that of a standing female nude. A second level of investigation reveals that the chaste-looking pose with a right hand covering her modesty is our best independent evidence for the image being a generic Graeco-Roman deity or goddess, perhaps even a local variant of Venus or Aphrodite. A third level might reveal a whole range of symbolic and cultural viewpoints regarding divinity, desire, lust and physical sex, including those determining attitudes to women's bodies and their role in ancient Greek and Roman culture and society.

As Anne D'Alleva has pointed out, Panofsky's systematic study of art is not always this straightforward. In reality, the idea of a simple 'pre-iconographic' state of analysis – the concept of an 'innocent eye' – has been seriously debated by art historians.[7] We all come to art with preconceptions that are formed by familiarity, cultural beliefs and historical knowledge. Many of us are brought up to read images and the world around us almost instantaneously, so there is no need for Panofsky's pre-iconographic level of interest. With a less informed viewpoint, however, we may not even be able to engage in the interpretative act at any level. It is important to remember that symbols and allegories are specific to any given culture. For example, Māori Tā moko (referring strictly to the Māori tattoo) is the traditional marking given to the face or body. The motif of an individual moko is exclusive to the holder and bears personal and historical data in respect of genealogy, tribal affiliations (*Iwi*), standing in society and accomplishments. However, moko may mean almost nothing to *Pakea* (non-Māori or Polynesian) cultures. Without knowledge of the Māori Tā moko

Tāmati Wāka Nene *(1890) by Gottfried Lindauer. The subject was an important Maori leader, a Rangatira or chief of the Ngāti Hao people in Hokianga, and an important war leader.*

depicted on the faces in Lindauer or Goldie's portraits, we have no idea of what they actually represent, or what is being conveyed about the particular individual.

Panofksy's ideas made an undeniable impact on the subject of art history, proving instrumental throughout the twentieth century. They were widely applied to a whole host of eras and cultures by prominent art historians such as Ernest Gombrich (1909–2001), Jan Bialostocki (1921–88), Hans Belting (1935–) and Leo Steinberg (1920–2011), the latter's *The Sexuality*

of Christ (1996) a masterly implementation of iconographic–iconological enquiry. Moreover, Panofsky's work is still regarded as indispensable to the field of Renaissance art history, particularly his influential *Early Study of Netherlandish Painting: Its Origins and Character* (1953).[8]

Sigmund Freud (1856–1939) photographed by Max Halberstadt in c.1921, whose ideas were highly influential on the study of art.

PSYCHOANALYSIS AND ART HISTORY: FREUD'S *INTERPRETATION OF DREAMS* (1900)

Art history at times drew its approaches from psychological hypotheses. Wölfflin saw himself as a 'psychologist of style',[9] and Warburg was caught up in 'identifying the psychic context of art production and consumption'.[10] We might consider these methodologies together with the psychoanalytical work of Sigmund Freud (1856–1939). But how are the rudiments of Freudian psychoanalysis relevant to the study of art history?

In his large body of psychoanalytical material, we can boil down Freud's ideas to some basic concepts which have impacted the discipline of art history. Freud developed the clinical practice of psychoanalysis, and his oeuvre is a record of modern psychological thinking. His so-called talking cure had a practicality beyond the consulting couch too: his model of the mind inferred a theory of culture from which art history was not excluded. Freud's essays on 'Leonardo da Vinci and a Memory of His Childhood' (1910) and 'Michelangelo's Moses' (1914) demonstrate an intense interest in the subject of art, applying his clinical pathology to a psycho-biographical reading of the life and work of both artists.

Freud: the Fundamentals

Two basic concepts are essential to all psychoanalytic ideas:

- That our waking or conscious life is not the same as the unconscious mental world. Freud's theories concerning the secret of dreams, psychiatric illness and the concept

of repression are the foundation on which the entire edifice of psychoanalytic theory sits. In essence, psychoanalysis involves the recovery of unconscious thoughts and feelings.

• That sexual impulses and repressed material (including fears, longings, desires, wish fulfilments and traumatic memories) are the crux of human existence – an idea outlined in his famous text *Three Essays on the Theory of Sexuality* (1905).

Freud's most distinctive contribution to psychoanalytical knowledge was that all repressed memories are preserved and that dreams leave permanent traces. When we dream, it comes from the inner psychic realm; it is the result of our own mind, dreams lying beyond our control and evidence of a division between the conscious and subconscious realms.

Regarding the second key principle, this psychical material is not something that we can easily do away with, but is active, and part of an eternal battle between the conscious and unconscious worlds. This is most manifest in everyday disturbances:

• Misspeaking (Freudian slips).
• Mislayings (lost keys).
• Misreadings.
• Everyday mistakes.
• Malfunctions of memory.

For the psychologist, society functions in much the same way as the human psyche – mentally divided and with no real difference between the 'neurotic' and 'normal' states of mind. This goes for civilization, too, which Freud saw as irrational and symptomatic of society's primordial conflicts, created by repressing our disguised impulses, fantasies and wishes in order to fit the social order. Freud further argued, somewhat gloomily, that society must curb its destructive psychical impulses, or 'death drive', yet if we are deprived of the consummation of aggression, we turn in on ourselves.

This neurotic instinct is at the core of culture, and human artistic expression permanently carries the traumas and anxieties of the unconscious mind. In *Totem and Taboo* (1913), Freud likened 'primitive mentality' to the mental life of children and, more crucially, to narcissistic, neurotic and paranoiac states in modern civilization. While in neurotic states, 'a considerable part of this primitive attitude has survived in their condition, only in the single field of our civilisation has the omnipotence of thoughts been retained, and that is in the field of art.'

These suppositions did much to popularize and determine primitivizing stereotypes in relation to the principles of religion and magic among French, German and other avant-garde circles. Modernist groups of artists, such as the Fauvists, Cubists and Surrealists, appropriated tribal artefacts (*art nègre*) in such a way as to establish what can only be described as a 'cult of the primitive' (*see* Chapter 11). For Freud, too, art is a type of sublimation, generated by the clash between impulse and civilization, but carrying out a social purpose or compromise between the two contradictory states. As Freud puts it, when describing Leonardo's 'Memory of His Childhood', 'nature has given the artist the ability to express his most secret impulses,

which are hidden even from himself, by means of the works that he creates.'[11]

Freud, Feminism and his Critics

Unsurprisingly, few of Freud's ideas have remained uncontested. His theories relating to the body, sexuality and early childhood development have very vocal critics within feminism. In *The Female Eunuch* (1970), Germaine Greer stated: 'Freud is the father of psychoanalysis. It had no mother.' Freud's ideas have frequently been criticized for their sexism and homophobia. Many feminists have, however, looked beneath Freud's typically male and fin-de-siècle attitudes to women and supposed sexual transgression to see that his theories have provided a strong platform to contest standardized ideas about sex and sexuality. Moreover, Freud's radical premise that the mind is shaped by the underlying forces of the unconscious psyche is now broadly accepted. There is, nonetheless, a serious problem with respect to Freudian ideas and their potential connection with works of art. As Anne D'Alleva rightly asks: 'do works of art really function [by] expressing unconscious desires?'[12] What about other external influences such as the sitter or patron's wishes for a work of art, not to mention the wider social context? Freud's theory of presupposing a psychological disorder for the art of Michelangelo or Leonardo, for instance, does not allow for the larger historical viewpoint of the time.[13]

Opposite: The Dream *(1910) by Henri Rousseau. Rousseau wrote an accompanying poem, 'Inscription pour La Rêve'.*

Chapter Eight

FROM ROCOCO TO REVOLUTION: EUROPEAN ART IN THE AGE OF ENLIGHTENMENT

The Enlightenment and 'the Age of Reason' – Art in France: From Rococo to Neo-Classicism – Picturing Society: Fêtes

Galantes, Social Critiques and Moral Instruction in the Age of Discovery – Art and the French Revolution

THE ENLIGHTENMENT AND 'THE AGE OF REASON'

The eighteenth century was a complex period of ever-changing coalitions across political, social, economic and artistic frontiers. The final years of the preceding decade in England and France saw the origins of an intellectual and artistic transformation that was to eradicate the basis on which seventeenth-century Baroque culture had lain.

As Francis Haskell (1928–2000) identified, this movement was an age 'of "enlightened" ideas', and in his famous 1784 essay *Was ist Aufklärung?* (*What is Enlightenment?*), Immanuel Kant described Enlightenment as 'man's emergence from self-imposed minority', the minority being 'the … lack of resolution and courage … to use your own understanding!' The Enlightenment is still the subject of critical discussion, more contested now than at any time previously. What it stands for has endured as a topic of debate by writers and thinkers, as much as by art historians.

Triumph of reason over prejudice and superstition

Philosophical ideas of freedom and equality

THE ENLIGHTENMENT

New understanding of humanity's place in the world

Improvement in human circumstances

The term *Enlightenment* (the English translation) was devised in the nineteenth century, and combines the French *lumières* (knowledge) and the German *Aufklärung* (clarification), both terms referencing the concept of light. (The French word *lumière* means 'light' in the singular, but when used in the plural implies 'knowledge'.) The term *light* naturally carries with it many religious and philosophical connotations. Light signified God's presence filling the souls of the faithful, and Christ conveyed the light of the New Testament to the world. In Plato's *Republic*, the light of knowledge was fundamentally associated with truth, as opposed to the obfuscating shadows seen by the philosopher's ill-informed cave dwellers.

By 1751, the link between light, ideas of historical progress and philosophy was captured by Jean-Baptiste d'Alembert (1717–83) and Denis Diderot (1713–84) in *Encyclopédie, ou dictionnaire raisonné des sciences, des arts et des metiers (Encyclopedia, or Systematic Dictionary of the Sciences, Arts and Crafts*, 1713–83). This was the world's first encyclopedia, and many writers and thinkers contributed to its 28 volumes between 1751 and 1772, including one of the United States' founding fathers, Thomas Jefferson (1743–1826). The *Encyclopédie* is particularly famous for its image of the Tree of Knowledge, one of 3,123 illustrations outlining the systematic depiction of human learning and a search for knowledge and understanding in general.

INSPIRATIONS
- René Descartes (1596–1650) – ideas expressed in his *Discourse on Method* (1637).
- John Locke (1632–1704) – advocated a philosophy grounded in empirical observation – knowledge based on common sense, experience and the senses.
- Isaac Newton (1642–1727) – offered a logical account of the physical laws governing the structure and mechanism of the known universe.

THE *ENCYCLOPÉDIE*

CONTRIBUTORS
- Voltaire (1694–1778).
- Montesquieu (1689–1755).
- Turgot (1727–81).

AIMS AND INTERPRETATIONS

- Aimed to loosen the grip of traditionalism, both political and religious, on culture, and to initiate a new scientific attitude to erudition.
- Included the 'genealogy' – a historical interpretation of *les progrès* (the progress) of human knowledge from the sixteenth century onwards.
- All doctrines were viewed equally: entries referring to religion, crafts, arts, sciences and occupations sat side by side with meticulous descriptions written by the experts and leading intellectuals (mainly French) of the day.

ON THE ARTS

- Art was to be a force for good, for change, and to help shape public awareness, standards and educate socially.
- Art was to convey a social, educational and moral message – the artist as a philosopher, transmitting art's values to society in order to contribute to greater human improvement.
- Art was to be practical: the concept of 'functional' art – art forms that could edify – was to inspire much work later in the century.

Understandably, D'Alembert's genealogy of human knowledge and chronological explanation of *les progrès* of human learning hailed English philosophers and scientists such as Locke, Newton, David Hume (1711–76), Thomas Hobbes (1588–1679) and George Berkeley (1685–1753), who had previously expounded a sense-based philosophy and whose French followers included Voltaire, Montesquieu, Condillac (1714–80) and Buffon (1707–88).

One moral and political philosopher who did question the concept of history as the progress of society was Jean-Jacques Rousseau (1712–78). In his *Discours sur l'origine et les fondements de l'inégalité parmi les hommes*, better known as the 'Second Discourse' (1755), Rousseau argued that the disparities between the members of supposed savage and civilized societies lay in the former 'breath[ing] nothing but repose and freedom; living "within himself". The citizen, otherwise, forever active, sweats, scurries, constantly agonizes in search of ever more strenuous occupations … He courts the great whom he hates, and the rich whom he despises. Civilised man is capable of living only in the opinion of others.' Rousseau unequivocally associated modern civilization with immorality, radically promulgating the idea of a highly ambivalent modern age. The problem rested therefore in man and nature, their connection to one another, and to civilization. For it was in civilization that Rousseau identified the source of inequality and every evil.

By marshalling in a rational and scientific attitude to philosophy, culture and art, the Enlightenment became a select weapon of the intellectual middle classes, used to challenge

traditional power structures. Features of what we now recognize as the modern Western realm – commercial manufacturing, scientific discovery, democratic government, new philosophical ideas, the supremacy of reasoning and opinion – confronted the old political and social hierarchy, the *Ancien Régime*. This moment was both the final period in which it was commonly considered that 'kings are by God appointed', and the first in which it could be declared plainly that 'all men are created equal, that they are endowed by their Creator with certain inalienable rights, that among these are Life, Liberty and the Pursuit of Happiness' – according to the American Declaration of Independence (1776).

Jean-Jacques Rousseau, whose writings influenced the course of the Enlightenment throughout Europe.

It is something of a contradiction of the period that enlightened autocrats – including Louis XIV of France (1643–1715), Fredrick the Great of Prussia (1740–86) and Joseph of Austria (1780–90) – also endeavoured to endorse progress, justness, liberality and philanthropy, and in doing so they frequently superseded the benefits of the old organizations of Church and State. In an enlightened century, there was also the need to understand the mechanism of the world and a desire to harness its potential for

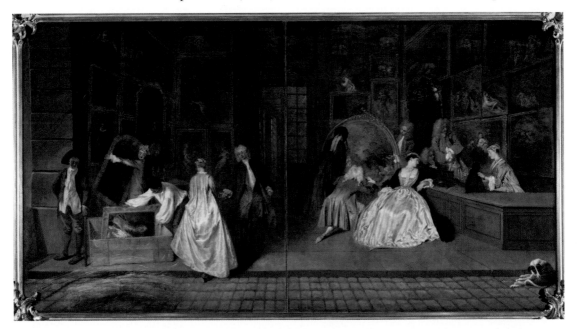

L'Enseigne de Gersaint (The Shop-Sign of Gersaint – 1720-21) b Jean-Antoine Watteau. Gersaint was an art dealer.

Known as the Bureau du Roi, this was Louis XV's writing desk. Richly ornate, it is decorated with the scroll work typical of the Rococo period.

the benefit of humankind, resulting in a great age discovery.

The Shop Sign of Gersaint (1720) by Jean-Antoine Watteau (1684–1721) is usually interpreted as a reference to the radical change in French taste, referencing the preceding government of Louis XIV (1643–1715) and the current, more dissolute Régent Philippe II, Duke of Orléans (1715–23). The now unfashionable portrait of the Sun King by Pierre Mignard (1612–95) is being packed away, probably a symbolic gesture referencing the demise of past rulers. The crowd of buyers reflects a growing bourgeois culture: middle-class patrons who would play a determining role regarding 'taste' and fashion in art. The beautifully dressed young lady on the threshold of the gallery and glancing at the king's image being packed away has one foot in the old and another in the new world. The

design and subject matter depicted on the walls of Gersaint's gallery – with art connoisseurs appraising a fashionably amorous, **Rococo**-themed painting on the right while austere portraits and religious subjects hang in the dark area on the left – anticipates the 'modern moralities' of the English artist and satirist William Hogarth, its tale perhaps ironically portraying the capricious and self-indulgent nature of a new social class.

It should also be remembered that in Catholic Europe, religious art accounted for much of the work by French, German, Italian and Spanish artists. There was no decline in the creation of churches, monasteries and other religious establishments, or of the works meant to furnish their walls. Enlightenment philosophers who cast doubt on Christian belief were a tiny component, and few renounced religion outright. Even so, Jean Restout's impassioned depiction of a religious encounter in *The Death of Scholastica* (1730) has a propensity 'to become a drama of sensibility, that most eighteenth-century of emotional states'.[1] The intelligence of Enlightenment thinking, albeit often quixotic, was such that the entire period has on occasion been labelled 'the Age of Reason'. Enlightenment thinkers collectively believed in the power of the mind

to resolve every difficulty – whether political, social, philosophical, religious or artistic – by studying it from a purely rational perspective.

ART IN FRANCE: FROM ROCOCO TO NEO-CLASSICISM

The word 'Rococo' was coined at the end of the century to identify the governing artistic taste. It probably stems from *rocaille*, a French expression denoting the sort of decoration used in ornamental gardens to mimic rocky outcrops, grottes, secreted gorges, pavilions and fountains, all generally caked with shells and pebbles.

This highly ornate style reached its height during the middle years of the reign of Louis XV (1717–70). As an expression of modern taste, the Rococo style was principally applied to interior decoration, furniture and tapestries. Here, the wavy, asymmetrical lines recollect the *rocaille* forms that evoke the curves of seashells. The term also indicates the aristocratic love of frivolity, sensuality and courtly amusements. In the revolutionary period, Rococo came to mean a shallow confection, one that fulfilled the distasteful fancies of a self-indulgent ruling class.

The Rococo spirit might appear anathema to the enlightened mind, but its art animated the early and central years of the eighteenth century. Although it had no coherent principle, Rococo had a certain aesthetic logic to it. Its art sought freedom from scholastic constraints in favour of spontaneity and novelty, disregarding the traditional rules and conventions in Classical

Opposite: Et in Arcadia Ego *(1637–38) by Nicolas Poussin. The artist painted two versions of this subject, drawing heavily on classical form for the shepherds.*

Left: Pierrot *(c. 1718–19) by Jean-Antoine Watteau. The work was formerly entitled* Gilles, *but is now considered to be a representation of the Commedia dell'arte character.*

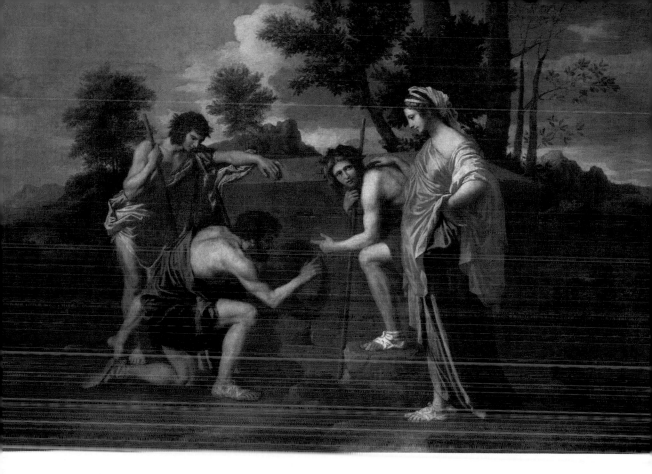

composition and ancient Greek architecture. Ironically, the Rococo style originated in France, where Classical authority, logic and clarity had been the driving force in artistic circles during the sixteenth century, particularly in the work of the neo-classical painter Nicolas Poussin (1594–1665) and architect Louis le Vau (1612–70). In 1699, however, Louis XIV had requested works of art that were far more playful and energetic than those previously authorized for the Palace of Versailles. Calls for an intrinsically carefree aesthetic were widespread during the era. In his poem 'An Essay on Criticism' (1711), the poet, satirist and amateur landscape gardener Alexander Pope (1668–1744) advocated that not all great artistic work can be explained by rules. There was philosophical support for such ideas, as seen in John Locke's instrumental treatise *An Essay Concerning Human Understanding* (1690), its empiricist logic denoting that all ideas emanate from experience and are not inherent. Such thinking would soon impact artistic sentiments: the eminent French theorist Jean-Baptiste Dubos (1670–1742) declared in 1719 that painting touches us profoundly since it works through the senses, and 'acts upon us directly through the organ of sight; and … the pleasure we derive from art is physical pleasure'.[2]

PICTURING SOCIETY: *FÊTES GALANTES*, SOCIAL CRITIQUES AND MORAL INSTRUCTION IN THE AGE OF DISCOVERY

Watteau is perhaps the greatest of eighteenth-century artists and embodies the Rococo spirit. He depicted a comprehensive set of genres, but was renowned for specializing in **fêtes galantes**, amorous themes and fanciful representations of French life, in which a fashionably attired society entertain themselves with music, dancing, conversation and courtship, all in luxuriant nature. This new genre – seen in *The Dance* (*Les fêtes vénitiennes*, *c.* 1717–18), *The Scale of Love* (*c.* 1715–18), *Pilgrimage to the Isle of Cythera* (1717) and *Pierrot* (*c.* 1718–19) – has its basis in popular theatre, of which Watteau was a keen connoisseur. His works reject the austerity of classicism and academic rigour in favour of playfulness, refinement and style, all clear Rococo mannerisms. Unsurprisingly, in 1717, Watteau was admitted to the Royal Academy of Arts, his *Pilgrimage to the Isle of Cythera* accepted as a new genre of painting. *The Scale of Love* is part of a series of small paintings on the theme of music. It is all about intimacy, closeness and dovetailed relationships, so much so that the perspective suggests the enamoured pair falling into one another, where 'the themes of music and love are so intertwined as to become inseparable.'[3] Traditionally, love and music go together, music being a metaphor for love-making and its transient physical pleasures. 'Music-making, as well as drinking and gaming, accompany love-making among the pursuits of the Children of Venus.'[4]

Even though Watteau's *fêtes galantes*, and those by contemporaries including Jean-Baptiste Pater (1695–1736), Nicolas Lancret (1690–1743), Jean-Honoré Fragonard (1732–1806) and François Boucher (1703–70), barely disguise the fantasies and liberal tastes of aristocratic art-buying connoisseurs, they do hint at both a deep sadness and a sense of the fleeting. It may be queried whether pictures such as these are what they seem to be: a mere festivity of the pleasures of the refined classes. Art historians have debated whether Watteau's *Pilgrimage to the Isle of Cythera* represents a visit to or away from the mythical land of love (Cythera) – note that the flying putti's burning torch literally points to a place of origin or destination – and the painting probably symbolizes the unavoidable demise of 'myth, of the great historical ideals, even of tragedy'.[5] The painting may similarly intimate the decaying of the *Ancien Régime*, coinciding with the awareness that Philip V of Spain, unreconciled to the Peace of Utrecht (1713–15), had failed to recapture the territory of the 'Two Sicilies' in Italy, effectively bringing an end to Spanish succession. A relative period of stability followed in the eighteenth century, but this also marked the end of dominance by the old French monarchy, and indicated the seafaring, mercantile and economic ascendancy of the British Empire.[6]

In *The Scale of Love* and *Pierrot*, a feeling of strain runs through Watteau's paintings. Here, fantasy and reality collide, and the work is permeated with a definite sense of irony. The charmed, idle and superficial aspects of an aristocratic life of leisure in the *fêtes galantes* evoke longing and a sense of a world soon to be destroyed by the French Revolution. That the artist's work struck a resounding chord

during the early eighteenth century is indicated by Watteau's many descendants, not only his followers and imitators in painting, but also representations made in porcelain, textiles, enamel and even decorative snuff boxes. The painter's impact is far more ubiquitous in print, however, with engravings after his work reproduced throughout Europe and enthusing artists as distinct as François Boucher, Thomas Gainsborough (1727–88) and Francisco de Goya (1746–1828).

Opposite: Pilgrimage to the Isle of Cythera (1717) by Jean-Antoine Watteau. Watteau painted another version the following year.

Above: Hercules and Omphale (1735) by François Boucher. The son of a painter, Boucher was inspired by Rubens and Watteau.

The innovativeness of British art can likewise be associated with unparalleled growth in commerce, industry and political power in the eighteenth century. New wealth created a burgeoning audience for art. It is no accident that a Golden Age of British painting should have happened in the Hanoverian era. Subsequent to the Glorious Revolution of 1688–1769, which essentially established a constitutional parliament over the British monarchy, the country entered a long period of economic and political expansion. Although royal authority was not destabilized, the old aristocratic values and tastes were openly challenged in British society, which had greater journalistic freedom than many other European monarchies.

Much less conservative in their tastes, this new art-buying public relished contemporary themes in pictures. As William Vaughan has rightly argued, the century fostered a whole host of dazzling artistic accomplishments: 'Never before or since has British painting played such a critical role in European culture.'[7] The English artist William Hogarth (1697–1764) established an entirely new kind of genre, the modern moral narrative: pictures that give an account of contemporary life, but which also have a moralizing intent to expose the idiosyncrasies and evils of British society and its political life. Hogarth is perhaps best known for his 'progresses': *A Harlot's Progress* (1732), *A Rake's Progress* (1735) and *Marriage à la Mode* (1743). All have a connection with literature and theatre, specifically the British literary giants of William Shakespeare (1564–1616), John Milton (1608–74) and Jonathan Swift (1667–1745), as indicated by the books on the table in *The Painter and his Pug* (1745).

Hogarth's characters are presented in such a way as to portray their inevitable social, financial and moral demise. His greatest gift was his ability to express such human weakness, indifference, ethical bankruptcy and narcissism – human and societal

Opposite: The Tête-à-Tête (1743) *by William Hogarth. The marriage depicted in the Marriage à la Mode series now shows signs of breaking down in this image.*

Left: The Marriage Settlement *(1743) by William Hogarth. This was the first work in the* Marriage à la Mode *series of six works.*

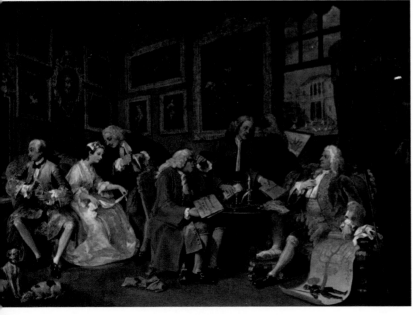

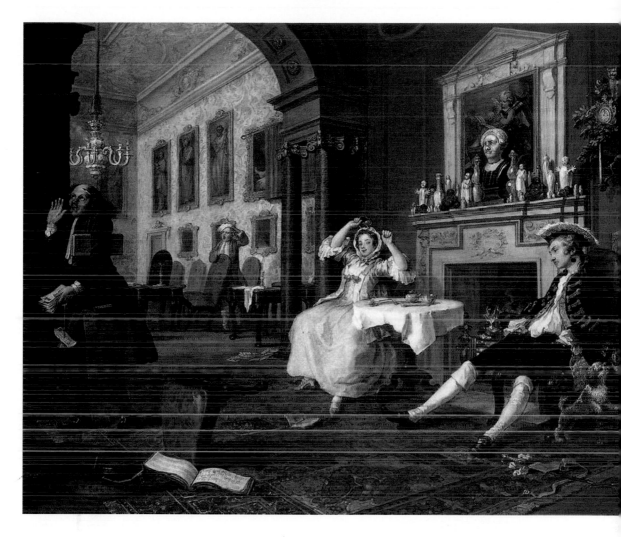

failings captured with a vicious causticity. In *Marriage à la Mode*, Hogarth counters the Enlightenment idea of history as progress by Jean-Jacques Rousseau, 'discrediting popular misconceptions about happy lives conferred by wealth and power, revealing how even the most privileged were wretched victims of a corrupt and inequitable society'.[8] In Hogarth's scene The *Tête-à-Tête*, the Italianate pictures, Chinese

porcelain and ludicrous clock adorned with lush, leafy trees and garlanded with an 'exotic' Buddha and other out-of-place objects denote a middle-class taste for Rococo ornamentation in the fashionable home of the young viscount and the merchant's daughter. In this context, such superficialities intimate pretension and fecklessness, even marks of aberration and cruelty with respect to art and life.

The symbols of ownership, decorum and respect for property, as parodied in *Marriage à la Mode*, were never more highly appreciated as an archetype for social standing than after the establishment of the constitutional monarchy which, under George I (1714–27), gave political power to landed gentry. This idea is most forcefully expressed in Gainsborough's quintessential English landscape *Mr and Mrs Andrews* (*c.* 1749), a new kind of 'conversation' portraiture for the countryside oligarchy of his indigenous Suffolk.

In France, theorists such as Denis Diderot otherwise sought out social reform in art. As the co-editor of the illustrious *Encyclopédie*, he is frequently acknowledged as the first art critic, and regularly appraised the Parisian Salons held by the Académie Royale at the Louvre in the 1760s. His exhibition reviews revealed mores that were worldly but also demanding,

Below: Mr and Mrs Andrews (c. 1749) by Thomas Gainsborough. The artist evokes a rural idyll in this work that shows off the Andrews' wealth as prominent landowners.

Opposite: An Experiment on a Bird in the Air Pump (1768) by Joseph Wright 'of Derby'. Wright painted a series of works showing his figures illuminated by candlelight.

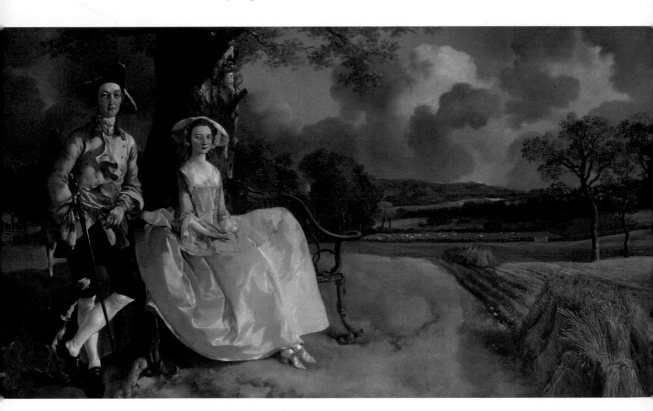

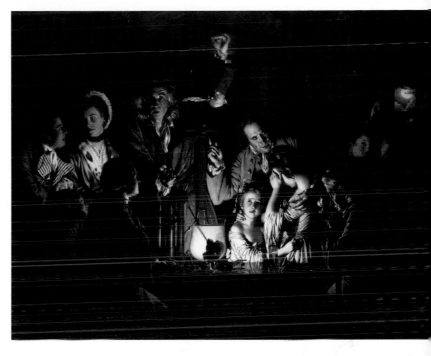

his aesthetic ideas leading him to place prominence on the educational and morally uplifting in art. Diderot, sounding more like a Capuchin monk than the searching art critic that he was, wished for a time 'when painting and sculpture, having become more decent and moral, will compete with the other arts in inspiring virtue and purifying manners.' While paintings by Boucher were written off as superficial and filled with 'garlanded putti [and] rosy and dimpled behinds', Greuze's otherwise 'moral paintings' were 'masterpieces of composition the interest simple and striking, yet appeal[ing] to all.' For Jean-Baptiste-Siméon Chardin (1699–1779), Diderot reserved his highest praise: 'Here is a real painter; here is a true colorist. The magic is beyond comprehension … it is as if vapor had been breathed on the canvas.'[9]

Greuze, Chardin and the English painter Joseph Wright 'of Derby' (1734–97) undoubtedly reflected Enlightenment thinking about knowledge and instruction. Chardin's *The Governess* (1739) and *Boy Blowing Soap Bubbles* (1734) are filled with similar overtones, reflecting a tradition not unlike the morally instructive household genre in Dutch seventeenth-century painting (*see* Chapter 5). While the boy blowing a bubble with a straw intimates life's intransient nature, it simultaneously teaches the necessity of the empirical and down-to-earth learning needed for a happy and fulfilling life, as advocated by the great Enlightenment thinkers. In the words of Diderot: 'Every work of sculpture or painting must be the expression of a great principle, a lesson for the spectator – otherwise it remains mute.'[10] In Joseph Wright's *An Experiment on a Bird in the Air Pump* (1786), art becomes a tutorial in experience, observation and life – 'objective scientific knowledge verses human emotion' – and the painting depicts 'the moment of discovery and knowledge for the onlookers, and life and death for a cockatoo'. Wright's *Experiment* emphasizes an instant of high drama with an indeterminate finale: the thrill and apprehension of the new age of discovery.

ART AND THE FRENCH REVOLUTION

The decade of the 1790s was a traumatic period within France and Europe. The sheer might of the Revolution, coupled with France's shift from a state of absolute monarchy to one controlled by the people, was a radical political change. The Revolution swept up everyone, even artists, who sought to capture the principles of an uprising that had begun with the people of Paris storming the Bastille in 1789. Hubert Robert depicted the exact moment, its battlements and stones cast into the moat below as Paris's citizens hurrying to witness the destruction. Covered in smoke and highlighted by flames, a symbol of the *Ancien Régime* falls.

The painter Jean-Jacques Louis David (1748–82) was a shrewd operative who rode the revolutionary tide. Initially, he hid his

Below: The Bastille *(1789) by Hubert Robert. Arrested in 1793, Robert survived to take a place on the committee that was put in charge of organizing the new museum in the Palais du Louvre.*

Opposite: Oath of the Horatii *(1784) by Jacques-Louis David. The three Roman Horatii brothers are shown saluting their father before they go to fight a family from Alba Longa.*

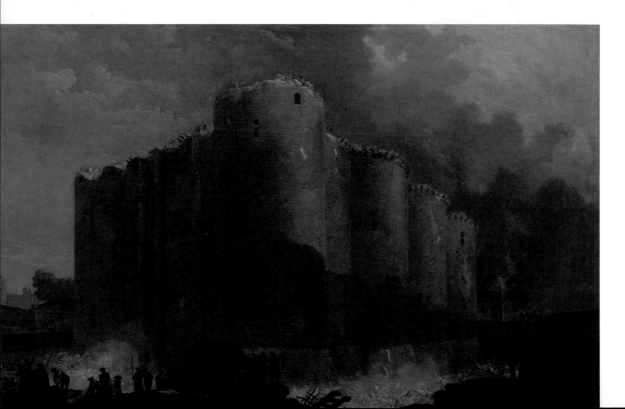

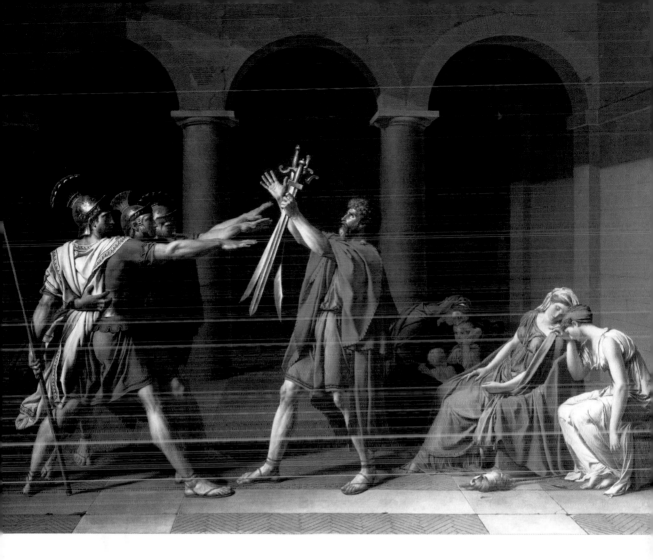

contempt for patrician authority and support for Republicanism, securing Royal commissions and mingling moral paintings à la Greuze with the rational values of neo-classicism and based on supposed ancient Roman virtues, most famously in his painting *Oath of the Horatii* (1784). Finally throwing in his hand with the extremists of the Jacobin Twelve, David was duly elected to the Convention in 1792, where he voted alongside others for the execution of the king. Elected to the controlling committee of General Security, David was largely responsible for overseeing the Terror, but was himself incarcerated when more restrained forces began to triumph in 1794.

David is best known for his painting of *The Death of Marat* (1793), which honours his comrade and journalist Jean-Paul Marat (1743–1793), the 'friend of the people', who sought 'death within 24 hours' for Louis and

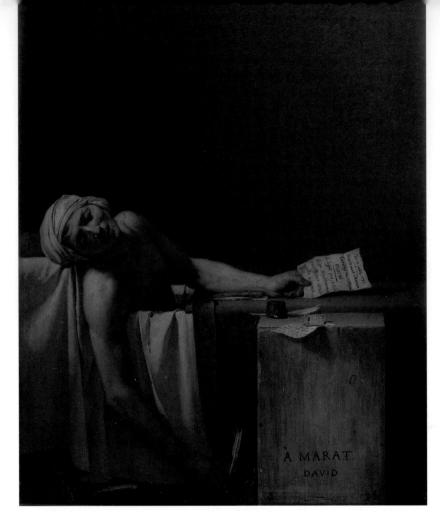

A MARAT.
DAVID

was himself murdered in his bath by Charlotte Corday (1768–93) on 13 July 1793. It is perhaps his most profoundly stirring painting, and the greatest political picture in the history art. The work depicts an unembellished image of the definiteness of death in which the infinite, empty void of the background is interrupted only by the downward trajectory of Marat's fallen arm, a direct reference to the dead Christ in Caravaggio's *The Entombment of Christ* (1603–04). It's a painting that David had sketched repeatedly as part of a protracted study he conducted in Italy of the seicento painters. All unnecessary detail is excluded in recreating the death of this revolutionary icon, the painting a Pietà not unlike Michelangelo's sculpture in which Mary grieves and holds Christ's lifeless body in her arms (1499, Vatican, Rome). David's painting was meant to commemorate Marat to his fellow men: the picture an expression of the political ideals of the Jacobin Twelve. It is a fittingly austere monument to the writer and painter who had praised, and was swept up in, the tyranny of Revolution that ended a turbulent century.

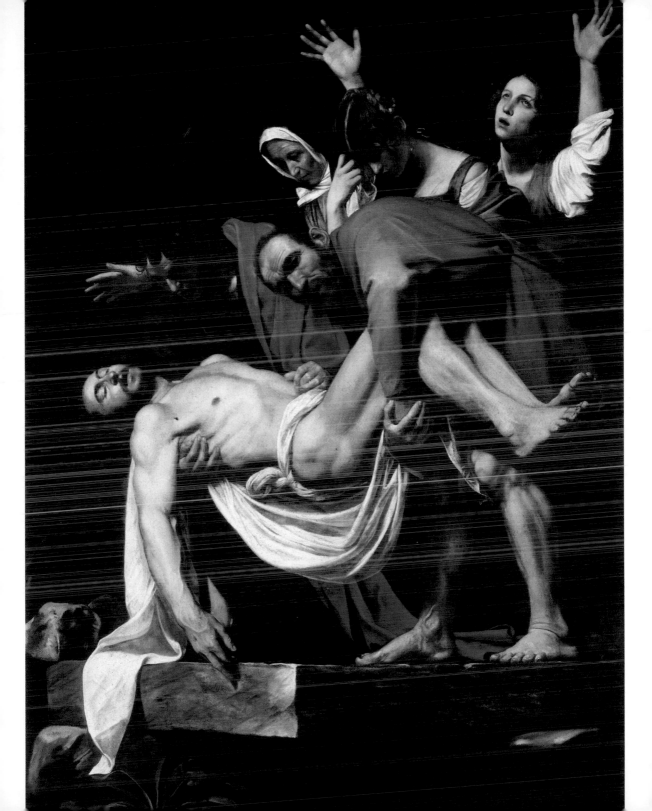

NINETEENTH–CENTURY ART: ROMANTICISM, 1765–1840

Part I: What is Romanticism? – Romanticism: Causes and Characteristics – Nature, 'The Sublime' and Arcadian Visions: Poetry, Philosophy and Science in Art – Part II: Progressive 'History' Paintings, the 'Imaginary Orient' and The Status Quo Crumbles

'THE SUBLIME'

INDUSTRIAL REVOLUTION

SLAVERY

LIBERTY LEADING THE PEOPLE

BLAKE

FRENCH REVOLUTION

DELACROIX

ROMANTICISM

SENSIBILITY

'HISTORY' PAINTINGS

THE RAFT OF THE MEDUSA

FRIEDRICH

NATURE

GÉRICAULT

ORIENTALISM

CONSTABLE

GOYA

SAID

LOS CAPRICHOS

TURNER

INGRES

HAMDI-BEY

PART I: WHAT IS ROMANTICISM?

'Romantic is that which presents us with sentimental material in a fantastic form determined by fantasy.'[1]

Whether **Romanticism** can be quantified as a specific movement is debatable. There was no individual Romantic mindset. Nor can the sheer diversity of Romantic concepts be condensed into a clear-cut formula. We do, however, find a universal agreement with respect to 'their ideas, beliefs, traits, commitments, tastes – and which traits their works share.'[2] In medieval times, the word *Romance* was used to differentiate songs in the French language from those composed in Latin, and vestiges of this sense endured. The re-evaluation of feudal art and literature in the eighteenth century led to a complete reappraisal of the arts, which for the Romantics meant an art that was not governed by rules, but rather was attuned to the sensibility of the individual.

Artists of the earlier century sought a universal mode of expression based on Classical ideals and truth. Romanticism was principally a movement of the arts, celebrating creative genius and unique individuality, involving an idiosyncratic set of beliefs, values and concepts, whose legacy includes great achievements in poetry, literature, music, theatre, ballet, architecture and fine art. Art historians tend to limit Romanticism to a short period from the late eighteenth to the mid-nineteenth century, when the movement seems to give way to other stylistic idioms such as Realism and Impressionism.

Even these later artistic idioms, such as **Impressionism**, **Symbolism**, German Expressionism and **Surrealism**, appear to have Romantic ancestries. Among the arts of Romanticism, we find only certain commonalities, however, one of the most important being emotion. Constable, Friedrich and the poet Charles Baudelaire (1821–67) all spoke of 'feeling' in art. Constable saw painting as simply an alternative term for feeling; Delacroix believed that an artist's guide was their own feelings; Baudelaire declared that: 'Romanticism is precisely situated neither in

ROMANTICISM – PAINTING STYLES

The term 'Romanticism' can encompass painters as diverse as William Blake (1757–1827), Mme Benoist (née Marie-Guillemine de Laville-Leroux, 1768–1826), John Constable (1776–1837), Francisco Goya (1746–1828), J.M.W. Turner (1775–1851), George Stubbs (1724–1806), Caspar David Friedrich (1774–1840), Philipp Otto Runge (1777–1810), Eugène Delacroix (1798–1863) and Théodore Géricault (1791–1824).

choice of subject nor in exact truth, but in a way of feeling.'[3] Such are the complexities, contradictions and variations in Romanticism that they escape any precise definition, individual style or single attitude to art. Regardless, as Michael Ferber explained, 'all this slippage of labels need not concern us much if we keep two referents of the term: a period of time, on the one hand, and a set of distinctive beliefs, sentiments, norms, and themes, on the other.'[4]

ROMANTICISM: CAUSES AND CHARACTERISTICS

Social, political and economic upheaval transformed Euro-pean society in the late eighteenth century. Resulting governments had to strike a delicate balance between shielding society from the fanaticism of Republicanism and returning to the nepotism and constraints of the *Ancien Régime*. The sway over art exerted by academies, the Church and the monarchy diminished, the principal cause being the new bourgeois affluence. A desire for human equality and empirical ideas meant that individual feelings and ideas had an intrinsic worth. But this helps only in part to explain the aesthetic pull of Romanticism. The traditional idea of Romanticism as simply a response to Enlightenment cogency is oversimplified. Recent scholarship argues that the Romantic Movement in literature and art was very much part of a greater idiom of 'Sensibility'. William Blake's illustrated poems *Songs of Innocence* (1789) are similarly designed to incite pity, empathy, sorrow and revulsion.[5] In 'The Chimney Sweeper', tears flow at will, but nonetheless express the real suffering and pain of the modern industrial world:

When my mother died I was very young,
And my father sold me while yet my tongue
Could scarcely cry 'weep! weep! weep!
* weep!'*
So your chimneys I sweep, and in soot I
* sleep.*

The French Revolution was caused by factors that spread beyond France. Everywhere saw the struggle between the traditional forces of stability (Church, aristocracy and landed oligarchy) and those voicing change (the middle or bourgeois classes mainly) and demanding involvement in government. While the European populace rose at a startling rate, agricultural production worked hard to keep pace. Industrialization managed to create a new social group entirely, the working class, whose move from the countryside to the cities (often unwillingly) shattered traditional social stability.

The Industrial Revolution began in earnest in England in 1780. Expansion created a new wealthy class augmented by industry and pacified by parliamentary amendment, but the price in human terms was to heap upon the working class truly appalling privations. 'From this foul drain the greatest stream of human industry flows out to fertilize the whole world,' wrote the French political expert Alexis de Tocqueville of the city of Manchester in 1835.[6] Little wonder that the industrial environment in Manchester inspired Karl Marx (1818–83), with the aid of the sociologist Friedrich Engels (1820–83), to write his *Communist Manifesto* (1848) and demand 'the forcible overthrow of all existing social conditions'.

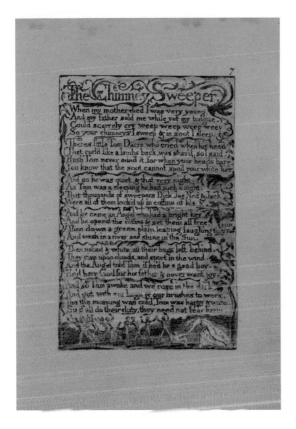

'The Chimney Sweeper', Songs of Innocence (1789) by William Blake. The author and artist drew on the concepts of John Milton's Paradise Lost (1667).

Just two decades into the Industrial Revolution, Philippe de Loutherbourg painted *Coalbrookdale by Night* (1801). It's an image that clearly highlights the effects of modern industrialization on nature and the wider landscape. Attempts to tackle the problems of growth and mass production led to the creation of utopian 'village settlements' and public parks, such as Regent's Park in London and New York's Central Park, to help purify the air and ameliorate modern industry's ill effects. An awareness of nature's healing properties and its spiritually recuperative powers played a central part in manufacturing the Romantic attitude in art.

The new art-buying classes also sought idealized subjects: recreations of a distant and nostalgic past, faraway lands, island paradises, countryside idylls and the awe-inspiring wonders of nature, all touched by 'the Sublime and the beautiful', and the very stuff of nineteenth-century Romanticism.

NATURE, 'THE SUBLIME' AND ARCADIAN VISIONS: POETRY, PHILOSOPHY AND SCIENCE IN ART

The concept of the sublime gained traction in the eighteenth century with respect to the poems of Wordsworth, Shelley, Coleridge, Schlegel, Nerval and others. In philosophy too, Kant in his *Critique of Judgment* (1790) talked of the sublime (*erhaben* in German) and 'all-powerfulness of nature'. Most famously, Edmund Burke was the first philosopher to separate the beautiful and the sublime in a treatise encapsulating the fundamental characteristics of what was to be later termed 'Romantic':

Whatever is fitted in any sort to excite the ideas of pain and danger; that is to say, whatever is in any sort terrible, or is conversant about terrible objects, or operates in a manner analogous to terror, is a source of the sublime; that is, it is productive of the strongest emotion, which the mind is capable of feeling.[7]

Burke's idea of the sublime comprised emotions like fear, doubt and incomprehensibility, generated by overwhelming forces such as darkness, solitude, vastness, danger and pain, crucial components in Romantic art. In fact, Stubbs's *Lion Attacking a Horse* (1765) neatly fuses neo-classical traits in painting with the sublime. Here, in a calm and tranquil landscape, not unlike the idylls painted by the French neo-classical artist Nicolas Poussin, the horse's terror and lion's ferocity are associated with Romanticism's preoccupation with the overwhelming power of nature. As in Stubbs's painting, the presence of a wide-eye horse in Fuseli's *The Nightmare* (1781) conjures a ghostly mare peering out of the dark, suggesting nature barely under control. Here, the boundaries between neo-classicism and Romanticism seem blurred.

Following prevalent discussions of the sublime among poets and philosophers, Romantic artists made determined attempts to recreate visions of nature in all its unruly ways, depicting disasters in which humans become helpless when battling natural destructive elements. J. M. W. Turner's *Snowstorm* (1842) evidences his life-long fascination with the devastating power of nature. It places the viewer at an unsure standpoint –

Opposite: Coalbrookdale by Night *(1801) by Philippe de Loutherbourg. The artist depicts a scene of fiery industrial hell, the air filled with conflagration, noise and pollution, slagheaps marring the landscape and chimneystacks belching filth into the night sky.*

Left: Lion Attacking a Horse *(1765) by George Stubbs. Here, the artist moves away from his renowned sedate horse portraits with this vivid encounter between two animals.*

Left: The Nightmare *(1781) by John Henry Fuseli. The Swiss-born artist was known for his sense of the dramatic and his interest in the supernatural as evidenced by his works for John Boydell's Shakespeare Gallery.*

typical of the terrifying and evocative effects of the sublime in Romantic painting.

Turner was well aware of recent advances in meteorology, so he probably had expert knowledge of this extreme weather event: 'I wished to show what such a scene was like; I got the sailors to lash me to the mast to observe it; I was lashed for four hours, and did not expect to escape, but I felt bound to record it if I did.'[8] Turner's claim has been disbelieved – he was 67 at the time and no such vessel seems to have existed – but it nonetheless demonstrates his highly Romantic temperament. This autobiographical account, William Rodner observes, 'combined with the viewer's detached perspective, produces a painting that links internal and external viewpoints simultaneously.'[9] As a central figure among landscape painters, Turner led the way in making statements regarding nature, the sublime and the Romantic temperament.

Caspar David Friedrich's painstakingly rendered landscapes can be equally sublime. In *Artic Shipwreck* (1824), a Romantic study of the terror and majesty of nature, the effortless crushing of a ship's prow by immense slabs of artic ice is far more unnerving than the vortexes in Turner's paintings. In works such as *Chasseur in the Forest* (1814) and *Wanderer above the Mist* (c. 1817–18), moreover, Friedrich positions his figures facing away from the viewer, looking into what can only be described as indifferent and impenetrable nature. His *Wanderer*, like Turner's *Snowstorm*, intimates that we are somehow *in* and outside nature – estranged

Left: Arctic Shipwreck (1824) by Caspar David Friedrich. His works convey his interest in the elements and his dissatisfaction with the materialism of society.

Bottom left: An Artist Travelling in Wales (1799) by Thomas Rowlandson. Rowlandson's satirization as regards the popular nineteenth-century taste for 'the great outdoors' can be associated with a general re-evaluation of nature by the Romantic movement.

Opposite: Snowstorm (1842) by J. M. W. Turner. Turner likely alludes to scientific advances in Snowstorm, in particular the research of his friends Mary Somerville and Jams Faraday, who showed that magnetic fields of energy were capable of creating the arced patterns seen here.

and alienated from a world that is not under our control. Dramatic subjects such as these are in accord with the new scientific knowledge that now saw the Newtonian universe as less orderly and far more mysterious and dynamic in conception.

Here, we should ask why landscape assumes increasing importance in Romanticism, and what precisely is the rapport between nature and the Romantic temperament? Turner's remarks doubtlessly express a wish for an authentic experience of nature, signalling a new relationship between artists and the natural world. Artists sought to immerse themselves *in* nature, in the physical elements they recorded. Popular illustrations by caricaturists including Thomas Rowlandson (1756–1827) and Carl Johan Lindström (1808–41) hilariously captured how 'it must be devastating in nature'. These

images satirized the vogue for picturesque landscape paintings as well as a fashion for the great outdoors, fresh air and the natural environment.[10]

John Constable, who saw his work as 'science' and his paintings as 'experiments', typified the mood of enquiry with his cloud sketches that show, as in Turner's shipwrecks, an informed knowledge of meteorology, and introduced a new component to naturalistic analysis, the study of growth and change. In Constable's work, landscape became on the one hand a way of contemplating the emotional truth of nature and perception, while on the other hand undertaking a scientific enquiry into its laws. Ultimately, this type of approach led to a radically new aesthetic regarding picture-making, exemplified by one of the greatest revolutions in the history of art – the *plein-air* (open-air) studies of Impressionism. New scientific and geological understanding led to geologists and philosophical thinkers

Salisbury Cathedral from the Meadows (1831) by John Constable. Constable included lines from a poem by James Thomson (1700–48) – from 'Summer' in The Seasons *(1727) – when exhibiting his picture at the Royal Academy in 1831: 'as if in sign Of Danger past, a glittering robe of joy, set off abundant by the yellow ray, invests the field, and nature smiles reviv'd.'*

The Hay Wain *(1821) by John Constable. Literature plays a large part in the romanticism of Constable's countryside landscapes, particularly Coleridge's odes to nature's beauties.*

expressing the theory of vitalism: that humanity was not detached from nature, but inextricably bound up with the natural process.

Literature plays a large part in the romanticism of Constable's countryside landscapes, particularly Coleridge's poetic odes to nature's beauties, and his letters reveal his intention to 'make laborious studies from nature' by studying its varying conditions based on close observation of the facts.[11] Many of Constable's major landscapes, including *Flatford Mill* (1817), *The Hay Wain* (1821) and *Salisbury Cathedral from the Meadows* (1831), are nonetheless Arcadian visions of rural England. As the countryside shifted into profound crisis in the wake of the Napoleonic Wars, and as the 1832 parliamentary Reform Bill decreased the power of countryside constituencies, Constable's melancholic landscapes forewarn the demise of the rural idyll. As a consequence, the visual sense of unpredictability and troubling forces within *Salisbury Cathedral* has led some to see its grand edifice as a symbol of the Anglican Church 'under a cloud'.[12] Equally, Salisbury Cathedral, with its great rainbow, becomes 'an allegory of life' and is inescapably personal and poetic in intention.[13]

PART II: PROGRESSIVE 'HISTORY' PAINTINGS, THE 'IMAGINARY ORIENT' AND THE STATUS QUO CRUMBLES

Théodore Géricault

In France, it was known that *le style anglais* had something special to contribute to art. Constable was awarded the gold medal at the Salon in Paris in 1824 for *The Hay Wain*. The naturalism and modernity of Constable's landscapes were crucial to his success at the time. Considered old-fashioned now, during the era it was seen as revolutionary and progressive, much like the culture in which it was made.

French artists transgressed academic boundaries in new ways, too. Although some continued to paint subjects glorifying establishment figures, others (including Géricault) regularly crossed artistic boundaries. Géricault, in particular, concentrated on either individual suffering (*see The Mad Woman*, 1819–20, Musée des Beaux-Arts, Lyon) or anonymous events from history, subjects

that French academicians often deemed unworthy. *The Raft of the Medusa* (1818–19) is Géricault's established masterpiece, depicting the survivors from the scuttled *Medusa*, which ran aground off the coast of Africa in 1816. When this was originally exhibited in the Paris Salon of 1819, the title was *Shipwreck Scene*, though it was generally understood that the painting referred to the French government's doomed frigate.[14]

Hans Belting argues that the painting is a metaphor for 'the life-raft of art': 'as we

The Raft of the Medusa *(1818–19) by Théodore Géricault. The* Medusa *carried nearly 400 passengers, who were abandoned by the captain and his officers. Only 15 survived, with five dying shortly after their rescue.*

Opposite: The 28th of July: Liberty Leading the People *(1830) by Eugène Delacroix.*

look at Géricault's painting as though we ourselves were in the picture, the aftermath of the shipwreck is still taking place.'[15] By contrast, Julian Barnes sees it as having 'slipped history's anchor': 'We are all lost at sea, washed between hope and despair ... Catastrophe has become art ... It is freeing, enlarging, explaining ... that is, after all, what [art] is for.'[16]

Historians have indicated a wider historical context for the artist's picture, Géricault being a member of an abolitionist group who sought an end to slavery. The black soldier depicted waving a flag at the summit of the pyramidal group of misery might support this idea, and it certainly shifts the drama from pessimism to optimism.[17] Unsurprisingly, French observers were strictly divided down political lines. While supporters of the restored Bourbon monarchy of Louis XVIII saw it as a meaningless spectacle of human suffering, revolutionary Republicans loyal to Napoleon praised its exposure of political and Royalist nepotism. *The Raft* was awarded a gold medal in the category of genre painting, not history painting – reflecting the current artistic conservatism. Regardless, 40,000 visitors paid to see *The Raft* in London's Egyptian Hall in June 1820, and it later came to be regarded as a profound political symbol.

The Dream: Sleep of Reason Produces Monsters (c. 1797–99) by Francisco de Goya. Here, the slumbering figure is accosted by dark-spotted horned owls, a prediction of ill fortune. The lynx on the floor keeps watch, perhaps warning of a need to keep vigilant.

Eugène Delacroix

Delacroix met the test of Géricault's Raft in his *The 28th of July: Liberty Leading the People* (1830). Liberty's triangular composition has a similar momentum (up and to the right, though forward as opposed to receding), which grounds the rebels charging the barricades to a reference line of the fallen. The painting is a rousing ode to Republican ideals, inspired by the July uprising of 1830.

Delacroix's painting centres on a dramatic story then in circulation: a laundress happening upon the bullet-riddled body of her younger brother and taking up the Tricolour, the flag of the French Revolution. With proletariat and bourgeois companions in tow, Liberty straddles the barricade to attack the Swiss Guard before suffering the fate of the corpses underfoot. Her attitude to those dead and dying – one not unlike one of the figures from *The Raft* – indicates that Géricault was well aware of the doubled-sided nature of *liberté*, *égalité* and *fraternité*. Purchased by Louis Philippe at the Salon of 1831, partly to convince the French public of his Republican sympathies, the work was deemed too inflammatory for long-term exhibition. Indeed, it was not until 1861 that it was considered suitable for permanent exhibition. The German poet Heinrich Heine (1797–1856), who reviewed the Salon exhibition of 1830, saw in the work 'a great thought', but recognized that it also represented the 'power-smoke' of Revolution.[18]

Francisco José de Goya y Lucientes

A Romantic obsession with irrationally creative and destructive forces is unsurpassed in the work of Francisco Goya, particularly his print series *Los Caprichos* (*The Caprices*), published in 1799. Goya probably chose the title because the authoritarian Roman Catholic Jesuit Order in Spain ascertained 'caprices' to be the domain of madness. The most famous in the series is his **aquatint** *The Dream: Sleep of Reason Produces Monsters*. Like Fuseli's *Nightmare*, Goya's print intimates that no material or intellectual constructs can debar the grotesque and harmful potencies of the exterior world,

nor our psychological torments. However, Goya rather ambiguously described the print as: 'Imagination, deserted by reason, begets monsters. United with reason, she is the monster of all arts and the source of their wonders.'[19]

There are clear precedents for Goya's print. In the Middle Ages, bats and owls symbolized darkness, unable to tolerate truth – the owl was linked with a rejection of Christ's teachings. In the seventeenth century, these winged creatures were used in *The Idea of a Christian Political Prince* (1642) by Diego Saavedra Fajardo's engraved emblem Excaecat Candor, illustrating that: 'On the right side, the sun sheds its light on the sphere of the world, while on the left, bats and owls take refuge from its rays.' Other possible influences include the frontispiece to Rousseau's *Philosophie* (*Complete Works*, Vol. 2, 1793), where the philosopher is shown at his desk in deep thought and 'bathed by rays of light from the Tribune God', with his Enlightenment manuscripts, most conspicuously *The Confessions*, at his feet. In Goya's original drawings for the 'Dreams', the artist sits in a painting chair not unlike the *Painting Stand* depicted in Diderot's famous *Encyclopédie* (1771).[20]

Goya's 79 prints for *Los Caprichos* share the morally inspiring message of the Enlightenment, but satirize injustice, oppression, religious intolerance, falsehood and cruelty, particularly the torture and executions practised by the Spanish Government and the Church's Inquisition. In 1800, and under threat from the brutal Inquisition, Goya withdrew *Los Caprichos* from sale. Carlos IV later bought all the engraved copperplates and 240 unsold sets of prints in 1803, no doubt to help usher them into obscurity.

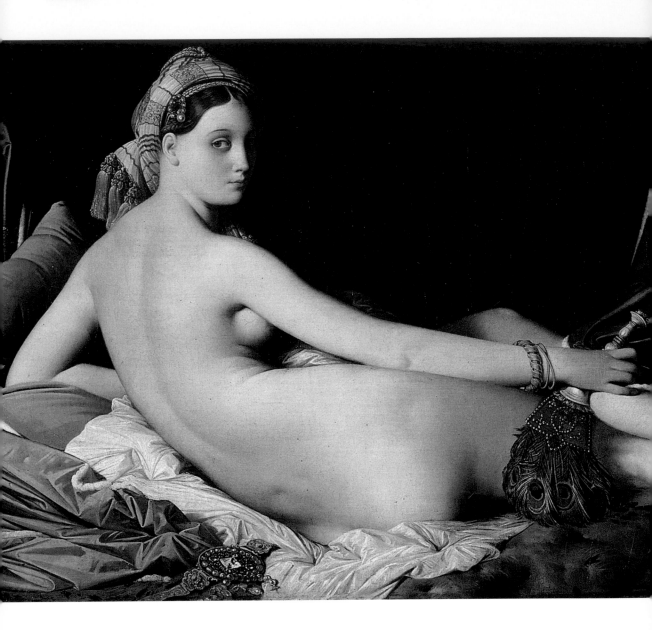

La Grande Odalisque *(1814) by Jean-Auguste-Dominique Ingres.*

The Imaginary Orient

Romantic representations of the Orient as an exotic milieu captured the imaginations of countless nineteenth-century French and British artists. This picture genre essentially drew thrilling pleasure from eroticized depictions of the Orient: visual fantasies of 'sensuality, promise, terror, sublimity, idyllic pleasure, and intense energy.' It's what Edward Said famously termed '**Orientalism**':

> *Orientalism ... is based on the Orient's special place in European Western experience. The Orient is not only adjacent to Europe; it is also the place of Europe's greatest and richest and oldest colonies, the source of its civilisations and languages, its cultural contestant, and one of its deepest and most recurring images of the Other.[21]*

New knowledge of the Orient and its artefacts did little to stem the tide of *Arabian Nights*-style fantasies, from artists such as Jean-Léon Gérôme (1824–1904), Eugene Delacroix and, in particular, Jean-Auguste-Dominique Ingres (1780–1867). Perhaps most famous for his nude odalisques in West Asian settings, Ingres exhibited *La Grande Odalisque*, exhibited at the 1855 Exposition Universelle in Paris. *Odalisque* is French for 'harem woman', the forbidden yet desired territory of many a male Western fantasy. This was the Orient as imagined by Wolfgang Amadeus Mozart (1727–91) in the opera *Abduction from the Seraglio* (1782) and by Lady Mary Wortley Montagu's infamous *Turkish Embassy Letters* (1762), which undoubtedly inspired Ingres and many others with its Orientalist descriptions.

Jean-Léon Gérôme's *The Slave Market* (1866) has likewise been an iconic marker of Orientalism since the publication of Said's text and Linda Nochlin's assessment of the picture in her correspondingly seminal essay, 'The Imaginary Orient' (1983). Nochlin articulates the view that *The Slave Market* presents the imperialist, racist and Orientalist perspective of male European power; other art historians contend that the work can be interpreted as an 'abolitionist painting'. It is hard to dispute Nochlin's argument that such imagery perpetuates the Western canon's depiction of the Orient as a place of 'picturesque timelessness', while also offering a moralizing and racist commentary on the 'savage' nature of contemporary Islamic society.

We need only compare the European Orientalist fantasy with the work of the Turkish intellectual and pioneering painter Osman Hamdi-Bey (1842–1910). His subjects recall his European teacher, Gérôme, but alternatively depict sophisticated images of his female Muslim family members, as in the likes of *Two Musician Girls* – both by complicating and negating Western stereotypes and assumptions regarding the Orient, and by intentionally eradicating the Orientalist gaze. As Zeynep Çelik has forcefully argued, Hamdi's prestige as a scholar means that many view his work as dissident and highly censorious of European orientalism.[22]

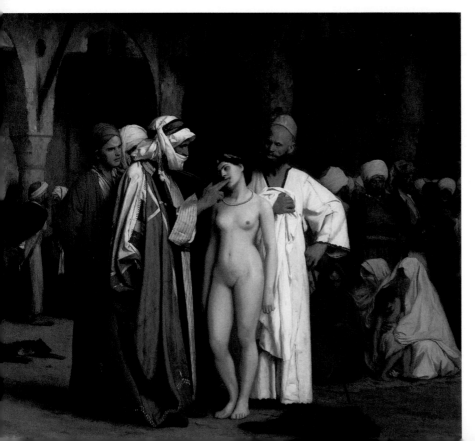

The Slave Market *(1866)* by Jean-Léon Gérôme. It is likely, according to the historian Sarah Lees, that Gérôme may have been inspired to create this work after reading Gérard de Nerval's account of a similar incident in his fictional Voyage en Orient *(1851).*

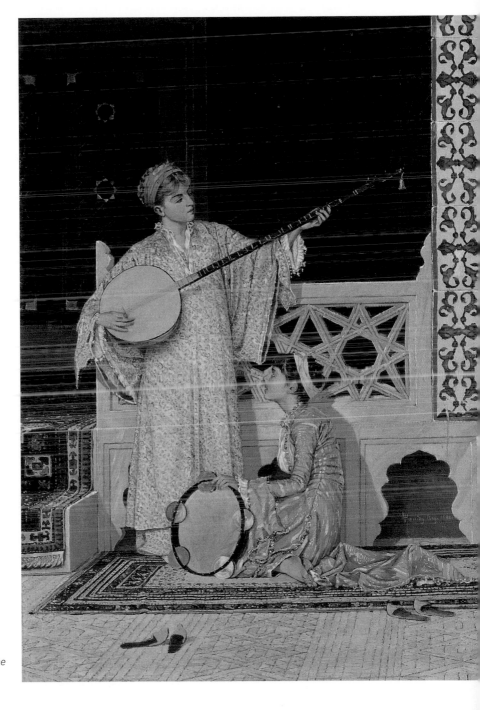

Two Musician Girls
(1880) by Osman Hamdi-
Bey. Although he worked
as a museum curator
and an archaeologist,
Hamdı still managed to
paint throughout his life,
influenced strongly by his
teachers, the artists Gérôme
and Boulanger.

J. M. W. Turner

Turner's *The Slave Ship* (originally called *Slavers Throwing Overboard the Dead and the Dying – Typhoon Coming On*, 1840) illustrates a horrifying episode in Britain's colonial history. The subject was of special interest because in 1833 Britain had enacted the first legislation to abolish slavery, insisting that the practice be stopped throughout its Empire by 1840. That goal was actually realized in 1838, and the years that followed saw a surge in campaigning across the world against the trade. Turner depicted an incident from 1781, in which the ship *Zong* threw overboard many sick and dead slaves; the ship owner could claim insurance only on 'cargo lost at sea'. Rather than a critique of slavery, however, Turner's *The Slave Ship* has been interpreted as a gloomy universal visualization of humanity striving hopelessly against the primal forces of nature. Turner chose to append lines to accompany its exhibition at the Royal

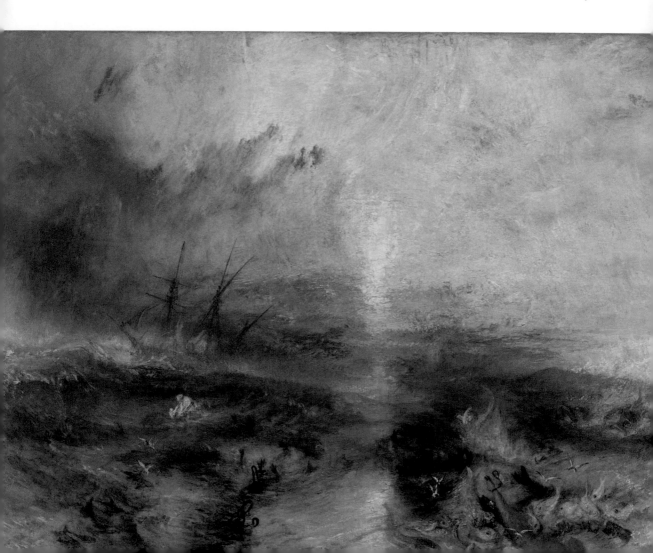

Academy in 1840, taken from his unfinished poem 'The Fallacies of Hope': 'Hope, Hope, fallacious Hope!/Where is thy market now?'

Turner moved in liberal circles and was a member of the British Society for Effecting the Abolition of the Slave Trade, and he would certainly have read much abolitionist writing. The abolition of slavery throughout the Empire meant that when visitors to the 1840 Royal Academy exhibition saw Turner's *The Slave Ship*, they could look upon it with a certain air of self-congratulation rather than outright shame. Nonetheless, *The Slave Ship* is one of the most disturbing of all paintings depicting the slave trade. It has been described as a picture that 'attacks the optic nerves.... It's quite simply the greatest union of moral power and poetic vision that British art ever accomplished.'[23]

Artists were engaged to advance the abolitionist cause, the Society's insignia of 1787 showing a slave pleading to be freed: 'Am I not a man and a brother?' The fact that François-Auguste Biard (1799–1882) exhibited his painting *The Slave Trade* (1840) alongside Turner's picture was probably no accident. The exhibition coincided with preparations for the first international convention of the British and Foreign Anti-Slavery Society in London in June 1840.

While the British made noises of righteous indignation, the slave trade remained legal in many countries until 1888. In the United States, slavery was a fiery issue. Yet Eastman Johnson's 1859 Negro Life at the South shows none of the racial tensions, hardships, sexual abuse and indignities suffered. The image appealed both to abolitionists, who saw in it an exposure of the miserable conditions of slaves, and the pro-slaver faction, who saw depicted the peaceful existence between slaves and owners. Alternatively, Nathaniel Jocelyn's Cinqué (c. 1840), commissioned by a leading abolitionist Robert Purvis (1810–98), is a picture of a noble rebelliousness that makes a salient comparison to paintings by Biard and other Europeans, whose images of enslaved Africans suggested their shame as opposed to esteem.

Above: The Slave Trade (1840) by François-Auguste Biard. However admirable, the motives of abolitionists were habitually filled with racist sentiments equating slaves with defenceless animals.

Opposite: The Slave Ship (1840) by J. M. W. Turner. The sobering subject was given added impact by Turner's introduction of a sky of blood.

The Status Quo Crumbles

The turmoil at the end of the eighteenth century and the complete transformation of European society in the early nineteenth century meant that life had altered greatly from one decade to the next. Europe shifted from a predominantly rural, agrarian culture to a progressively urban and industrial one of iron, steel and coal, meaning that a sense of consistency and stability became

Left: Negro Life at the South (1859) by Eastman Johnson. *Newspaper reports on the exhibition of the painting led to the belief that the work portrayed life in Kentucky, but in fact it showed a street scene in Washington, DC.*

Right: Cinqué (c. 1840) by Nathaniel Jocelyn. *Joseph Cinqué, the subject of this portrait, was the leader of a revolt on the Spanish slave ship* La Amistad.

ever more difficult to achieve. Overthrowing absolutist rule meant greater freedom and democratization from the *Ancien Régime* and the loosening of individual creativity and ideas from the grasp of tradition. But with this change

came great economic and political uncertainty about the future. While romantic, revolutionary and orientalist visions expressed a degree of alienation and escapism, artists simultaneously mounted a great challenge to the status quo. This reflected a valiant refusal to conform, and was one of the great trademarks of modernist pioneers. The genesis of twentieth-century creativity was thus born of nineteenth-century innovation.

ART IN FRANCE, 1848–1904

From Realism to Symbolism: Images of the People – Manet and the 'Salon des Refusés' – The Impressionist Subject – Impressionism as Theory – Post-Impressionism and

Symbolism: the Politics of Vision – Against the Wolves: Pessimism and Optimism in Symbolist Art – En Route to the Twentieth Century

MANET

OLYMPIA

FIN DE SIÈCLE

TRANSFORMATION OF PARIS

SALON DES REFUSÉS

EXHIBITIONS

VAN GOGH

GAUGUIN

HISTORICAL CONTEXT

IMPRESSIONISM

SYMBOLISM

MUNCH

SUBJECTS

FRENCH ART IN THE NINETEENTH CENTURY

CÉZANNE

REALISM

POST-IMPRESSIONISM

COROT

ART FOR ART'S SAKE

COURBET

DIVISIONISM

SEURAT

FROM REALISM TO SYMBOLISM:
IMAGES OF THE PEOPLE

The journey from Romanticism to Realism is often long, unclear and fraught. In France, the crisis following a number of revolutions was resolved in 1851, when a Second Republic was delivered into the hands of Napoleon Bonaparte's nephew, Charles-Louis Napoleon (1808–73). His reign lasted until the disastrous Franco-Prussian War in 1870, ushering in a Third Republic that brought an end to the

Boulevard Montmartre à Paris (1897) by Camille Pissarro shows the effect of Baron Haussmann's renovation of Paris at the end of the ninetenth century.

The Stone Breakers *(1849) by Gustave Courbet gave rise to cricisms of the artist as a socialist sympathizer – 'the Pierre-Joseph Proudhon of painting' as one writer put it.*

monarchy in France. Yet in the intervening 20 years, Paris was transformed into what Walter Benjamin would term the 'capital of the nineteenth century'.[1] This great change can be associated with Georges-Eugène Haussmann's (1809–91) renovation of Paris that included wide, straight and tree-lined avenues which cut straight through the heart of the old city, and gave rise to a new, very visible social order. This new type of urban planning did much to determine the imagery of modern Paris.

The process of renewal does not in itself account for the vitality of Parisian culture during

the era, 'which was achieved at least as much despite Haussmann's enterprise as because of it'.[2] Two intrinsic components allow us to identify avant-garde culture in the second half of the century. The first is that it kept its distance from polite society. Secondly, it continued to keep in focus the very image of a society that

the new urban changes were meant to exclude, the aspect which lay unacknowledged but was always needed: 'the stone breakers, ragpickers, entertainers and prostitutes, forced to eke out an existence on the margins of public life.'[3] For example, Gustave Courbet's *The Stone Breakers* (1849) highlights the new requirement for paving to allow transport to flow efficiently into French towns and cities. The work carried out here does not reference a traditional type of labour fixed in the past, nor indicate the reciprocal relationship between people and nature. More exactly, *Stone Breakers* shows us peasant workers ejected from the land into backbreaking and poorly remunerative work, the benefits of which found their way straight into the pockets of the bourgeois upper classes.

The Stone Breakers imparted fear among the polite classes precisely because its faceless, powerfully built workers lugging huge stones and wielding sharp tools like weapons suggested that these plebeians (and perhaps the artist himself) were the genuine children of the revolutionary Republic. *The Stone Breakers* and the later *The Peasants of Flagey* (1855) go some way towards capturing the complexity of the new social formations in France, when rural populations were drawn away by industrialization.

These dynamics help explain part of the social context for art between the 1840s and 1860s. By the 1860s, however, Realism in painting had come to mean not just a commitment to the motifs derived from the visible world, but also that the surface of artworks should be employed to make the observer *feel* its existence. So the idea of modernity was intrinsically associated with the material *effects* of art. At this juncture, Realism and Naturalism began to morph into

something very different, even in the custody of Jean-Baptiste-Camille Corot (1796–1875) – the greatest landscape artist of his age, who considered himself a Realist painter. As Corot's notebooks attest, during the era there was a tendency to perceive picturesque subject matter as resolved not by nature necessarily – *en* **plein air** (in the open air), for example – but rather by temperament and something made known by the act of depiction itself. We might call this tendency *l'art pour l'art*, and it was an aesthetic that would challenge Realism.[4]

The idea of 'art for art's sake' – of the independence of the artwork, free from political, social and moral intention – originated with Kant's *Critique of Judgement* (*see* Chapter 7). But the principle *l'art pour l'art* is itself attributed to the French philosopher Victor Cousin (1792–1867), the notion appealing keenly to Romantics rebelling against traditional academic rules. While some writers argued that works of art depended upon their utility, others such as the poet Charles Baudelaire (1821–67) distanced themselves from the 'doctrinaires of Realism' by stressing the self-directed veracity of works of art. For Baudelaire, art rested solely with the creative individual and 'The Queen of the Faculties', as he labelled it, by which he meant the imagination and the sheer force of artistic ideas.[5]

Following Baudelaire, the French poet Jules Laforgue (1860–97) fashioned the most articulate expression of Impressionism as a similarly transitory and contingent art form. In his essay for the Impressionist exhibition at the Gurlitt Gallery, Berlin, in 1883, which included works by Renoir, Degas and Pissarro, he wrote: 'Object are subjects … irretrievably in motion,

inapprehensible and unapprehending … In a landscape … the Impressionist sees light as bathing everything not with a dead whiteness but rather with a thousand vibrant struggling colours of rich prismatic decomposition.'[6]

MANET AND THE 'SALON DES REFUSÉS'

From the 1860s onwards, an argument for the modern was to be defined in terms of an unavoidable conflict between on the one hand an unqualified truth to nature, and on the other an art of entirely autonomous *impressions*. Conservative reactions to the Salon des Refusés (Salon of the Refused) in 1863 and then to the Salon of 1865, particularly Manet's modern *Olympia* (1862–63), highlighted the problem of nineteenth-century academic conventions. The Salon des Refusés was a crucial moment in the emergence of modern art, not least because all three of Manet's submissions were rebuffed, including the work now known as *Le Déjeuner sur l'herbe* (literally, *The Luncheon on the Grass*, 1863), but then known as *Le Bain* (*The Bath*). Out of the 5,000 submitted to the Salon jury, 3–4,000 works were rejected, resulting in an uproar that quickly caught the attention of Louis Napoleon III. The result was a separate exhibition, ostensibly to allow the public to decide. Responses ranged from outright antagonism to keenness, the exhibition immediately dubbed by the critic Louis Leroy as the work of the 'pariahs of the Salon'.[7] Inevitably, the problem of artistic quality raised its head, concerning the topic of the applicability of Academic standards in a new artistic age.

The disinterest of the protagonists in *Le Déjeuner sur l'herbe* and the severe artificiality of its conception helped dissociate it from Realism and nineteenth-century academic standards. Simultaneously, Manet's painting had its origins in tradition, particularly Giorgione's naked *Pastorl Concert* (*c.* 1508), which the artist had studied in the Louvre, and it could be interpreted as an updating of Italian Renaissance subjects. It was also probably a nod in the direction of Courbet's *Young Ladies on the Banks of the Seine* (*c.* 1852–57), which indicated the commonness of prostitution in mid-century France.

Two years after the Salon des Refusés, Manet's submitted his *Olympia* (1863) to the jury, and this time it was accepted. Controversy continued as regards artistic norms. Of the 87 reviews of the Salon of that year, 72 were related to *Olympia*, and most were critical.

Le Déjeuner sur l'herbe *(1863)*
by Édouard Manet. The reviewer
Édouard Lockroy wrote in the Courrier
artistique *that 'Manet had a gift for*
displeasing the jury [of the Salon]'.

Manet's *Olympia*

Manet's fascination with the subjects and individuals of modern life was undoubtedly influenced by his connection with Baudelaire, whom he had befriended in 1855. Baudelaire applauded artists who depicted the fashions, attitudes and feelings of the time: his famous text 'The Painter of Modern Life' (first published in *Le Figaro* between November and December 1863) did more than any other essay to characterize modernity as represented in art during the late nineteenth century. In the opinion of T. J. Clark, only one reviewer managed to grasp the essential meaning of Manet's *Olympia*. Alfred Sensier, writing in *L'Epoque* (1863) identified it as a 'painting from the school of Baudelaire'.

Olympia, as with *Déjeuner*, alluded to past and present art. Referencing Titian's *Venus of Urbino* and Goya's *The Naked Maja* (1795–1800, Prado, Madrid), the picture also satirized the politely titillating and exploitative female nudes exhibited in modern French Salons. Typical of the paintings of the time were *La Source* by Ingres (1855) and *The Birth of Venus* (1863) by Alexandre Cabanel (1823–99), which expressed the innocence, freshness and vitality of the female body in nineteenth-century academic classicism. The 'acceptable' Salon nude was a nineteenth-century confection – soft pornography in disguise. Manet's *Olympia* has a name redolent of high-class courtesans of the day, and looks straight out at the spectator with an uncoquettish stare that represents a disturbingly modern female: brazen, powerfully athletic, self-assured, and independent and free from male oppression. Manet's inclusion of a black-skinned handmaid equated *Olympia* with an exotic harem and orientalist male fantasies – Africans during the period were stereotypically perceived as bestial, 'primitive' and highly sexualized. Colonialist racial arrogances additionally connected whiteness with civilization, and blackness with inferiority.

Lest we forget, Manet was not only seeking out new subjects in art, but also developing a new style of painting by experimenting with shadows and bright colour combinations, and by creating dazzling contrasts between shades at either end of the painting spectrum, moderating the intermediary range. This is another reason why the picture made such an impression on a younger generation of artists, who recognized this revolution in

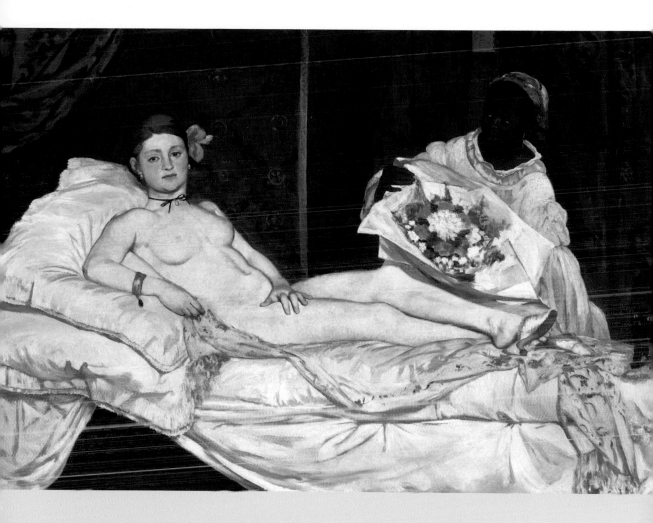

Olympia *(1863) by Édouard Manet.*

painterly *effects.* Such was the work's impact that, following Manet's death, when it was feared that *Olympia* might end up in America, Claude Monet initiated a fund to help raise money to keep the work in France.

THE IMPRESSIONIST SUBJECT

There is considerable debate among art historians as to the subject of Impressionism. Many have argued that Impressionism made the subject irrelevant. For these art historians, what made the movement historically significant was the willingness of artists to paint virtually anything that presented itself *as a subject*. Manet, for instance, is reported to have said on a visit to Venice in 1847: 'They are so boring, these Italians, with their allegories … with all their showy bric-à-brac. An artist can say anything with fruit and flowers, or simply with clouds.'[8] Generally speaking, Impressionist artists avoided historical, literary and religious subjects to focus on what were traditionally deemed lowly genres, a move that essentially played down the importance of subject matter. Monet's *Impression: Sunrise* (1872), which gave the famous idiom its name when first exhibited in 1874, appears to confirm this idea: 'When you go out to paint, try to forget what object you have before you … until it gives you your own naïve impression of the scene before you.'[9]

Certainly, the pleasant atmosphere of garden picnics, parks, luncheon parties, boating scenes, seaside resorts and tranquil suburban landscapes seems to quash any clichés of artists alienated from and commenting on society. Few, if any, of these painters thought of themselves as insurgents or outsiders. Many, in fact, like Manet and Morisot were 'Parisians of long standing, [who] were out of the same middle-class drawer, sons and daughters of *haut fonctionnaires* [high-ranking civil servants] from the professional fields of tax inspection and engineering'.[10] From well-to-do families, artists enjoyed the advantages of

Impression: Sunrise *(1872) by Claude Monet. Now exhibited at the Musée Marmottan Monet in Paris, the work was one of six that the artist made showing the port of Le Havre at different times of the day.*

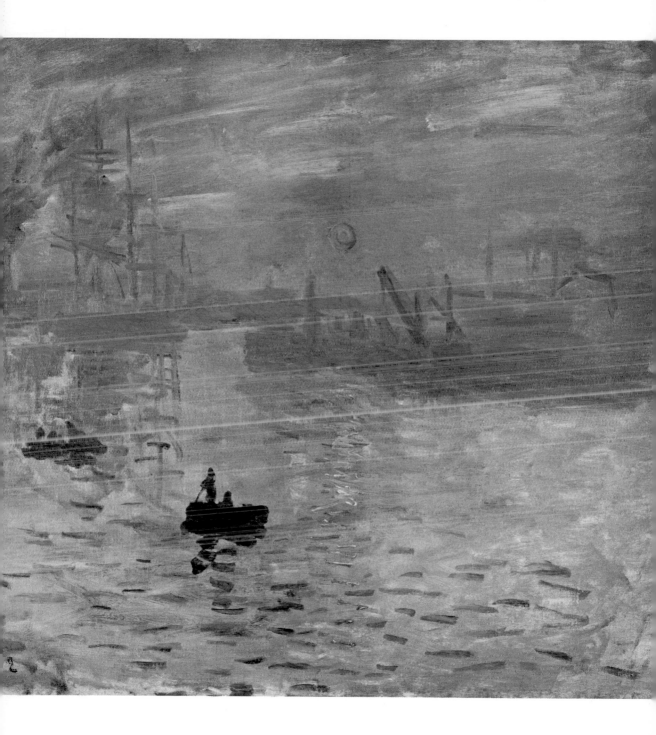

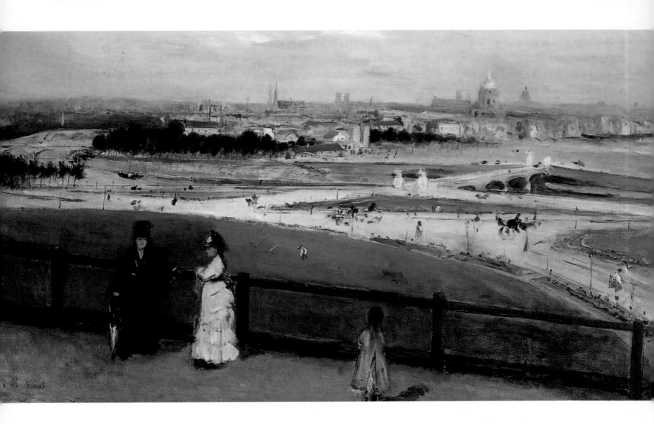

privileged positions, their paintings imparting a characteristically *haut bourgeois* vision of contentment – inconsistently, needless to say, for the Impressionists claimed to be relatively detached psychologically from their subjects.

More recently, however, artist historians including T. J. Clark, Robert Herbert, Griselda Pollock, Linda Nochlin and Witney Chadwick have made the social context of Impressionism central to the study of late nineteenth-century art. And these new social formations were similarly the subject of Impressionists and Post-Impressionists. In the 1860s and 70s, the search for modern subject matter generally focused on social environments altered by the impact of industrialization and the swelling

View of Paris from the Trocadéro (1871–72) by Berthe Morisot. The locale of the viewpoint was a popular recreational spot for women to take their children, while their husbands went to work.

bourgeois class. The figures that populate the urban settings of Manet, Renoir and Morisot tend to be those unsettled by the aftershock of Haussmannization, and caught up in social or economic change. *View of Paris from the Trocadéro* (1871–72) evidences Morisot preceding her friend Manet by painting *en plein air*, near her home in the western suburb of Passy. It had the advantage of a high viewpoint looking over a meander in the Seine

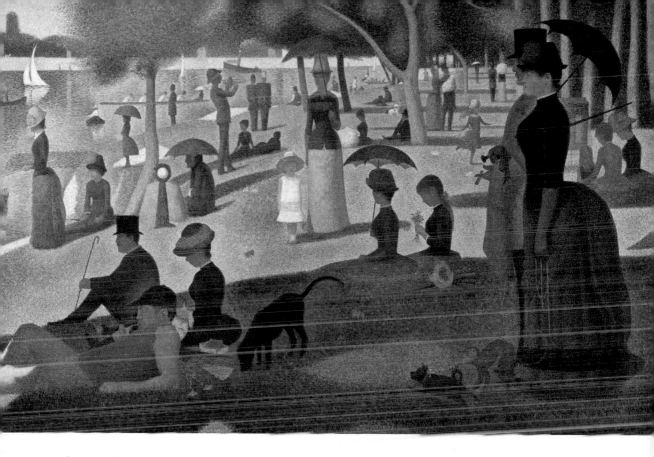

and across its waters to the Trocadéro and the Bois de Boulogne. This was a favoured spot of the upper-class *haut fonctionnaires*: quiet, safe and with clean air, and thus ideal for well-to-do families.

By contrast, Seurat's *A Sunday Afternoon on the Island of La Grande Jatte* (c. 1884–86) depicts the leisure time of Parisian workers on Sunday, their day off. The scene is not an *haut-bourgeois* haunt or a working-class hangout, but probably represents the *petite bourgeoisie* of Paris – clerks, shop-workers and maids dressed in department-store fashions, with a few troopers added into the mix. This is a space of utopia – or a dystopic place of alienation. The social groups are isolated, not interacting,

A Sunday Afternoon on the Island of La Grande Jatte (c. 1884–86) by Georges Seurat. Seurat was fascinated by the optical relationship between colour and form. This work saw him hailed as the leader of the Neo-Impressionists.

a reality that seems to be taken for granted by Seurat's urban dwellers. Whatever the case, *La Grand Jatte* appears to critique modern society's strange – even disturbing – manners and customs. Leisure is now part of the diversions of mass culture – parks, cheap entertainments, music halls and popular music – understood as a period integrated into the rhythms of labour and production. Such diversions are, naturally, a producer of profit in their own right, giving

rise to a new 'culture industry'. It is this form of cultural activity that we now conceive as modernism.

In avant-garde art and literature, the notable image of the period was inaugurated by two basic types: the *flâneur* and the *demimonde*. In one form or another, in seclusion or placed next one another, these two corresponding individuals appear again and again throughout the period. When Degas's *Women on the Terrace* (1877) was shown at the Third Impressionist Exhibition in Paris in 1877, its theme of prostitution was easily identifiable. Manet's *A Bar at the Folies-Bergère* (1882), which continues his fascination with modern subjects, shows a young, arresting woman looking straight on, unambiguously challenging the viewer. Its intricate array of lighting and mirror reflections within Paris's famous café-concert reveals both the vitality and ambiguous nature of Paris's nocturnal world. This complex creation is suitably strange enough to raise questions. Why are we, the spectator, not part

Right: Women on the Terrace *(1877) by Edgar Degas. The faces of the prostitutes imply the boredom of their work as they sit waiting for custom.*

Below: A Bar at the Folies-Bergère *(1882) by Édouard Manet. The Folies Bergère was renowned for its cabaret shows and risqué revues featuring naked or semi-naked dancers.*

of the reflection? And who is the shady *flâneur* in a top hat proffering a coin to the barmaid? In the barmaid's blank expression, Manet records something of the solitude, dissatisfaction, alienation and the feeling of life in a large modern European city. Impressionist artists were depicting the characters who were an inevitable feature of modern urban life, and they did so, it seems, without exciting in the spectator judgement, scorn or even pity.

Impressionism as Theory

Impressionism had no notable aesthetic theory or an express procedure – both Monet and Renoir abhorring theorizing. Even so, it may be considered to be, in the broadest sense, the last phase of Realism. There are various points to note about the movement:

- There was a growing propensity for attention to be paid to the painted surface as well as to the effects of light and atmosphere.
- Modern ideas about colour did not, however, originate with the Impressionists. John Ruskin's *Elements of Drawing: Three Letters to Beginners* (1857) reminds us that the concept of nature as a web of colour patches was on a par with the most progressive colour theory of the time, anticipating the aesthetic principles of the French Impressionists. Painting, wrote Ruskin, 'depends on the recovery of *the innocent eye*; that is to say, of a sort of childish perception of these flat stains of colour ... Painting consists merely in perceiving the shape and depth of these patches of colour ... on the canvas.'
- It reflected the positivist, scientific attitudes of the age, aided by the investigation into optics and colour theory. As a philosophical system, **Positivism** acknowledged the scientifically verified, logical or mathematically proven. In doing so, it insisted that our sense perceptions are the only satisfactory type of knowledge. These ideas were already noticeable in the work of Realist artists, who sought out the everyday tangible facts of the modern world. For the Impressionists, this meant restricting art to an objective translation of the visible world, capturing their immediate, fleeting sensations – the impression – with the utmost possible faithfulness.
- The Impressionists attempted to seize the shimmering character of natural light by adopting unblemished vivid colours, applied with diverse, broken brushstrokes and laid down on a white (not the conventionally brown) canvas. The finished picture, not just the study, could record the immediate effects of an open-air scene, and this first impression would not be lost.

POST-IMPRESSIONISM AND
SYMBOLISM: THE POLITICS OF VISION

Artists such as Georges Seurat and Paul Cézanne (1839–1906) would soon adapt Impressionist discoveries to their own ends. Although Cézanne exhibited with a number of Impressionist artists in 1873 and 1877, his art was conducted in a self-imposed relative isolation at his home in Aix-en-Provence. Early on, he encountered the problem of how to modify Impressionist innovations to his work. As he famously recounted in a letter to Émile Bernard (1868–1941) on 15 April 1904, he explained how the elements of painting should be reduced to simple geometry: 'treat nature by the cylinder, the sphere, the cone,' while also remembering that nature is 'represented by reds and yellows, a sufficient amount of blue to give the impression of air'.[11] Cézanne sought to create something concrete and lasting out of Impressionism: an idiom that he perceived as lacking in pictorial grandeur, simplicity and structure. The problem was how to remain true to the luminous colour, evanescent sensations and fluidity of Impressionism without losing all sense of structural order, solidity and form in a painting. The solution was, it seems, to recoup these things by means of colour alone: 'colour

Mont Sainte-Victoire Seen From Les Lauves *(1902–04) by Paul Cézanne. At the end of his life, the artist acknowledged the spiritual feeling that he felt when he was working* en plein air.

must reveal every interval in depth'. His view of *Mont Sainte-Victoire Seen From Les Lauves* (1902–04), for instance, reveals a complex construction made of short, flat brushstrokes and equivalent lines that resonate form and unite to create a sense of depth without relinquishing the overall surface pattern. This was a painterly feat nothing short of heroic, and it gave Cézanne's late great landscapes a pseudo-spiritual dimension.

By the mid-1880s, Impressionism was seen by a younger generation as troublesomely objective and subjective. Monet and Camille Pissarro (1830–1903) were claiming on the one hand to create a precise and frank representation of nature, while on the other hand speaking about the 'personal' or 'unique' sensation of the artist. Solutions to this kind of problem were to some extent found in the **Divisionism** or **Pointillism** of Seurat's work (his own term was Chromoluminarism), dot-like brushstrokes that were evocative of the tesserae patterns in mosaics, juxtaposed or divided – but not mixed on the palette as in Impressionist works. When surveyed from a distance, it was hoped that the colours would fuse optically in the eye of the beholder. In effect, Seurat's Divisionism was a methodization of Impressionist technique (derived in particular from the contemporary colour theories of Michel Eugène Chevreul [1786–1889]), its meticulous and arduous application at odds with the spontaneity and ephemeral atmospherics of Impressionism. Seurat's *La Grande Jatte* and *Bathers at Asnières* (1883–84) are perhaps an indication of the explicitly social and political nature of Neo-Impressionist or Divisionist art. In *La Révolte* of June 1891, Paul Signac (1863–1935),

the subsequent spokesman for the group and involved with Socialist and anarchist movements in France, wrote that Neo-Impressionism attested to 'the great social struggle that is now taking place between the workers and capital'.

Bathers at Asnières (1883–84) by Georges
Seurat. The artist used a technique of flat,
criss-crossing brushstrokes, which he
called balayé, on parts of the work such as
the grass in the foreground, that helped to
indicate the effect of the light.

AGAINST THE WOLVES: PESSIMISM AND OPTIMISM IN SYMBOLIST ART

By the end of the century, many artists and Symbolist literary critics rejected Realism, Impressionism and Neo-Impressionism, and sneered at Naturalism. They saw the latter as artificial, appealing instead for an art that articulated subjective concepts and more universal veracities. Partly as an escape from the purely naturalistic and tangible in art, and partly as an attempt to work more truthfully, many artists turned to subjectivity, fantasy and the imagination for inspiration. In the 18 September 1886 issue of the Parisian newspaper *Le Figaro*, Jean Moréas (1856–1910) – the post-Baudelairean 'decadent' – proclaimed in his manifesto that Symbolists were the 'enemy of teaching, of declamation, of false sensitivity, and of objective description'.

Symbolist artists now looked inwards – 'the analysis of the *Self* to the extreme', as Gustave Kahn (1859–1936) expressed it – feelings and ideas now the starting point of works of art.[12] We can roughly separate Symbolists into two opposing groups contingent on whether they were, in the main, optimistic or pessimistic with respect to human nature and the future of humanity itself. These artists were subsequently categorized as 'Idealists' and 'Decadents'. Symbolist artists habitually expressed a deep longing for the past, where imagined societies were said to be eternally joyful and congruent – living in 'a state of nature', as the Enlightenment philosopher Rousseau put it. 'I am leaving [for Tahiti] in order to have peace and quiet, to be rid of civilization…. I have to immerse myself in virgin nature, see no one but savages, live their life, with no other thought in my mind but to render, the way a child would, the concepts in my brain,' wrote Gauguin (1848–1903).[13]

Opposite: Where do we come from? What are we? Where are we going? *(1897) by Paul Gauguin. He first visited Tahiti in 1891–93 and then returned in 1895 to live out the rest of his life there.*

Below: Starry Night *(1889) by Vincent van Gogh. Now one of the most recognized artworks in the world, van Gogh painted this view from the window of the room in the asylum at Saint-Rémy-de-Provence, where he stayed after cutting his left ear. Van Gogh described the work to his fellow painter Émile Bernard as a 'failure'.*

Decadents alternatively expressed a gloomy, destructive and fatalistic worldview. So, while Vincent van Gogh (1853–90) in his *Starry Night* (1889) hoped to express in nature the divine beauty and truths of God filling the universe, Edvard Munch (1863–1944) depicted in *The Scream* (1893) deterioration, despair and eventual madness. Painters and sculptors like Munch, Gauguin, August Rodin (1847–1917) and other artists at the fin de siècle were fundamentally preoccupied with allegories of modern life. Gauguin's large painting *Where do we come from? What are we? Where are we going?* (1897) is a highly subjective statement and Symbolist parable of human existence from birth to death. Rodin's *The Gates of Hell* (1887–

1917), a 20-year project left unfinished, is filled with pessimism, anxiety and fear concerning humanity's future.

The Symbolist decadents saw human beings as fundamentally corrupt, self-seeking and petty-minded, bringing unavoidable harm and destruction upon civilization. Van Gogh, who often quoted Voltaire, believed that society had changed little since the French writer's day. Indeed, van Gogh's own fundamental nature was perhaps best expressed by James the Anabaptist, the character from Voltaire's *Candide*: 'Men, the Anabaptist said, must have somehow altered the course of nature; for they were not born wolves. God did not give them twenty-four pounders or bayonets. Yet they have made themselves bayonets and guns to destroy themselves.'

EN ROUTE TO THE TWENTIETH CENTURY

Gauguin, Cézanne, van Gogh and Rodin emphasized the sheer difficulty of life for the modern artist during the fin de siècle, and of revealing their own place in the world. Symbolist artists frequently experimented with new or unconventional techniques and materials such as lithography and pastel, and, in the case of Munch's *The Scream*, introduced written text into the paint – a radically avant-garde gesture. The Symbolists also included highly unconventional locations, dramatic colours and thick impasto or very thinly spread paint, and used two-dimensional graphic procedures that exploited and underscored to great effect the flat nature of painting. This type of experimentation was a sign of what was to come in art. Modern movements in twentieth-

century art, including Expressionism, Abstraction and Surrealism, all have origins in Symbolism. Many of the most influential artists of the twentieth century began as Symbolists, including Vasily Kandinsky (1866–1944), Piet Mondrian (1872–1944), Constantin Brancusi (1876–1957), Paul Klee (1879–1940) and Pablo Picasso (1881–1973). Although these young artists grew up in the shadow of Realism,

Impressionism and **Post-Impressionism**, Symbolism struck a chord with this frequently disenchanted youth who found themselves living in an era of rapid change, chaos and conflict. Symbolism's search for transcendent meaning in poetry and art was the instinctive choice of the young, chiefly because the future seemed more and more uncertain as the twentieth century dawned.

Opposite: The Gates of Hell (1887–1917) by Auguste Rodin. Taking its theme from the first part of Dante's Divine Comedy, the sculpture remained unfinished at Rodin's death.

Right: The Scream (1893) by Edvard Munch. The artist created four versions using a combination of oil paint, tempera, pastels and crayon.

Chapter Eleven
MODERNISM: ART IN FRANCE, 1906–36

Defining the Modern: Competing Visions of the Modern World –
Feature: Picasso's Les Demoiselles d'Avignon *and the Coming*
of Cubism – Matisse, Fauvism and Primitivism – L'Art Nègre and

Colonialism – Cubism: An Art of 'Little Cubes', Facets or Signs?
– Marcel Duchamp and the 'Art' of the 'Readymade' – Conformity
and Dissent – Surrealism – The Modernist Ambition

DEFINING THE MODERN: COMPETING VISIONS OF THE MODERN WORLD

This chapter investigates the notion of the avant-garde and its relationship to the dynamic aspects of modernization, modernity and modernism, which can be defined as follows:

Modernization refers to scientific and technological advance, in particular the machine. Think of the control exerted upon human life by the internal combustion engine, engineering, industry and other new technologies that began rapidly to outpace older or established traditions.

Modernity denotes social and cultural changes, i.e. the character of change and adaptation to such changes, reflecting a form of social and inner experience. According to Paul Wood and Charles Harrison, the modern condition 'exists in a shifting, symbiotic relationship with Modernism' – in short, 'that inchoate experience of the new'.[1]

Modernism refers in general to a response and representation of the new: a reaction in visual, intellectual and cultural terms to modernity and modernization.

To understand the modern and the avant-garde, we first need to consider the idea of the modern world as it was *contested* in the early twentieth century, i.e. artists projected *competing visions* of the modern. And modern art was deeply conflicted.

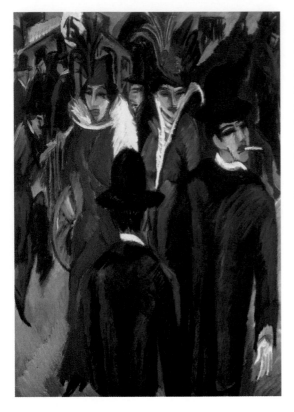

Berlin Street Scene *(1913) by Ernst Ludwig Kirchner. He was one of the founders of* Die Brücke *(The Bridge) group in 1905.*

The conflict can be identified by the specific character of the work and a stance taken by the avant-garde in the years before World War I. Avant-garde groups produced art that was clearly a reaction both positive and negative to the circumstances surrounding the modern world and its urban pressures: works as varied as those by Pablo Picasso, Käthe Kollwitz (1867–1924), Ernst Ludwig Kirchner (1880–1938) and Umberto Boccioni (1882–1916). The idea of

the modern condition can be defined in terms of a concept of expression, found in many forms within avant-garde culture in the first two decades of the twentieth century. As the journey into the new century intensified, the avant-garde felt the modern condition deeply and, as a consequence, the term is combined with the idea of the 'self' of the artist, which may *possibly* be expressed. This combination demanded the attributes of authenticity, which was typically found in marginalized places and in Nature – Nature cults and so-called peasant or primitive cultures. Part of the paradox of the modern condition is that while it sought the authenticity of Nature, its art was practised in a modern urban setting. Before the outbreak of war, sophisticates and avant-garde intellectuals – those at the forefront of the art world – used these apparent authenticities, notions and ethnographic artefacts to critique Western environments and societies, distancing themselves from their own cultural values and priorities.

The modern condition was felt across Europe and had become entirely international by the beginning of World War I. It spawned various art movements, most notably:

- **Cubism** – pre-eminent in Paris, in the period 1907–14.
- **Expressionism** – developed in the German-speaking world (Berlin, Munich, Dresden and Vienna) and aligned with a tendency towards the highly expressive or subjective within a German philosophical and cultural tradition that distinguishes Expressionism from the more rationalist and classicizing tendencies submerged in, for instance, art in France.

- **Futurism** and **Constructivism** – embraced by centres in Italy and Russia (which came relatively late to modernization) that found in their art 'the distinctive rhythms of the modern as it shot through those hitherto relatively backward societies'.[2] The Futurists were exhilarated by the vibrancy of life in modern cities.

Throughout Europe a deep feeling for tradition nonetheless shadowed the acute experiences of the modern. Representationally, it follows that that Cubism, Expressionism and Futurism indicate the varying aspects of the avant-garde's reaction to the modern.

The response to the modern condition manifested itself in two diametrically opposing ways:

1. A deeply felt cynicism as regards mass industrialization and urbanization, which brought about a sense of alienation and even the apocalyptic.
2. A near unrestrained exhilaration for the modern world. The German sociologist Max Weber (1864–1920) struck a resoundingly pessimistic tone in his *The Protestant Ethic and the Spirit of Capitalism* (1904–05), describing modern culture as being like a restrictive 'iron cage'. By contrast, the French philosopher Henri Bergson (1859–1941), in his *Creative Evolution* (1907), sought to map human cognizance in connection with flux, change and sensation. Bergson's concepts of memory, the *élan vital* (the vital force or impulse of life) and the subjective formation

of reality pervaded avant-garde circles, having a bearing on Cubism and, more directly, Futurism. But Modernist forms of expression were marked by a concern with the *surface* of an artwork, and with wrestling colour and structure from traditional representation.

Laughter *(1911) by Umberto Boccioni. As well as shaping the Futurism movement through his painting, Boccioni also turned to producing sculpture after a visit to Paris in 1912.*

Max Weber *(seen here in 1894) – one of the founders of sociology.*

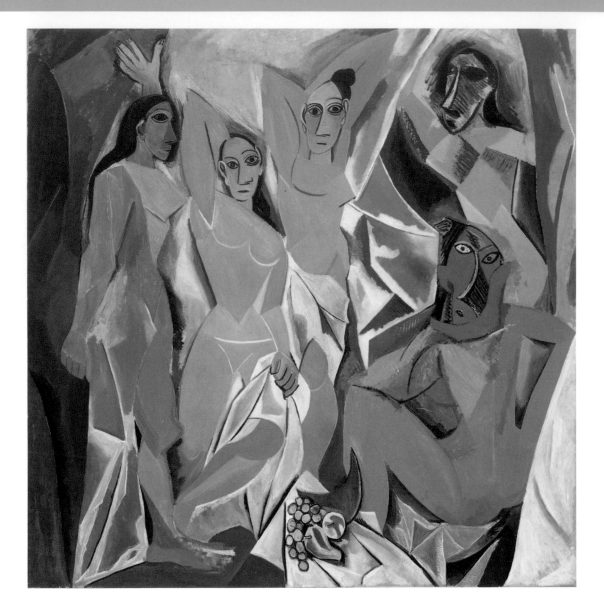

Above: *Les Demoiselles d'Avignon (1907) by Pablo Picasso. He made many preparatory drawings for the work.*

Opposite: *Les Grandes Baigneuses (1906) by Paul Cézanne. The artist worked on the painting for seven years and it remained unfinished at the time of his death. It was one of a series on the same subject and owes much to the influence of Titian and Rubens.*

PICASSO'S *LES DEMOISELLES D'AVIGNON* AND THE COMING OF CUBISM

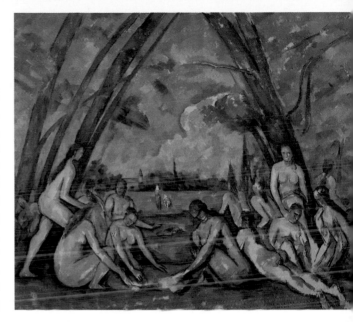

Historians of Picasso have long argued that *Les Demoiselles d'Avignon* (1907), although not a Cubist painting in itself, allowed nonetheless for the dramatic break that made Cubism possible. *Les Demoiselles* has been at the centre of debate in critical theory for some decades: with its huge inconsistencies in style, strident ugliness and intentionally shocking subject matter, the work has drawn more attention than any other painting in the history of Modernism. *Les Demoiselles* is now seen as the first true painting of the twentieth century – the first to encompass complex discussions, including personal traumas (desire and death), anarchist sympathies and colonialism, relating to Picasso's primitivizing appropriation of non-Western statuary, African masks and Egyptian hieroglyphs. Alternatively, the adaptation of spatial solidity, seen in the work of the Post-Impressionist painter Paul Cézanne, has been regarded as a key component in the creation of *Les Demoiselles*. The Cubist facets that appear on some of the women's breasts and among the crumpled drapery have been linked to the attempts of Georges Braque and Picasso to create sculptures through means of painting.

The work portrays five nude females, prostitutes in a bordello, tightly packed into a shallow space and standing on a narrow platform, leaning back against a pair of bulky curtains that act like huge stage flanks. While two masked females burst onto the scene through a background set of curtains, their forward-facing companions threaten the spectator with menacing and disconcerting gazes. Given the content of *Les Demoiselles* – primitivized faces and female bodies in connection with debased sexuality, prostitution and brothel life – Picasso is either manipulating or fostering stereotypes that link both white and non-white women with coarse sexual displays and a supposed instinctual vitality and potency.

Picasso was also deeply affected by Paul Cézanne's large bather compositions (such as *Les Grandes Baigneuses* [1906]), particularly the monumentality and structural arrangements of his female figures, which were often associated with the avant-garde's 'discovery' of **l'art nègre** around 1906. In this work and others, Picasso laid the foundations of a movement that would become one of the most important and debated idioms of twentieth-century art history: Cubism.

MATISSE, FAUVISM AND PRIMITIVISM

With *Les Demoiselles*, Picasso was perhaps trying to distance himself from the Parisian vanguard, particularly Henri Matisse (1869–1954) and Fauvism, although 'Matisse himself never claimed for any definitive role within Fauvism as a movement.'[3] Controversial paintings by Matisse such as *Luxe, calme et volupté* (*Luxury, Calm and Sensuality*, 1904) and his masterpiece *Le Bonheur de vivre* (*The Joy of Life*, 1906), exhibited at the Salon des Indépendants of 1906, certainly demonstrate that the modern condition is based on a search for authenticity. It was perhaps no accident that Matisse's fauve landscapes, which resulted from a summer sojourn, are formed by means of highly bold painterly expression, flat brushwork and glowing patches and marks of bright colour that suggest heat and light, and that 'affirm the planarity of the [picture] surface as a taut, stretched membrane'.[4] More to the point, in Matisse's *La Danse II* (1910), his primitives are likewise far away from the afflictions of modern society.

Matisse's glowing landscape, strewn with naked females in an uncritical state of primitive nature, mentality, joyful abandon and a certain orientality, must have irritated Picasso in the extreme, just as much as Matisse perceived *Les Demoiselles* as 'an outrage, an attempt to ridicule the modern movement' and an 'audacious hoax'.[5]

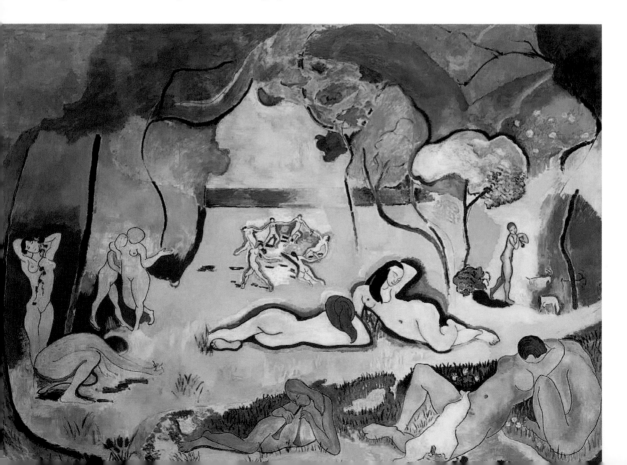

FAUVISM ▶ a term coined by Louis Vauxcelles, who described exhibiting artists as 'wild beasts'. It was one of the earliest stylistic, Modernist movements to channel the desire for expression via a search for authenticity in art.

Below: A Fang mask, dating from the late nineteenth or early twentieth century, that would have been worn in a Ngil ceremony in Gabon by the Fang people.

L'ART NÈGRE AND COLONIALISM

In later life, Picasso always took the stance of denying any connection between *Les Demoiselles* and tribal art, but as his preparatory studies for the painting reveal, its relationship with primitivism and *l'art nègre* is irrefutable. *L'art nègre* (translated literally as 'negro art', but better understood as African art), and related derivations such as 'primitive' or even 'savage' art, are now universally seen as pejorative and even racist terms. Nevertheless, they were habitually used in France, Germany and other European countries to describe non-Western artefacts, primarily from Africa and Oceania, up until about 1940. In *Totem and Taboo* (1913), for instance, Sigmund Freud remarked that the only discipline in our civilization to have retained an element of magic was the field of art. Freud's interest in magic was restricted solely to a fascination with animism and the 'omnipotence of thoughts', in what he called primitive or savage societies. The suppositions of the psychiatrist and the anthropologist James Frazer's *The Golden Bough* (1890–1915) did much to popularize and determine primitivizing stereotypes in relation to the principles of religion and magic among French and German avant-garde circles. Modernist groups of artists appropriated *l'art nègre* in such a way as to establish what can only be described as 'a cult of the primitive'.

Picasso's reference to the primitivism of *l'art nègre* therefore clearly affected the conception of *Les Demoiselles d'Avignon*, as well as changing the formal structure of his Cubism in general. It is under these circumstances that we can begin to understand his references to tribal sculpture, masks and fetishes in later Cubism.

CUBISM: AN ART OF 'LITTLE CUBES', FACETS OR SIGNS?

Cubism was the creation of two artists, Georges Braque (1882–1963) and Pablo Picasso (1881–1973). Cubism is not easily recognizable, but is a highly esoteric art form. Its forms were

Opposite: Le Bonheur de vivre (1906) by Henri Matisse. As a student of the Symbolist painter Gustave Moreau (1826–98), Matisse was drawn to ideas relating to sensibility and imagination in art, as opposed to the quasi-scientific colour theories promoted by nineteenth-century artists. Matisse's great canvas foresees the end of Fauvism and demonstrates a reaction by many French avant-garde painters to the large Bather subjects of Cézanne.

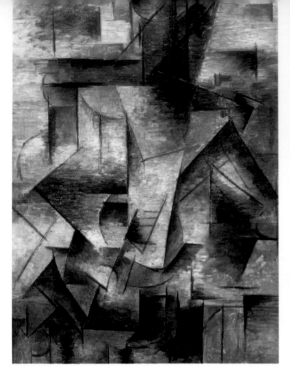

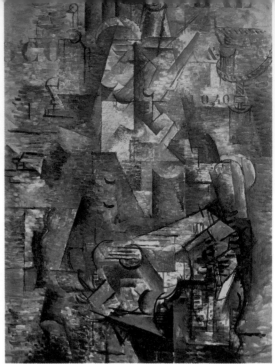

quickly adopted by the Salon Cubist (followers) and avant-garde groups, but what Cubism meant, what it stood for, what it represented and how it was perceived, was – and still is – a point of contention, particularly in its so-called 'analytic' and 'hermetic' phases. The term *Cubism* – originating from Matisse's description of Braque's work as composed of 'little cubes' – cannot possibly do justice to the highly heterogeneous, inventive, animate and astonishing idiom that it is. The term gives us something to cling to when looking at this difficult and varied art, but the term is misleading, even meaningless.

In Cubist painting, the subject is frequently hidden beneath a surface of shifting planes, facets and fractured objects, which break up solid masses into a series of abstract components – Cubism's primary objective. Painted in the summer of 1910, Picasso's

Above left: The Guitar Player *(1910) by Pablo Picasso. This form of Cubism focuses on the analysis of the subject depicted. Picasso denied that the work was abstract, believing that the reality of the original object still existed within the work.*

Above right: Le Portugais *(1911) by Georges Braque, one of Cubism's most famous early works. Art historians often focus on the use of stencilling.*

The Guitar Player (1910) becomes a mass of horizontal/diagonal lines that suggest abstracted planes, features and forms, splintering the figure into a multiplicity of parts. In many works created between 1910 and 1911, Picasso and Braque's paintings (and that of their fellow Cubist innovator Juan Gris, 1887–1927) incorporate phenomenological details of letters, numbers, words, phrases, musical notation,

excerpts from advertisements, newspapers or popular songs and other descriptive details in this Cubist lexicon. In Braque's *Le Portugais* and Picasso's *The Mandolin Player* (both 1911), the modernity is difficult to define: to know *what* exactly is signified, or even *where* it is situated, that strange, indeterminate 'thing' nonetheless irrefutably perceptible.[6] As Neil Cox, a specialist scholar of Cubism, indicates, the form and subjects of Cubist paintings can be interpreted in many 'different ways, depending on the subject one imagines it depicts'.[7] John Golding, in his pioneering study *Cubism* (1959), instantly recognized one of the most enduring features of Cubist art: 'It is as if the painter had moved freely around his subject, gathering information from various angles and viewpoints. This dismissal of a system of perspective which had conditioned Western painting since the Renaissance marks ... the beginning of a new era in the history of art.'[8]

The Guitar *(1912) by Pablo Picasso. Recent examination of* The Guitar *at the Museum of Modern Art in New York confirms its makeshift-looking characteristics, the original constituents held in place by gravity and fixed only temporarily with pins.*

Perhaps the difficulty lies in the fact that Cubism internalizes its modernity with a new pictorial 'language'. Picasso's 1912 *Guitar* is clearly a built image: a cardboard construction with definite pictorial and iconographical characteristics, its simple cut-out shapes imitating a real guitar. The debris of the construction, perhaps found in and around the studio, is assembled to form new signs, giving meaning to the material in its most physical sense and to the flat shapes arranged in simple semantic relationships. The use of modern manufactured objects and materials likewise signifies Cubism's modernity, and ground-breaking works such as Picasso's *Still Life with Chair Caning* (February–April 1912) and *The Guitar* (Autumn 1912) were to become the paradigm of the modern condition. In the words of the great American writer Gertrude Stein (1874–1946), the intention of these avant-garde movements, and of artists such as Picasso with his 'grande machine' *Les Demoiselles*, was 'to kill the nineteenth century'.[9]

MARCEL DUCHAMP AND THE 'ART' OF THE 'READYMADE'

The Cubists' use of collage, construction and assemblage techniques provided new ways to explore and express a sense of modernity's wider culture. But modern artists like Marcel Duchamp (1887–1968) set out to challenge the very concept of art and the notion of an artwork itself. Duchamp was one of the most important artistic provocateurs, and his influence is not without significance. His concept of the **readymade** allowed choice, chance and the mundane to inhabit artistic practice by 1913–14, taking Cubism's use of the ubiquitous to

its logical conclusion. Essentially, Duchamp's readymades should be understood within the context of the nihilism of **Dada** and the era of World War I, since Dada was a reaction to the war and the political, social and economic chaos that followed it. It was an attitude summarized by the Dadaist painter and filmmaker Hans Richter (1887–1976), who explained, 'Pandemonium, destruction, anarchy, anti-everything of the world of the war? ... How could Dada have been anything but destructive, aggressive, insolent, on principle and with gusto?'[10] Duchamp did not unveil his seminal concept until 1916, in New York, where he had resided intermittently since 1914. Nevertheless, the artist had previously enacted this revolutionary step some three years earlier, appropriating and upturning a wheel and stool to fashion *Bicycle Wheel* (1913). The highly provocative nature of Duchamp's readymade works – objects that questioned the very character of art and whose production reflected both sardonicism and scepticism – defined the Frenchman as an interloper with a nihilistic sensibility.

Duchamp's use of play, games of illusion and reality, irony, nonsense and paradox littered his works with a wit, while also signalling his assault on traditional artistic methods and his fascination with modern-day industrial processes, mechanical reproduction and contemporary objects or products. Iconoclasm, mockery and an irreverence for artistic production are the stamp of Duchamp's oeuvre. The readymades also encapsulate Duchamp's much sought-after artistic freedom, his search for an art derived from mental constructs, and his archetypal persona as artist-provocateur.

His bastardized version of Dada used motifs that would reappear in Pop and Conceptual art in the 1960s. With his 1913 *Bicycle Wheel*, 'the first expression of the thing that would be called the "readymade"', Duchamp's art rejected purely visual processes – which he decried as 'retinal' – in search of a more conceptual system of art-making. This readymade object gave rise to the query as to whether a work could be made that was not a work of art. The answer was a liberation: art could now be made from anything. It could represent anything, be anything.

Duchamp's readymades and 'assisted readymades', such as the iconoclastic *Fountain* (1917) and *L.H.O.O.Q.* (1919), are nonconformist objects unparalleled in the development of Modernism in the twentieth

century. It's true that these should be understood within the context of Dada, but it would be churlish not to recognize that Modernist artists sometimes also appropriated the choices, objects and materials of Duchamp and other Dadaist artists. However, early Modernist art appropriated elements from reality at large only to further its own independent status as art. Despite the blurred boundaries, this is something that distances Duchamp's conceptualism from the wider concerns of Modernism.

CONFORMITY AND DISSENT: NEO-CLASSICISM, 'CALL TO ORDER' IDEOLOGY AND REACTION IN FRENCH ART

There is good reason to believe that the timing of the avant-garde venture into a form of neo-classicism was influenced by the outbreak of World War I. In the decades before and after the war, various ideas and contrasting visions of conformity and dissent operated within avant-garde groups in France. Contemporary society was seeking some sort of order and sobriety, particularly through the myth of France

as a nation steeped in Latin traditions and civilizing values – an idea often championed by right-wing writers and politicians as an antidote to Modernist idioms like Cubism, which they perceived to be nothing less than a foreign invasion from the Left. The precise reasons for this shift towards the neo-classical or naturalistic in modern art are complex, but reflect a general reaction within post-war Western Europe to the profound social and political disturbances of the time. In 1917, Russia was in the paroxysms of a revolution, and the war deeply affected the European art world. The art trade withered and works of art became harder to sell. In returning to classical principles, modern art was thought to be appropriating the authentic spirit or values of French culture, in particular the tradition of Poussin, Ingres and Cézanne.

These and other factors undoubtedly had an impact on French art. However, they do not explain the artistic dissent in wartime France. Nor do conservative ideologies account for the contrasting styles that Picasso and other Cubists produced at this time. *The Bathers* (1918),

Opposite: Bicycle Wheel *(1913) by Marcel Duchamp.

Right: Fountain *(1917) by Marcel Duchamp. The original work was lost and a replica was recreated in 1964. Duchamp submitted it for exhibition to the Society of Independent Artists, whose board decided to exclude it.*

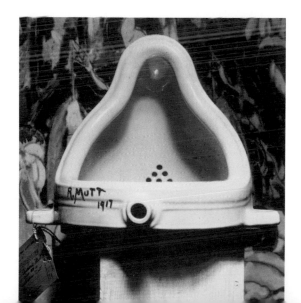

created during the wartime period, does not ascribe to 'call to order' idioms or post-war propaganda and codes rejecting irrationality, sexuality, excess and disharmony. In fact, trying to classify the artist's painting at this time is almost impossible given that Picasso employed neo-classical, naturalist, realist and Cubist styles (often simultaneously). The melancholy and nostalgic *Three Musicians* (1921) made self-conscious allusions to the theatre, to the modern painting

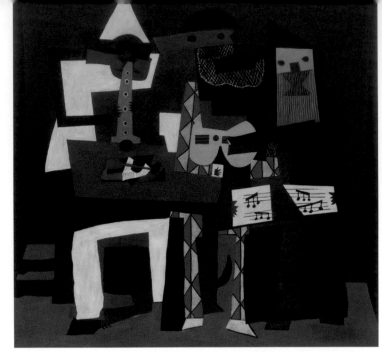

style of Cubism and to themes of antiquity derived from poetry. By contrast, *Seated Woman* (1920) and *Three Women at a Spring* (1921) infer that the Cubist innovator had returned to a kind of neo-classicism, abandoning Cubism's fragmentation for a more 'naturalistic' style of painting: one that espoused post-war 'call to order' values of *fécondité et maternité* (fecundity and maternity). Picasso's paintings show monumental female figures seemingly absorbed and lost in thought or reflecting on things past. They also equate the figures with Roman or Greek goddesses, drawn from poses and in garments that referenced the world of classical antiquity. If this is the artist's version of Arcadia, it inverts traditional iconography in favour of a barren and desolate interior: a mausoleum containing funerary objects (jars and jugs), perhaps holding the ashes or spirits of the dead souls from the immediate aftermath of the war.[11]

In a volatile political climate, clamouring for 'civilizing, Latin values', French writers and artists were keen to defend Cubism and Modernism through any means possible, notably by using precisely the same conservative language as those critics who saw Cubism as little better than a foreign enemy. In France, Cubism was seen as pro-German and hostile to the core values of French culture. Although a highly irrational stance, this reaction expressed nationalist anxieties and fears provoked by the avant-garde and concerning the fate of traditional French culture.

It was under these 'call to order' principles and other reactionary mandates that the Purist movement evolved. In *Still Life with a Pile of Plates* (1920) or *Purist Still Life* (1922), we can observe Purism's highly conservative or 'classicizing' tendencies in post-war art. Alongside Amédée Ozenfant (1886–1966), the founder of the Purist movement, was Charles-

Right: Still Life with a Pile of Plates *(1920) by Le Corbusier. Tasteful, not strident, colour introduces muted tones and intimates artistic restraint. Hence the Purists sought to 'correct' or purify the earlier geometrical errors of Cubism.*

Opposite: Three Musicians *(1921) by Pablo Picasso. With his use of the Pierrot and Harlequin characters, the artist evokes the traditional figures from the Italian commedia dell'arte.*

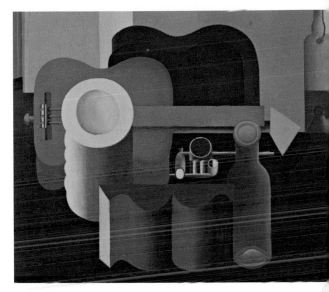

Édouard Jeanneret (1897–1965), better known as Le Corbusier. His paintings are in no sense post-Cubist or a 'movement of Purism', as Ozenfant earlier claimed, but rather are an academicization of Cubism, based, illogically, on a general misinterpretation of the Cubist project. In an earlier essay, 'Notes on Cubism' (published in *L'Élan*, No. 10, Paris, December 1916), Ozenfant stated his burning desire, in the altered circumstances of the war and its aftershock, to cleanse Cubism by distancing it from any international – i.e. German – connections. Ozenfant intentionally sought to create a direct association with the French classical tradition.

On the whole, Purist painting is schematic and orderly. Gone are the ambiguities, complexities and spatial fragmentation of Picasso and Braque's pre-war Cubist works. In Le Corbusier's still lifes, the complexities of detail reduce each element to its essential form. The Purists sought to 'correct', rationalize or purify the earlier geometrical 'errors' of Cubism. Unsurprisingly, Purism's tract *L'Esprit Nouveau* (*The New Spirit*, 1920), edited by Le Corbusier and Ozenfant, praised logic, restraint and order in art.

None of this was new, of course. Purism's ideas were first touted in October 1912 by a group exhibiting at the Salon de la Section d'Or (Golden Section). Subsequently, the type of work admired by the Purists included Léger's cityscapes, which resembled the factory chimneys, ocean liners, modern cars and other mechanistic devices illustrated in the pages of *L'Esprit Nouveau*. So Purist paintings recode the classical, presenting them as a more logical and universally legitimate type of expression. The Purists saw a direct connection between modern art and mathematics, claiming that 'a work of art should induce a sensation of a mathematical order, and the means of inducing this mathematical order should be sought among universal means.'[12]

Left: The cover of the first edition of L'Esprit Nouveau which appeared in 1920. It produced just 28 editions.

Below: The City (1919) by Fernand Léger. The artist began his career as an architectural draughtsman, but went on to evolve a very personal form of Cubism that influenced the development of Pop Art.

SURREALISM

Surrealism as an idiom or movement is not easy to define, but the term is most commonly used to describe a fascination with the unconscious, dreams and desire. The Surrealists' investigations into irrationality, madness, delirium and desire were driven by, and symptomatic of, a long history of psychoanalytical theory, in particular the work of Sigmund Freud (*see* Chapter 7). Whereas Freud attempted to harness the undirected stream of the subconscious or to 'cure' pathological states, the Surrealists celebrated the 'dream state' as the purest declaration of mankind's creative freedom. André Breton (1896–1966) published the inaugural edition of *La Révolution surréaliste* on 1 December 1924; it contained a plethora of images,

objects and literary experiments that were an attempt to explore the hidden territory of the subconscious.

Surrealism issued out of the Dadaist movement, though its use of collage and the *objet Surréaliste* took a highly iconoclastic and dangerous form: the group's concept of 'convulsive beauty' involved shocking and irrational ideas, actions or juxtapositions. The film *Un Chien andalou* (1929) by Salvador Dalí (1904–89) and Luis Buñuel (1900–83) is ostentatiously avant-garde in its tactics. With *Un Chien andalou*, Dalí burst onto the Surrealist scene without warning, his talent for self-aggrandizement quickly marking him out as the movement's most infamous spokesperson. (Surrealism's founder and actual leader was André Breton.) Throughout his career, Dalí cultivated bizarreness, shock tactics and exhibitionism – his most outlandish stunt involved delivering a lecture wearing a diving suit; he almost suffocated. He made another experimental film, *L'Age d'or* (1930), and created a dream sequence for Alfred Hitchcock's film *Spellbound* (1944). Dalí is especially famous for his *objets Surréalistes* such as *Lobster Telephone* (1936) and hallucinatory paintings that depict strange biomorphic creatures on stilts; eerie landscapes filled with, for instance, burning giraffes and melting clocks crawling in ants, as in *The Persistence of Memory* (1931).

Surrealism's ultimate target was the self-satisfied tyranny of reason, and it sought to force open the unconscious floodgates so that humanity could be reborn whole again. André Breton adopted the avant-garde manifesto to announce the new French Surrealist group. 'SURREALISM, n.,' his characterization ran, 'Psychic automatism in its pure state … Dictated by thought, in absence of any control exercised by reason, exempt from any aesthetic or moral concern,'[13] Breton's manifesto set out to acquire the results of psychic automatism in two of the following ways:

1. A type of automatic writing exercised by stream-of-consciousness thinking, which he had previously explored in his poetic work *Les Champs magnétiques* (*Magnetic Fields*, 1920), where he first suggested the term 'automatically'.
2. The irrational products provided by dreams. In fact, Surrealism's very first act was

A still from the film Un Chien andalou *(1929) showing the moment a man appears to cut the eye of a woman with a razor.*

to establish a focal point – a bureau of research – to collect dream-data (presented by younger associates) and to create a periodical, *La Révolution Surréaliste*, in which to publish their psychic investigations.

Unlike Purism, Surrealism was entirely opposed to a rationalist aesthetic. A number of artists and intellectuals, including Breton and the German émigré Max Ernst (1891–1976), had first-hand experience of the war, and Breton's recognition of Freud's ideas about psychoanalysis, dreams, hysteria and various forms of psychic trauma derived from his wartime experiences and the disturbances of its casualties: key factors that had a crucial impact on the development of Surrealism. Max Ernst's collage *Murdering Airplane* shows two figures carrying a wounded soldier from the wasteland trenches. Above, a bizarre and nightmarish creature is conflated with airplane parts, disjointed fragments of gesturing female hands, and a strange wing-like appendage. *La Conquête de l'air* (*The Conquest of the Air*) was the outstanding and glorifying image of modern art, but here that symbol is turned on its head to become a bizarre harbinger and angel of death.

The Persistence of Memory (1931) by Salvador Dalí. In this classic Surrealist work, Dalí investigated the relationship between time and space and his thoughts on the concepts of 'hardness' and 'softness'. The strange, creature-like form that appears to fade into the surface of the image owes much to Hieronymus Bosch's The Garden of Earthly Delights.

Although Surrealism sought to release the individual's creative potential through art, it was as much a political as an artistic idiom seeking to transform society and human consciousness. The surrender to chance and the automatic were key factors in Surrealism. André and Simone Breton (née Kahn, 1897–1980), Max Morise (1900–73) and Jacques Prévert (1900–77) modified the common game of Consequences in which each player contributes words without the next participant being able to observe the earlier word(s). It's a principle that voided conscious control and, when adapted to a visual game, produced the most striking images. *The Exquisite Corpse* (1927) by Man Ray (1890–1976), Yves Tanguy (1900–55), Joan Miró (1893–1983) and Max Morise involved a sheet of paper being folded into three or four sections, participants taking turns to draw parts of a creature without seeing what the others had created. No one could predetermine the final outcome, the result being the 'automatic' fashioning of a fantastical creature: *Le Cadavre exquis*. The game not only disclosed a treasure trove of the imagination, combining reflection with chance,

but also undercut individuality in a work of art. In this manner, the game epitomized the Surrealist anti-aesthetic far more stringently than, say, the art created by a specific member of the group.

Other themes of great interest to the Surrealists were those of transformation and taboo. The bronze sculpture *Woman with Her Throat Cut* (1932), by Alberto Giacometti (1901–66), is a figure that is part-woman, part-insect and part-plant, and is additionally suggestive of a deadly mechanical mantrap. The way that her internal parts are laid open, revealing a bony carapace and bulbous organs, intimate rape or disembowelment. (Preliminary sketches show the figure being pierced by a stake or screw.) By presenting his subjects in this way, Giacometti was probably testing the limits of taboo in art, part of the disturbing trend in Surrealism.

Yet Freudian ideas regarding fetishism, sexuality and the unconscious are both celebrated and sent up by Méret Oppenheim (1913–85) in *Object: Luncheon in Fur and Ma*

Above: The artist Joan Miró photographed in 1935 by Carl van Vechten.

Right: La Conquête de l'air (1920) by Max Ernst. With its two giant arms, the giant airplane is shown as a bringer of death. Airplanes were used in combat for the first time in World War I.

gouvernante – My Nurse – Mein Kindermädchen (1936). As the art historian Carol Duncan long ago identified in her book *Aesthetics of Power* (Cambridge University Press, 1993), the art of the early twentieth-century vanguard was habitually steeped in a culture of masculinism. Oppenheim was infamous for her *objets Surréalistes*, subverting the world of male morality. While women artists including Oppenheim, Lee Miller (1907–77) and Claude Cahun (1894–1954) did not overthrow the suppression of women identified in the work of male Surrealists, they nonetheless exploited the freedom offered by the idiom to articulate their own ideas. As such, they did much to change the Surrealist movement.

THE MODERNIST AMBITION

Modernist movements were predominantly occupied with wrestling art away from traditional forms of representation. 'However, different they may have been, the variant responses of depression and exhilaration are two sides of the same coin.'[14] That is to say, Modernist art tries to decode the modern and 'even participates in changing it' by converting it into an understandable language. Alternatively, it reacts to the modern condition and concludes that art must change itself. As Charles Harrison and Paul Wood point out, the latter signifies the machination and complexity of Modernism, and that the 'problem of the relation of … art to a wider social change has remained constitutive of all ambitious art in the modern period'.[15]

Le Cadavre exquis (The Exquisite Corpse) *(1927) by Man Ray, Yves Tanguy, JoanMlró and Max Morise. Many groups of artists produced similar works.*

Left: Woman with Her Throat Cut (1932) by Alberto Giacometti. This work forms part of a series created by the artist in 1930–33.

Below: Ma gouvernante – My Nurse – Mein Kindermädchen (1936) by Méret Oppenheim. The first version of the work was destroyed and this replica was made for an exhibition in 1967.

GLOSSARY

1. **Abstract Expressionism** – an art movement arising in New York during the post-war period of the 1940s and '50s, characterized by spontaneous or subconscious brushstrokes, including spattered, poured and scraped paint.

2. **Aquatint** – a printmaking technique in which an artist inscribes the surface of a copper or zinc plate. These sunken areas then hold the ink, and the finished result has areas of tone and colour rather than just lines.

3. **L'Art nègre** – literally *'Negro Art'*, but better understood as African art. The term and other terms – such as 'primitive' and 'savage' art – were commonly used in Western Europe up until 1940 to refer to artefacts that originated in Africa and Oceania. *See also* Primitivism.

4. **Avant-garde** – from the French avant meaning 'before' and garde meaning 'guard'. In the nineteenth century it was used in a very literal, military sense. The term filtered into artistic circles in the 1880s. It was borrowed again around 1910 as a term for 'pioneers or innovators of a particular period'. Avant-garde refers to art and artistic movements that were seemingly ahead of their time, those pushing the boundaries.

5. **Baroque** – an era after the Renaissance, from the beginning of the seventeenth century to the mid-eighteenth century, starting in Italy and spreading throughout most of Europe and the colonies of the Americas. It was characterized by exuberance, extravagance and realism, with great drama, rich colours and intense contrasts between light and shade.

6. **Bottega** – a fifteenth-century Renaissance workshop in which master artists taught their students.

7. **Camera obscura** – from the Latin meaning 'dark room', a seventeenth-century device that aided accurate drawing and painting by projecting an image through a small hole in a screen onto a surface opposite the opening. An artist could then trace the projected image, thereby achieving the proper perspective.

8. **Chiaroscuro** – a term originating in the Renaissance, in which a painting has strong, bold contrasts between light and dark.

9. **Connoisseurship** – the art of authenticating and dating paintings; the ability to discern who painted a particular work, and when and how they painted it. Together with Formalism, it allows scholars to identify works by individual artists. *See also* Formalism.

10. **Constructivism** – a philosophy of art originating in Russia in 1913, rejecting the idea of autonomous art in favour of 'constructed' art. Objects were not created to express beauty or the artist's point of view, but as functional items to be put into mass production. Constructivists were interested in the properties of various materials such as wood, glass and metal, and their artworks were dictated by these materials.

11. **Cubism** – an avant-garde art movement that took hold in Paris around 1907–14. Objects and figures were expressed as distinct areas or splintered planes, with several different viewpoints showing at the same time. This created the illusion of three-dimensional depth, with the addition of hidden subjects and abstracted components.

12. **Dada** – an early twentieth-century European art movement founded by Hugo Ball (1886–1927) as a reaction against the horrors of World War I. Artists such as Marcel Duchamp and Man Ray rejected the violence of war, and created art that was satirical and sometimes nonsensical.

13. **Divisionism** (or **Pointillism**) – a Neo-Impressionist style of painting in which colour was separated into individual dots or strokes of pigment. 'Divisionism' refers to the separation of colour, while 'Pointillism' refers to the technique of applying the dots.

14. **Expressionism** – a modern German art movement in which an image of reality was deliberately distorted in order to convey an artist's subjective inner feelings about the subject matter. Colour was often very bright and non-naturalistic, and paint was applied liberally.

15. **Expression** – in the context of Heinrich Wölfflin's Principles of Art History, refers to the four stylistic and historical forms that characterize all works of art: temperament, school, country and race.

16. **Fauvism** – from the French les fauves meaning 'wild beasts', the term was coined by the critic Louis Vauxcelles in his mocking review of Henri Matisse and André Derain's paintings at the 1905 Salon d'Automne exhibition in Paris. The Fauvist movement was typefied by bold colours and fierce brushwork, and the subject matter was highly simplified and 'primitive' in style.

17. **Fêtes galantes** – literally 'courtship parties'. These were representations of French life during the eighteenth century, often depicting groups of elegantly attired people in parkland settings entertaining themselves with music, dancing and courtship.

18. **Form** – a three-dimensional element used by an artist as a tool to compose an artwork; it has a length, width and depth, and may be geometric or organic in shape. Geometric forms may include cubes, spheres or cylinders; free-flowing (organic) forms may consist of flowers, clouds or the human figure. *See also* Style.

19. **Formalism** – the study of art based purely on analyzing and comparing form and style, including the way in which objects are constructed and what they look like.

20. **Fresco** – a mural-painting technique perfected in Italy during the Renaissance, in which water-based paint is applied directly onto wet plaster so that the paint is absorbed and becomes an integral part of the wall. *See also* Secco; Tempera.

21. **Futurism** – a twentieth-century Italian art movement in which artists were inspired by the exuberance and energy of modern city life. Proponents used

elements of Impressionism and Cubism to create compositions that celebrated the dynamism of modern industry and technology.

22. **Guild** – an association of artists, craftsmen or merchants. Guilds flourished in Europe between the eleventh and sixteenth centuries, with professional artisans being significant members of society.

23. **Historiographer** – a writer of history, especially an official historian appointed to write about a particular group, period or institution.

24. **Humanist** – a person espousing the non-religious belief that the universe is a natural phenomenon, with scientific method and critical thinking being the best way of understanding it.

25. **Iconography** – from the Greek meaning 'image' and 'to write or draw', the term refers to a branch of modern art history in which imagery is studied by analyzing its subject matter. *See also* Iconology.

26. **Iconology** – the study of imagery by interpreting its symbols and how they relate to cultural factors, such as nationality, social class, religion and philosophy. *See also* Iconography.

27. **Impressionism** – a major art movement originating in Paris in the 1860s, in which artists often painted *en plein air* (in the open air), with the aim of capturing spontaneous impressions of the moment. Impressionist painters were especially interested in the transient qualities of light, colour and movement.

28. **Memento mori** – from the Latin meaning 'remember you must die', a symbolic image that reminds us of the fragility of life and the inevitability of death. *See also* Vanitas.

29. **Orientalism** – the depiction of aspects of the Eastern world in works of art. Many scholars have debated its implications, from being timeless and exotic to patronizing or even demeaning.

30. **Parietal art** – archaeological term for wall art, including paintings and etchings, and carvings.

31. **Plein air** – literally 'open air', French Impressionist painters advocated outdoor painting because it allowed them to capture light effects that were unique to certain times of day and particular locations.

32. **Pointillés** – small dots of white or slightly yellowish paint that look like points of light.

33. **Positivism** – a philosophical theory in which knowledge is derived from sensory experience and then interpreted through reason and logic. The term was adopted by the Impressionists who captured the fleeting sensations of their subjects *en plein air*, and also the Realists who focused on everyday tangible facts of the modern world.

34. **Post-Impressionism** – an art movement that emerged in France as a reaction against the Impressionism. Post-Impressionist artists instead favoured geometric forms and used unnatural or arbitrary colours.

35. **Primitivism** – the interest of early modern European artists in 'primitive' art, including tribal art from Africa, the South Pacific and Indonesia, as well as European folk art and prehistoric art. *See also* L'Art nègre.

36. **Readymade** – a term coined by the modern French artist Marcel Duchamp, who challenged the very concept of art by exhibiting ordinary, functional manufactured objects.

37. **Realism** – a mid-nineteenth-century style in which everyday objects and settings were painted in a naturalistic manner.

38. **Renaissance** – an era that spread from Italy throughout the rest of Europe from the fifteenth to the sixteenth centuries, in which art, architecture, philosophy, literature, music, science, politics and religion underwent a 'rebirth' after the Middle Ages.

39. **Rococo** – from the French rocaille meaning 'rock-work', recalling the curves and scrolls of seashells, an exceptionally ornate, decorative style that developed in the 1730s in France.

40. **Romanticism** – a nineteenth-century movement in art, literature, poetry, music, theatre, ballet and architecture, characterized by the expression of personal feelings, beliefs and values, as well as celebrating the beauty of the natural world.

41. **Secco** – a technique for painting on dry plaster walls using pigments mixed in water. It contrasts with fresco in that the painting is executed on dry plaster rather than wet. The technique was very popular during the Renaissance. *See also* Fresco; Tempera.

42. **Style** – the way an artwork looks; the manner in which the subject matter is portrayed and how the artist expresses their vision. Style is influenced by form, colour, composition, the handling of the chosen medium and the ideas behind the artwork. *See also* Form.

43. **Sublime** – an eighteenth-century Romantic concept, as espoused by Edmund Burke in 1757. In his definition, the sublime comprised fear, doubt, darkness, solitude, vastness, danger, pain, loudness and suddenness. Romantic paintings in this style often depicted magnificent mountain ranges, terrifying seascapes, violent storms or animal attacks.

44. **Surrealism** – meaning 'beyond realism', a twentieth-century art movement in which artists explored the workings of the mind. It aimed to unlock images held in the unconscious.

45. **Symbolism** – a late nineteenth-century art movement, especially prevalent in France, that advocated the expression of ideas in art. Symbolist artists looked inwards to their own subjective thoughts and imagination, painting dream worlds populated by mysterious figures.

46. **Tempera** – from the Latin temperare meaning 'to mix', a painting technique in which coloured pigments are mixed with a water-soluble medium such as water and egg yolks, oil and a whole egg, or plant gum. The paint dries to form a hard film, making the finished work highly durable. The technique was used by Renaissance artists before the invention of oil paint. *See also* Fresco; Secco.

47. **Theory** – a supposition or system of ideas intended to explain something. In art history, having a theory helps scholars to ask the right questions, and involves the study of a variety of topics, including cultural practices, philosophy and religion. There is no specific 'truth' to be had in the discipline of art history.

48. **Triptych** – an artwork consisting of three panels that can be either attached together or displayed side by side.

49. **Vanitas** – Closely related to memento mori, a vanitas is a still life picture containing images designed to remind us of our mortality and the worthlessness of worldly goods and pleasures. *See also* Memento mori.

SUGGESTED READING & NOTES

1. WAYS OF SEEING

S. Alpers. *The Art of Describing: Dutch Art in the Seventeenth Century*, Chicago University Press, 1983. 11 (p.23), 12 (p. 23).

G. Batchen. 'What of Shoes: Van Gogh and Art History', Verlag, 2009.

W. Benjamin. 'The Work of Art in the Age of Mechanical Reproduction', 1935 (orig. German ed.). 4 (p. 15); 6 (p.15); 7 (p.15).

J. Berger. *The Success and Failure of Picasso*, Penguin Books, 1980. 1 (p. 11); 2 (p. 12); 3 (p. 15); 5 (p. 15).

J. Berger. *Ways of Seeing*, Penguin Books, 1972.

C. Greenberg. 'After Abstract Expressionism', Art International, 1962.

C. Greenberg. 'Avant-Garde and Kitsch', *Partisan Review*, 1939.

C. Greenberg. 'Modernist Painting' in *Arts Yearbook*. 4, 1961.

H. Grimm. *Das Leben Raphaels von Urbino*, Drummer, 1872. 8 (p. 17).

M. Hatt and C. Klonk. *Art History: A Critical Introduction to its Methods*, Manchester University Press, 2017.

E. Panofksy. *Meaning and the Visual Arts*, Penguin Books, 1970. 10 (p. 21).

S. Schama. *The Embarrassment of Riches: An Interpretation of Dutch Culture in the Golden Age*, Vintage Books, 1987.

J.-P. Stonard. *The Books That Shaped Art History*, Thames and Hudson, 2013. 13 (p. 23).

H. Wölfflin. *Classic Art*, Phaidon, 1952. 9 (p. 17).

H. Wölfflin. *Principles of Art History: The Problem of the Development of Style in Later Art* (trans. M. D. Hottinger, Dover Publications, 1915 [1950].

2. THE ORIGINS OF ART IN ICE AGE EUROPE

K. Clark. *The Nude: A Study of Ideal Art*, John Murray, 1956.

J. Clottes. *What is Paleolithic Art: Cave Painting and the Dawn of Human Creativity*, University of Chicago Press, 2016. 1 (p. 26); 2 (p. 29).

B. David. *Cave Art*, Thames & Hudson, 2017. 4 (p. 30); 7 (p. 31).

R. Dunbar. *The Human Story: A New History of Mankind's Evolution*, Faber and Faber, 2004. 5 (p. 30).

I. Hodder, cited in N. MacGregor. *A History of the World in 100 Objects*, Allen Lane, 2010. 12 (p. 33).

J. Hahn. 'Aurignacian art in Central Europe', in H. Knecht et al., *Before Lascaux: The Complex Record of the Early Upper Paleolithic*, CRC Press, 1993.

Y. N. Harari. *Sapiens: A Brief History of Humankind*, Vintage, 2011. 3 (p. 30).

D. L. Hoffmann *et al.* 'U-Th dating of carbonate crusts reveals Neanderthal origin of Iberian cave art', Science 6378 [359], 23 February 2018. 6 (p. 31).

D. Lewis-Williams. *The Mind in the Cave: Consciousness and the Origins of Art*, Thames & Hudson, 2002. 8 (p. 31); 9 (p. 32); 10 (p. 32); 14 (p. 37).

L. Meskell. 'The Archaeology of Figurines and the Human Body in Prehistory', in T. Insoll (ed.), *The Oxford Handbook of Prehistoric Figures*, Oxford University Press, 2017. 11 (p. 32); 13 (p. 34).

C. Smith. 'The articulation of style and social structure in Australian Aboriginal art', *Australian Aboriginal Studies*, 1992 (1).

3. THE ITALIAN RENAISSANCE

L. B. Alberti. *Il libri della famiglia* in R. N. Watkins (translator), *The Family in Renaissance Florence*, University of South Carolina Press, 1969.

M. Baxandall. *Painting and Experience in Fifteenth-Century Italy*, Oxford University Press, 1990. 6 (p. 46).

J. Brotton. *The Renaissance: A Very Short Introduction*, Oxford University Press, 2006.

G. Bull (translator). *Giorgio Vasari: The Lives of the Artists*, Vol. I, The Folio Society, 1965.

J. Burkhardt. *Civilization of the Renaissance in Italy*, 1860. 3 (p. 39); 8 (p. 47).

W. Chadwick. *Women, Art and Society*, Thames & Hudson, 2012. 10 (p. 49).

B. Deimling. 'Early Renaissance Art in Florence and Central Italy', in Toman (ed.), *The Art of the Italian Renaissance*, Ullmann & Könemann, 2005.

J. Kelly-Gadol. 'Did Women Have a Renaissance', in R. Bridenthal and C. Koonz (eds.), *Becoming Visible: Women in European History*, Houghton Mifflin, 1977. 9 (p. 48).

J. Huizinga. '*Das problem der Renaissance*', English trans. in *Men and Ideas*, Princeton University Press, 1984. 1 (p. 39).

L. James. 'Senses and sensibility in Byzantium', *Art History*, 27 [4], September 2004.

G. A. Johnson. *Renaissance Art: A Very Short Introduction*, Oxford University Press, 2005. 13 (p. 50).

G. A. Johnson and S. F. Matthews Grieco (eds.). *Picturing Women in Renaissance and Baroque Italy*, Cambridge University Press, 1997.

J. Larner. *Italy in the Age of Dante and Petrarch, 1216–1380*, Longman, 1983. 2 (p. 39).

L. Nochlin. 'Why Have There Been No Great Women Artists?' in T. Hess and E. Baker (eds.), *Art and Sexual Politics*, Collier–Macmillan, 1971.

P. L. Rubin. *Images and Identity in Fifteenth-Century Florence*, Yale University Press, 2007. 7 (p. 46).

P. Simons. 'Women in Frames: the Gaze, the Eye, the Profile in Renaissance Portraiture', *History Workshop*, 25, Spring 1988. 12 (p. 50).

R. Toman (ed.). *The Art of the Italian Renaissance*, Ullmann & Könemann, 2005. 5 (p. 41).

G. Vasari. *Lives of the Artists, 1550–68*. 11 (p. 49).

E. Welch. *Art in Renaissance Italy, 1350–1500*, Oxford University Press, 2000. 4 (p. 41).

4. THINKING THROUGH ART

G. Agamben. *The Man Without Content*, Stanford University Press, 1999. 2 (p. 56).

L. B. Alberti. *De Pictura*, 1435. Translated by Cecil Grayson with an Introduction and Notes by Martin Kemp, Penguin Books, 1972 [2004]. 5 (p. 58); 6 (p. 59).

C. Allen. *French Painting in the Golden Age*, Thames & Hudson, 2003. 8 (p. 68).

A. D'Alleva. *Methods & Theories of Art History*, Laurence King Publishing, 2012 [2018]. 1 (p. 55).

G. Bellori. A. Wohl (translator), H. Wohl (ed.). *The Lives of the Modern Painters, Sculptors and Architects*, Cambridge University Press, 2005.

G. Bull (translator). *Giorgio Vasari: The Lives of the Artists*, Vol. I, The Folio Society, 1965.

W. Chadwick. *Women, Art and Society*, Thames & Hudson, 2012.

M. Hatt and C. Klonk. *Art History: A Critical Introduction to its Methods*, Manchester University Press, 2017. 7 (p. 67).

H. Honour and J. Fleming. *A World History of Art*, Laurence King, 2009.

L. Nochlin. 'Why Have There Been No Great Women Artists?' in T. Hess and E. Baker (eds.), *Art and Sexual Politics*, Collier Macmillan, 1971.

Plato. *Republic*. Translated with an Introduction and Notes by Christopher Rowe, Penguin books, 2012. 3 (p. 56); 4 (p. 57).

A. Potts. *Flesh and the Ideal: Winckelmann and the Origins of Art History*, Yale University Press, 1994.

D. Preziosi (ed.). *The Art of Art History: A Critical Anthology*, Oxford University Press, 2009.

Sir J. Reynolds, M. Wark (ed.). *Discourses on Art*, Yale University Press, 1975.

G. Vasari. *Lives of the Artists, 1550–68*.

W. Vaughan. *British Painting in the Golden Age*, Thames & Hudson, 1999.

5. INTERPRETING DUTCH ART AND CULTURE IN THE SEVENTEENTH CENTURY

A. J. Adams. 'Competing Communities in the "Great Bog" of Europe: Identity and Seventeenth-Century Landscape Dutch Painting in W. J. T. Mitchell (ed.), *Landscape and Power*, University of Chicago Press, 2002.

Anonymous, quoted in J. Cats. *Spiegel van der ouden ende nieuwen tijdt* (Mirror of Old Times), 1632. Cited in D. M. Mancoff. *Danger! Women Artists at Work*, Merrell Publishers Limited, 2012. 13 (p. 83).

M. Fokkens. Description of the Widely Renowned Commercial City of Amsterdam, 1662 (quoted by S. Schama in *The Embarrassment of Riches*, Vintage Books, 1987). 4 (p. 77); 5 (p. 77).

W. E. Franits. *Dutch Seventeenth-Century Genre Painting*, Yale University Press, 2008. 2 (p. 76); 3 (p. 77).

W. E. Franits. *Paragons of Virtue: Women and Domesticity in Seventeenth-Century Dutch Art*, Cambridge University Press, 1993.

F. F. Hofrichter. 'Judith Leyster's Proposition – Between Virtue and Vice', in N. Broude and M. Garrard (eds.), *Feminism and Art History: Questioning the Litany*, Harper and Row, 1982. 12 (p. 83).

H. Honour and J. Fleming. *A World History of Art*, Laurence King, 2009. 18 (p. 95).

D. W. Meinig. 'Symbolic Landscapes', in D. W. Meinig (ed.). *The Interpretation of Ordinary Landscapes*, Oxford University Press, 1979.

S. Schama. *The Embarrassment of Riches*, Vintage Books, 1987. 7 (p. 77); 9 (p. 77); 10 (p. 79); 15 (p. 88); 17 (p. 89).

N. Schneider. *Still Life. Still Life Painting in the Early Modern Period*, Taschen, 1999. 14 (p. 88).

S. Slive. *Dutch Painting: 1600–1800*, Yale University Press, 1966. 6 (p. 77).

R. Temple (ed.). *The Travels of Peter Mundy in Europe and Asia, 1608–1667*, Hakluyt Society, 1925, cited in Schama, *The Embarrassment of of Riches*, Vintage Books, 1987. 8 (p. 77).

A Vierlingh, Tractaet van Diekgie, cited in Schama, *The Embarrassment of Riches*, Vintage Books, 1987. 1 (p. 75).

M. Westermann. *A Worldly Art: The Dutch Republic 1585–1718*, Yale University Press, 2004. 11 (p. 79); 16 (p. 89).

6. SEVENTEENTH-CENTURY SPANISH ART

J. Brown and J. H. Elliott. *A Palace for a King*, Yale University Press, 1980.

J. Brown. *Images and Ideas in Seventeenth-Century Spanish Painting*, Princeton University Press, 1978. 8 (p. 112); 9 (p. 113).

J. Brown. *Painting in Spain: 1500–1700*, Yale University Press, 1998. 1 (p. 102); 3 (p. 107).

J. Brown. *Velázquez*, Yale University Press, 1986.

A. Sutherland Harris. *Seventeenth-Century Art and Architecture*, Laurence King Publishing, 2008. 2 (p. 102); 7 (p. 112).

H. Honour and J. Fleming. *A World History of Art*, Laurence King, 2009.

F. Pacheco. *Arte de la Pintura*, Seville, 1649, in Bartolomé Bassegoda I Hugas (ed.), Madrid, 1990, cited in Brown, *Painting in Spain: 1500–1700*, Yale University Press, 1998. 5 (p. 110).

F. Pacheco, quoted by J. Brown in *Images and Ideas in Seventeenth-Century Spanish Painting*, Princeton University Press, 1978.

N. Schneider. *Still Life: Still Life Painting in the Early Modern Period*, Taschen, 1999. 6 (p. 111).

S. Schroth. 'Burial of Count Orgaz', in J. Brown (ed.), *Figure of Thought: El Greco as Interpreter of History, Tradition and Ideas, Studies in the History of Art*, 11, Washington, 1982. 4 (p. 108).

7. THEORY OF ART: THE FUNDAMENTALS OF MODERN ART THEORY

A. D'Alleva. *Methods & Theories of Art History*, Laurence King Publishing, 2012 [2018]. 7 (p. 129); 12 (p. 132).

A. Ashley-Cooper, Earl of Shaftsbury. *Second Character; or the Language of Forms* (B. Rand ed.), Cambridge, 1914, in T. Puttfarken, *The Discovery of Pictorial Composition: Theories of Visual order in Painting, 1400-1800*, Yale University Press, 2000.

L. Ferry. *Homo Aestheticus: The Invention of Taste in the Democratic Age*, trans. Robert de Loaiza, University of Chicago Press, 1993.

S. Freud. 'Civilisation and Its Discontents' in *Civilization, Society and Religion*, Penguin Books, 1989 [1991], vol. 12.

S. Freud. *The Interpretation of Dreams*, Penguin Books, 1974 [1991].

S. Freud. *The Standard Edition of the Complete Psychological Works of Sigmund Freud*, James Strachey in collaboration with Anna Freud, 24 vols, Hogarth Press, 1953 [1974], vol. II. 11 (p. 132).

S. Freud. *Three Essays on the Theory of Sexuality*, Franz Deuticke, 1905.

S. Freud. *Totem and Taboo: Some points of Agreement between the Mental Lives of Children, Savages and Neurotics*, Ark Paperbacks, 1950 [1991].

C-A. Du Fresnoy and Rogier de Piles. 'De arte graphica' (1668), in T. Puttfarken, *The Discovery of Pictorial Composition: Theories of Visual order in Painting, 1400-1800*, Yale University Press, 2000.

M. Hatt and C. Klonk. *Art History: A Critical Introduction to its Methods*, Manchester University Press, 2017. 10 (p. 130).

I. Kant. *The Critique of Judgement*, 1790 (excerpts in D. Preziosi, *The Art of Art History: A Critical Anthology*, Oxford University Press, 2009).

S. Nash. 'Erwin Panofsky' in J.-P. Stonard. *The Books That Shaped Art History*, Thames and Hudson, 2013. 8 (p. 130).

E. Panofsky. *Meaning in the Visual Arts*, Penguin Books, 1970 [1955]. 5 (p. 125).

E. Panofsky. *Studies in Iconology: Humanistic Themes in the Art of the Renaissance*, Oxford University Press, 1939. 6 (p. 127).

E. Panofsky. *Early Study of Netherlandish Painting: Its Origins and Character*, Harvard University Press, 1953.

M. Podro. *The Critical Historians of Art*, Yale University Press, 1982. 1 (p. 119); 2 (p. 122); 3 (p. 122).

T. Puttfarken. *The Discovery of Pictorial Composition: Theories of Visual order in Painting, 1400–1800*, Yale University Press, 2000.

M. Schapiro. 'Leonardo and Freud: An Art Historical Study', *Journal of the History of Ideas* 17, 1956. 13 (p. 132).

H. Wölfflin. *Principles of Art History: The Problem of the Development of Style in Later Art* (trans. M. D. Hottinger, Dover Publications, 1915 [1950]. 1 (p. 119); 4 (p.123); 9 (p. 130).

8. FROM ROCOCO TO REVOLUTION: EUROPEAN ART IN THE AGE OF ENLIGHTENMENT.

J-F. du Bos. *Réflexions critiques sur la poésie et la peinture* (*Critical Reflections on Poetry and Paintings*), Chez Pierre-Jean Mariette, 1719. 2 (p. 141).

R. Descartes. *Discourse on Method*, 1637.

L. Eitner. *Neoclassicism and Romanticism: 1750–1850*, vol. 1, Prentice Hall, 1970. 10 (p. 148).

M. Facos. *An Introduction to Nineteenth-Century Art*, Routledge, 2011. 8 (p. 145).

F. Haskell. *Patrons and Painters: A Study in the Relations between Italian Art and Society in the Age of the Baroque*, Yale University Press, 1980.

H. Honour and J. Fleming. *A World History of Art*, Laurence King, 2009. 1 (p. 139); 9 (p. 147).

I. Kant. '*Was ist Aufklärung*' ('*What is Enlightenment?*'), 1784.

J. Locke. *Essay Concerning Human Understanding*, 1690.

J. Nash. *Vermeer*, Scala Books, 1991. 4 (p. 142).

R.R. Palmer. *Twelve Who Ruled: The Year of the Terror in the French Revolution*, Princeton University Press, 1989.

A. Pope. *Essay on Criticism*, 1711.

J. Robertson. *The Enlightenment*, Oxford University Press, 2015.

J.-J. Rousseau. *Discours sur l'origine et les fondements de l'inégalité parmi des homes*, 1755.

D. Tarabra. *European Art of the Eighteenth Century*, trans. Rosanna M. Giammanaco Frongia, The J. Paul Getty Museum, 2008. 3 (p. 142); 5 (p. 143);

G. M. Trevelyan. *A Shortened History of England*, Penguin Books, 1942. 6 (p. 143)

W. Vaughan. *British Painting in the Golden Age*, Thames & Hudson, 1999. 7 (p. 144).

9. NINETEENTH CENTURY ART: ROMANTICISM: 1765–1840

M. Andrews. 'Nature as picture or process', from *Landscape and Western Art*, Open University Press, 1999. 10 (p. 160).

J. Barnes. *A History of the World in 10½ Chapters*, Knopf, 1989. 16 (p. 163).

C. Baudelaire. 'Salon de 1846', *Oeuvres complètes de Charles Baudelaire*, Michel Lévy frères, 1868. 3 (p. 154).

Hans Belting. *The Invisible Masterpiece*, Reaktion Books, 2001. 14 (p. 162); 15 (p. 163).

N. Benedict. '*The Raft* from the point of view of subject matter: Theodore Géricault', *The Burlington Magazine*, vol. 96, no. 617, 1954. 17 (p. 163).

W. Blake. *Songs of Innocence*, 1789.

E. Burke. *A Philosophical Enquiry into the Origin of our Ideas of the Sublime and the Beautiful*, Wilson and Co., 1801. 7 (p. 155).

Z. Çelik. 'Speaking Back to Orientalist Discourse', in J. Beaulieu and M. Roberts (eds.), *Orientalism's Interlocutors*, Duke University Press, 2002. 22 (p. 168).

J. Constable. 'Letters and Notes on Painting: 1802–1836', from Joshua C. Taylor. *Nineteenth Century Theories of Art*, University of California Press, 1987. 11 (p. 161).

F. Engels and K. Marx. *The Communist Manifesto*, 1848.

M. Ferber. *Romanticism: A Very Short Introduction*, Oxford University Press, 2010. 2 (p. 153); 4 (p.154); 5 (p. 154).

J. Hamilton. *Turner and the Scientists*, Tate Gallery, 1998.

H. Honour and J. Fleming. *A World History of Art*, Laurence King, 2009. 6 (p. 154).

S. Lees (ed.) *Nineteenth-Century European Paintings at the Sterling Clarke Institute*, vol. 1, Sterling and Francine Clarke Art Institute, 2012.

C. G. Leland. *The Works of Heinrich Heine*, The Salon, 1893. 18 (p. 165).

J. Lopez-Rey. 'Goya's *Caprichos*: Beauty, Reason, and Caricature', in F. Licht (ed.), *Goya in Perspective*, Prentice Hall, 1973. 19 (p. 165).

E. Lorenz. *Géricault His life and work*, Orbis Publishing Limited, 1983.

A. Lyles (ed.). *Constable: The Great Landscapes*, Tate Publishing, 2006. 13 (p. 161).

L. Nochlin. 'The imaginary orient' (1982) in *The politics of vision: essays on nineteenth-century art and society*, Thames and Hudson, 1991.

G. Reynolds. *The Later Paintings and Drawings of John Constable*, 2 vols. Yale University Press, 1984.

W. Rodner. *Encyclopedia of the Romantic Era: 1760–1850* (C. J. Murray ed.), vol. 2, Fitzroy Dearborn, 2004. 8 (p. 158); 9 (p. 158).

M. Rosenthal. *Constable: the Painter and his Landscapes*, Yale University Press, 1983.

E. Said. *Orientalism*, Penguin Books, 1978 [2003]. 12 (p. 161); 21 (p. 167).

A.E.P. Sánchez and E.A. Sayre (eds). *Goya and the Spirit of the Enlightenment*, Bullfinch Press, 1989. 20 (p. 165).

S. Schama. *The Power of Art*, BBC Books, 2006. 23 (p. 171).

F. Schlegel. 'Letter About the Novel', 1799, in E. Millân-Zaibert, *Friedrich Schlegel and the Emergency of Romantic Philosophy*, State University of New York Press, 2007. 1 (p. 153).

W. Vaughan. *British Painting in the Golden Age*, Thames & Hudson, 1999.

10. ART IN FRANCE: 1848–1904

C. Baudelaire. 'The Painter of Modern Life', *Le Figaro*, 1863.

C. Baudelaire. 'The Queen of the Faculties', Salon review, 'The Modern Artist', 1859. 5 (p. 177).

T.J. Clark. *Image of the People, Gustave Courbet and the 1848 Revolution*, Thames and Hudson, 1973 [1982].

T. J. Clark. *The Painting of Modern Life*, Thames and Hudson, 1985.

C. Corot, Notebook Entry, transcribed by E. Moreau-Nélaton. *Histoire de Corot et des oeuvres*, 1905, trans P. Collier, and cited in Harrison et al, *Art in Theory, 1850–1900: An Anthology of Changing Ideas*, Blackwell Publishing Ltd., 1998. 4 (p. 177).

M. Facos. *An Introduction to Nineteenth-Century Art*, Routledge, 2011.

J. Finlay. 'Against the Wolves', *The Times Literary Supplement*, 4 July 2003.

G. Hamilton Heard. *Manet and His Critics*, Yale University Press, 1954 [1886].

C. Harrison, P. Wood and J. Gaiger (eds). *Art in Theory, 1850–1900: An Anthology of Changing Ideas*, Blackwell Publishing Ltd., 1998. 1 (p. 176); 2 (p. 176); 3 (p. 177).

H. Honour and J. Fleming. *A World History of Art*, Laurence King, 2009. 9 (p. 182).

J. Huret. 'Paul Gauguin discussant des peintres', in *L'Echo du Paris*, 23 Feb. 1891, in P. Gauguin, *The Writings of the Savage*, D. Guerin (ed.), Viking Press, 1978. 13 (p. 192).

G. Kahn. 'Response to the Symbolists', *L'Evénément*, 28 September 1886, trans. J. Rewald, *Post Impressionism from Van Gogh to Gauguin*, Secker & Warburg, 1956 [1978]. 12 (p. 192).

J. Laforgue. *Oeuvres Complètes*, Paris, 1902-3. Trans by W.J. Smith in Art News, May 1956.

L. Leroy. *Charivari*, 1963. 7 (p. 178).

G. Michaud. *Message poetique du Symbolisme*, Nizet, 1961. 6 (p. 178).

P. J. Proudhon. 'Definition of the New School', in *The Principle of Art*, Paris, 1865.

J. Rewald (ed.), *Paul Cezanne's Letters*, trans M. Kay, Cassirer, 1941. 11 (p. 189)

J. Ruskin. *The Elements of Drawing*, Letter I, 'On First Practice', Exercise I, John Wiley, 1886.

P. Signac. 'Impressionistes et Révolutionnaires', *La Révolte*, June 1891, trans. L. Nochlin, *Impressionism and Post Impressionism, 1847–1904: Sources and Documents*, Prentice Hall, 1996.

B. Thomson. *Impressionism: Origins, Practice, Reception*, Thames and Hudson, 2000 8 (p. 182); 10 (p. 182).

11. MODERNISM: ART IN FRANCE, 1906–36.

G. Apollinaire. *Apollinaire on Art: Essays and Reviews, 1902–1918*, Thames and Hudson, 1972.

H. Bergson. *Creative Evolution*, 1907 (trans. A. Mitchell, Henry Holt and Co., 1911).

Y.-A. Bois. *Painting as Model*, MIT Press, 1990.

A. Breton. 'Manifesto of Surrealism', *La Révolution Surréaliste*, 1924.

D. Cottington. *Modern Art: A Very Short Introduction*, Oxford University Press, 2005.

E. Cowling. *Picasso: Style and Meaning*, Phaidon Press, 2002. 11 (p. 209).

N. Cox. *Cubism*, Phaidon Press, 2000. 7 (p. 205).

S. Dalí. '*Objets Surréalistes*', *Le Surréalisme au Service de la Révolution*, Paris, no. 3, Décembre 1931. Cited and translated in R. Hohl (ed.), *Giacometti: A Biography in Pictures*, Verlag Gerd Hatje, 1998.

M. Duchamp. *The Blind Man*, April 1917, cited in M. Gale, *Dada and Surrealism*, Phaidon, 1997.

C. Duncan. *Aesthetics of Power*, Cambridge University Press, 1993.

J. Elderfield. *The 'Wild Beasts': Fauvism and its Affinities*, Museum of Modern Art, 1976. 4 (p. 202).

J. Frazer. *The Golden Bough*, Macmillan, 1890–1915.

T. Garb. 'To Kill the Nineteenth Century: Sex and Spectatorship with Gertrude and Pablo', in C. Green (ed.). *Picasso's Demoiselles d'Avignon: Masterpieces of Western Painting*, Cambridge University Press, 2001. 8 (p. 205); 9 (p. 205).

C. Green. *Art in France: 1900–1940*, Yale University Press, 2000. 3 (p. 202).

C. Green (ed.). *Picasso's Demoiselles d'Avignon: Masterpieces of Western Painting*, Cambridge University Press, 2001.

C. Green. *Cubism and Its Enemies: Modern Movements and Reaction in French Art, 1916–1928*, Yale University Press, 1987.

C. Harrison and P. Wood. *Art theory 1900–2000; an anthology of changing ideas*, Blackwell Publishing, 2003. 1 (p. 213); 13 (p. 215); 14 (p. 215); 15 (p. 215).

C.-E. Jeanneret (Le Corbusier) & A. Ozenfant. 'Purism', 4th issue of *L'Esprit Nouveau*, 1920. 12 (p. 211).

R. Krauss, H. Foster *et al. Art Since 1900: Modernism, Antimodernism, Postmodernism*, Thames and Hudson, 2016.

R. Krauss. 'In the Name of Picasso', October, vol. 16, Spring 1981.

H. Lebovics. *True France: The Wars Over Cultural Identity, 1900–1945*, Cornell University Press, 1992.

P. Leighten. 'The White Peril and *L'art nègre*: Picasso, Primitivism and Anti-Colonialism', *Art Bulletin*, December, vol. LXXII, no. 4, 1990.

D. Lomas. 'Canon of Deformity: *Les Demoiselles d'Avignon* and Physical Anthropology', *Art History*, vol. 16, no. 93, September 1993.

F. Marinetti. 'The Foundation and Manifesto of Futurism', 1909, in C. Harrison and P. Wood, *Art theory 1900–2000: an anthology of changing ideas*, Blackwell Publishing, 2003. 2 (p. 199).

J. Nash. *Cubism, Futurism and Constructivism*, Thames and Hudson, 1974. 6 (p. 205).

F. M. Naumann. '*Affectueusement, Marcel*: Ten Letters from Marcel Duchamp to Suzanne Duchamp and Jean Crotti', *Archives of the American Art Journal*, vol. 22, no. 4, 1982.

R. Penrose. *Picasso: His Life and Work*, HarperCollins, 1958. 5 (p. 202).

K. E. Silver. *L'Esprit de Corps: the art of the Parisian avant-garde and the First World War, 1914–1925*, Princeton University Press, 1989.

M. Turvey. 'Dada between Heaven and Hell: Abstraction and Universal Language in The Rhythm Films of Hans Richter', *Dada* Vol. 105, MIT Press, 2003. 10 (p. 207).

M. Weber. 'Asceticism and the Spirit of Capitalism', 1904–5.

INDEX

PICTURE CREDITS